Sony® α DSLR-A200
Digital Field Guide

Sony® α DSLR–A200 Digital Field Guide

Alan Hess

WILEY

Wiley Publishing, Inc.

Sony° α DSLR-A200 Digital Field Guide

Published by
Wiley Publishing, Inc.
10475 Crosspoint Blvd.
Indianapolis, IN 46256
www.wiley.com

Copyright © 2009 by Wiley Publishing, Inc., Indianapolis, Indiana

Published simultaneously in Canada

ISBN: 978-0-470-37915-8

Manufactured in the United States of America

10 9 8 7 6 5 4 3 2 1

For general information on our other products and services or to obtain technical support, please contact our Customer Care Department within the U.S. at (800) 762-2974, outside the U.S. at (317) 572-3993 or fax (317) 572-4002.

Wiley also publishes its books in a variety of electronic formats. Some content that appears in print may not be available in electronic books.

Library of Congress Control Number: 2008938384

WILEY

About the Author

Alan Hess is a freelance photographer based in Southern California. He is the author of the *Sony Alpha DSLR-A700 Digital Field Guide*. He has photographed a wide variety of subjects, from karate demonstrations to guitar manufacturing. He has even been known to shoot a wedding on occasion.

His concert and backstage images have appeared in numerous online and print publications and have been used for promotional purposes and music packaging.

He is a member of the National Press Photographers Association and the National Association of Photoshop Professionals.

Alan is a key contributor to the Lexar Pro Photographer Web site and has written articles on concert photography and technology.

Alan can be contacted through his Web site www.alanhessphotography.com.

Credits

Acquisitions Editor
Courtney Allen

Senior Project Editor
Cricket Krengel

Technical Editor
Ben Holland

Copy Editor
Kim Heusel

Editorial Manager
Robyn B. Siesky

Vice President and Executive Group Publisher
Richard Swadley

Vice President and Publisher
Barry Pruett

Business Manager
Amy Knies

Senior Marketing Manager
Sandy Smith

Project Coordinator
Erin Smith

Graphics and Production Specialists
Jennifer Mayberry
Christin Swinford
Ronald Terry

Quality Control Technician
John Greenough

Proofreading
Laura L. Bowman

Indexing
Sharon Shock

For Nadra

Acknowledgments

Special thanks to my wife for her understanding and patience with my crazy hours during the writing of this book.

Thanks to my family and friends for allowing me to always be pointing a camera at you and letting me use the photos in this book.

Thanks to Courtney and Cricket for all their help with this project. Without you two it never would have happened.

Thanks to Dennis for my first real concert photo pass. It changed the course of my life.

Contents

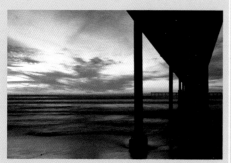
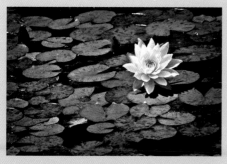
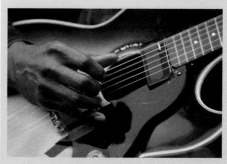

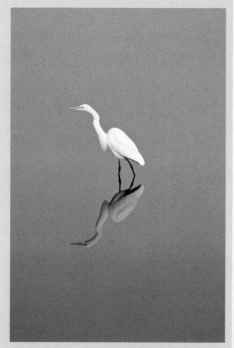

Chapter 5: All About Lenses 109

Chapter 6: Photo Subjects 125

Introduction

Welcome to the *Sony Alpha DSLR-A200 Digital Field Guide.*

The A200 is aimed at the beginner photographer, but with its 10.2 megapixel CCD, its Super SteadyShot vibration reduction built in and the ability to photograph in JPEG. RAW and a setting that records each mage in both file formats, the A200 is enough camera to keep the novice or intermediate photographer happy for years.

Moving from a point and shoot or an older film camera to a digital SLR can be a daunting task. The controls, settings and menus can be confusing to novice photographers and the camera manual can be vague and confusing. This book is here to help you through understanding the A200s many settings and menu choices so that you can get the most out of your camera.

As a working photographer, it is important to me to get the images that I want in any photographic situation, and it is very frustrating when the images don't turn out the way I wanted them to. This Digital Field Guide is here to help you use the A200 to its full potential and capture the best images in a wide variety of situations, from abstract to wildlife photography with plenty of photos along with the shooting data for each image.

If you are the type of person who just wants to jump into taking photos, and honestly, that the kind of person I am, then check out the Quick Tour and Chapter 6. That will get you started with setting your A200 and right out into a variety of photo situations. After photographing for a while, you might want to check out Chapters 1 and 2 on setting all the options on your A200 and a look at each of the menu options on the camera. This will help you know where the various settings are located and what each button, lever and switch does.

Chapter 3 is a review on the basics of photography, covering shutter speed, aperture exposure along with the basics of composition. This is the chapter to read to get a little brush up on the basics. A quick review on the Rule of Thirds or some of the other tips that can lead to better composition are covered in this chapter.

Light is the basis of all photography and Chapter 4 deals with light in digital photography, from daylight to using a flash. The direction, intensity and color of light are all covered along with the different types of electrical lights and how to best deal with them. Chapter 4 also covers the best way to use the built in flash and external flash units.

The A200 is a dSLR, a digital Single Lens Reflex camera that allows it to use different lenses than can be changed by the photographer. This lets the system grow along with the photographer and Sony has a full line of lenses that are compatible with the A200. Chapter 5 covers

the basics between prime and zoom lenses and the difference between wide angle, normal and telephoto lenses. Chapter 5 also covers focal lengths, maximum apertures and the lens crop factor.

Chapter 6, as mentioned before, is all about photographing in different situations. The chapter is broken down by subject, including such diverse subjects as weddings and concerts. Each topic has photo examples and the shooting data along with tips and techniques to get the most out of any situation. If you want to get the best possible images from any situation, from taking great photos on your next vacation to getting the best images of the flowers in your yard, Chapter 6 covers it all.

Taking the photos is one thing, showing them to others is another thing entirely. Chapter 7 deals with getting the images from the camera to a computer or just using the camera to display the images on a television. It is also possible to print images directly with the PictBridge software, and that is also covered in Chapter 7.

One key to getting the best possible results from your A200 is to keep it in good working order and to make sure that it is clean. Appendix A covers the cleaning of the camera and the lenses so that dust and dirt don't ruin your photos or camera. Even with the new anti-dust coating and self-cleaning, knowing the correct way to remove dust and dirt is important. Less time trying to get the camera clean means more time to photograph, and photographing is what it is all about.

Digital cameras require a digital darkroom, and while it is possible to drop your CompactFlash card off at a developer, part of the lure of digital photography is that you can do it your self. Sony bundles software with the A200 for this purpose and Appendix B covers that software along with some of the other choices for today's photographers. There are a great many different programs available, and there is no way to cover them all here, so I picked out a few that are available right now — some cost more than the camera, some are free.

Appendix C covers some general information to help with future decisions in regard to expanding your digital photography. CompactFlash cards, tripods, camera bags and Internet resources along with photography organizations are covered.

Grab your A200, turn the page and begin getting the most out of your camera. The best part is that you can read the book now and then just tuck it into your camera bag so that you can reference it later. While the book looks great on a bookshelf, it works much better to have it with you when you are out actually photographing.

Quick Tour

QT

Y ou are the proud owner of the Sony Alpha DSLR-A200 and you want to find out what the camera can do — not by sitting and reading all day, but by going out and photographing. This Quick Tour helps you set the camera up so that you can start using it right away. There will be time to come back and delve deeper into this book later. The first thing to do is to make sure that you have charged the battery and inserted it into the bottom of the camera, attached a lens, and turned on the camera for the first time; and set the date and time. All that is left is to insert a memory card and format it for use in the A200 and then you are ready to go.

Formatting the Memory Card

The CompactFlash memory card is the digital film for your A200, and to get it ready for use it should be formatted in the camera. The CompactFlash memory card slot is located on the right side of the camera. Just slide the cover toward the back of the camera and it pops open. Insert a CompactFlash card into the slot until it is firmly seated. The CompactFlash card can only fit into the camera one way, and that is the side with the little holes going into the camera while the side with the label faces towards the rear of the camera body. Do not force the card into the slot as the pins in the camera can get bent if the card is forced the wrong way. Close the door by pushing it closed and then sliding it forward toward the front of the camera.

To format the card, do the following:

1. **Press the Menu button on the back of the camera.** This opens the A200 menus.

2. **Use the Multi-selector to navigate to Format.**

3. **With the Format menu choice selected, press the Multi-selector center button.** The A200 displays "All data will be deleted. Format? OK or Cancel." This erases all the images on the card and gets it ready to store the images from the A200. If you have images already on

In This Quick Tour

Formatting the memory card

Setting an Exposure mode or a Scene mode

Setting the image size and quality

Setting the metering mode

Setting the ISO

Setting the white balance

Setting the Drive mode

Setting the Focus mode

Playback

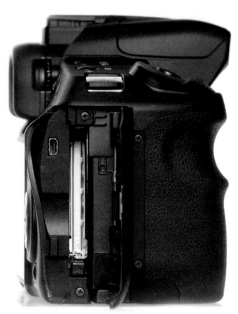

QT.1 The CompactFlash card cover on the A200 both closed and open

the card that you don't want to lose, press Cancel and remove the card from the camera. If the card is new or has no images that you want to keep on it, press OK.

The CompactFlash card is now ready to be used in your A200 and you are nearly ready to go out and shoot.

Setting an Exposure Mode or a Scene Mode

The A200 has 12 recording modes — six Exposure modes and six Scene modes.

You can select which mode the camera is in by turning the Mode dial on the top left of the camera. The only function of this dial is to set the Exposure or Scene mode of the camera. The Mode that is set here determines how the camera functions in taking photos and each of these settings are used for different photo opportunities.

✦ **Auto, No Flash.** The camera sets the shutter speed and aperture but the flash does not fire even in low light situations. This mode is very useful for situations where a flash would be considered disruptive, yet you want to use the camera on a fully automatic mode.

✦ **Auto.** Turns the camera into a powerful point-and-shoot camera. A good starting point for people new to using a DSLR. The A200 determines the shutter speed, aperture, and, in the default mode, the ISO. This mode produces good photos in a majority of shooting situations.

✦ **Program Auto.** Similar to Auto mode, in Program Auto mode the camera picks the shutter speed and the aperture, but the photographer can adjust them if wanted. Program Auto mode is a better choice than Auto especially if you are trying to freeze a fast moving subject. The Command dial can be used to adjust the shutter speed from the starting point that the camera picks when metering the scene.

✦ **Aperture Priority.** You set the aperture and the camera sets the shutter speed. Used when controlling the depth of field is more important than picking the shutter speed. This mode lets you control the opening in the lens, and the camera then controls how long the shutter is open.

✦ **Shutter Priority.** You set the shutter speed and the camera automatically sets the aperture. Used when the shutter speed is more important than the depth of field. This is a great mode to use to freeze a fast-moving subject, like at a sporting event, or children playing. It is also useful when wanting a long shutter in capturing light trails. You get to decide which shutter speed to use and the A200 picks the aperture. The higher the shutter speed, the quicker the shutter opens and closes.

✦ **Manual.** You get to pick the shutter speed and the aperture. This gives you complete control over the exposure of the image.

✦ **Portrait.** Best used when shooting a single person or small group. The camera tries to set the aperture to blur the background to make the subjects stand out.

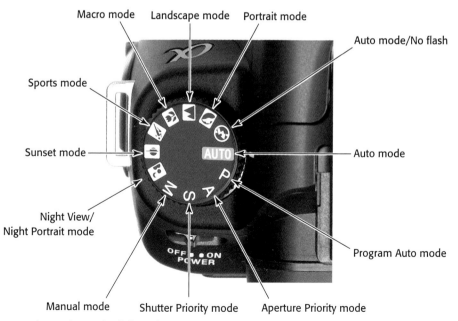

QT.2 The main Mode dial on the A200

✦ **Landscape.** Used for scenes where the whole scene needs to be in focus from foreground to background. The flash is turned off in this mode.

✦ **Macro.** This mode is designed to be used for close-up photography where the subject is not moving.

✦ **Sports/Action.** Best used for capturing fast-moving subjects in good light.

✦ **Sunset.** Adjusts the colors to bring out the reds and oranges of the light at sunrise and sunset. This is not a good choice for shooting people, as the colors will be off.

✦ **Night View/Night Portrait.** The camera uses a slower shutter speed so that the ambient light is used in creating an image. This is used mainly in low-light situations and needs a tripod or a very steady hand. When shooting people, turn the flash on, so they are evenly lit.

 For more detail on each mode, see Chapter 2.

Setting the Image Size and Quality

After deciding what exposure or scene mode to use, it is important to decide on what image size and quality to use. These settings determine how many images can be stored on a memory card and what size prints can be made from your photos. Taking photos at the biggest file size with the best possible quality allows you to make the best possible prints in the future. The default for the A200 is to use Large image size and Fine JPEG quality. Once you change these settings, they are stored until you change them again, even if you turn the camera off.

Setting the image size is done in the Recording menu 1.

1. **Press the Menu button to open the camera's menu on the LCD.**

2. **Use the Multi-selector to navigate to the Recording menu 1.**

3. **Use the Multi-selector to navigate to the Image size menu and press the Multi-selector center button.**

4. **The Image size submenu gives you three choices: Large, Medium, and Small.** Select the size you want with the Multi-selector and press the Multi-selector center button.

 The Image size menu is not available if the Quality is set to RAW or RAW & JPEG.

The A200 is capable of saving photos in both JPEG and RAW file formats. You can also save each image in both formats simultaneously. There are four Quality settings you can choose from for saving your files:

✦ **RAW.** The file is saved in the Sony RAW file format. Files are saved with the ARW file extension.

 Image size is covered in greater detail in Chapter 2.

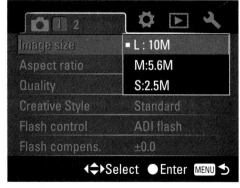

QT.3 The A200 Image size menu

✦ **RAW & JPEG.** The file is saved in the Sony RAW format and the JPEG format at the same time. This is a very useful feature, letting you create a JPEG file that can be used immediately by all image programs, printers, e-mail programs, and the Internet browsers, but also giving you the RAW file to process later if more editing is needed. It does impact how many images can be stored on a memory card, but this is the mode I use 90 percent of the time.

✦ **Fine JPEG.** The file is saved in the JPEG format, only with very little compression.

✦ **Standard JPEG.** The file is saved in the JPEG format, only with more compression than the Fine setting.

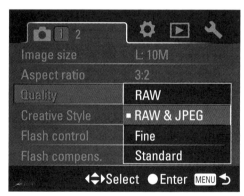

QT.4 The A200 Image size menu

To change the Image Quality setting, follow these steps:

1. **Press the Menu button to open the camera's menu on the LCD.**

2. **Use the Multi-selector to navigate to the Recording menu 1.**

3. **Use the Multi-selector to navigate to the Quality menu and press the Multi-selector center button.** The Quality submenu appears.

4. **Choose one of the four image quality options: RAW, RAW & JPEG, Fine JPEG, or Standard JPEG.**

Setting the Metering Mode

The built-in light meter on the A200 measures the light in the scene and uses that reading to determine what the settings for a correct exposure should be.

The A200 has three metering modes. Each of the three modes looks at the overall scene in different ways.

✦ **Multi-segment.** The whole scene is divided into 40 areas, and the light is measured in each segment. This mode is great for most general shooting and is the default mode of the A200.

✦ **Center-weighted.** Uses the whole scene to measure the brightness, but emphasizes the readings from the center section of the scene.

✦ **Spot.** Uses only the information from the spot-metering circle in the center of the frame.

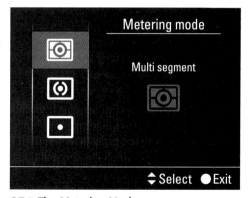

QT.5 The Metering Mode menu

To choose the Multi-segment, Center-weighed, or Spot mode, do the following:

1. **Press the Fn (Function) button on the back of the A200.** The camera's Quick Navigation menu appears on the LCD.

2. **Use the Multi-selector to navigate to the Metering Mode menu choice and press the Multi-selector center button. This opens the Metering mode menu on the LCD.**

3. **Use the Multi-selector to pick one of the three Metering modes and press the Multi-selector center button.** The Metering mode you selected is now set.

Setting the ISO

The ISO setting determines how sensitive the image sensor is to light. The A200 has an ISO range of 100 to 3200, with 100 being the least sensitive to light and 3200 being the most sensitive to light. Setting the ISO is quick and easy.

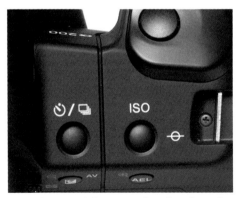

QT.6 The top of the A200 showing the Drive button and the ISO button

Follow these steps to set the ISO on the A200:

1. **Press the ISO button on the top of the camera.** The ISO menu appears on the LCD.

2. **Use the Multi-selector to navigate to your ISO choice from the list.**

3. **Press the Multi-selector center button to use the selected ISO.**

 Cross-Reference *See Chapter 2 for more information on ISO.*

There is also an Auto ISO mode available that tries to use the lowest ISO possible but increases the ISO to achieve the best exposure as determined by the built-in light meter. This mode is not available when shooting in Manual mode and can be set by choosing the AUTO setting in the ISO menu.

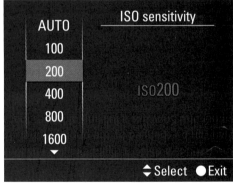

QT.7 The ISO menu

Setting the White Balance

Every light source has a specific color, and even though they all appear similar to our eyes, the sensor in the A200 can't tell them apart easily and needs to know what type of light is illuminating your scene so that the colors look realistic. For example, a white shirt looks the same to you both outside under sunlight and inside under fluorescent lights, that is, the shirt looks white. Your camera sees those two shirts as different colors because of the different types of light. For the A200 to capture that correctly, you need to tell it what type of light is present so that the camera can compensate for different colors in the different types of light. Setting the white balance is the method for telling the camera what type of light is in your scene.

> **Cross-Reference** *White balance is covered in more detail in Chapter 2; light in general is covered in Chapter 4.*

QT.8 The White Balance menu

The A200 has nine different white balance modes:

✦ Auto White Balance

✦ Daylight

✦ Shade

✦ Cloudy

✦ Tungsten

✦ Fluorescent

✦ Flash

✦ Color Temperature

✦ Custom

The Auto White Balance setting is the default setting. It is great for most photography and can handle most lighting situations.

Changing the white balance setting on the A200 is done by following these steps:

1. **Press the Function button on the back of the camera.** The camera's Quick Navigation menu appears on the LCD.

2. **Use the Multi-selector to navigate to the white balance setting and press the Multi-selector center button.** The White Balance menu appears.

3. **Use the Multi-selector to navigate to your choice of white balance setting and press the Multi-selector center button.** Your White Balance setting choice is now activated.

> **Note** *If you shoot in RAW mode, the white balance setting is not as important because white balance can be changed after you take the image. If you shoot using the RAW & JPEG mode, white balance is applied to the JPEG image only.*

Setting the Drive Mode

The Drive mode controls how many photos are taken when the Shutter button is pressed. The basic Drive modes are:

✦ **Single-shot Advance.** The default setting takes a single image every time you press the Shutter button.

✦ **Continuous Advance.** The camera continues shooting photos as long as you continue to press the Shutter button.

Changing the Drive mode is as easy as pressing the Drive button on the top of the camera, which displays the Drive menu (see QT.6 for the location of the Drive menu button). The Multi-selector can then be used to select the Drive mode. Pressing the Multi-selector center button sets the new Drive mode.

Choosing between Single or Continuous for the Drive mode depends on what you are shooting. For sports or action, catching the kids running around, or even concert photography, I set the Drive mode to Continuous advance mode. Getting the second or third shot in quick succession helps me get the shot I want.

 The Drive mode menu is covered in depth in Chapter 2.

Setting the Focus Mode

The A200 has four focus modes — three autofocus and one manual. Your first choice is to decide whether you want to use Autofocus or Manual focus, and pick the corresponding choice on the AF/MF switch located on the front left of the camera. I shoot 99 percent of my photos using Autofocus on the A200. The few times that I use Manual focus are for specific abstract images or when shooting macro photos.

Cross-Reference *Both Manual and Autofocus are covered in Chapter 6.*

QT.9 The Drive mode menu

QT.10 The AF/MF switch on the A200

Within Autofocus there are three modes:

✦ **Single-Shot Autofocus.** In this mode, the camera focus locks when the you press the Shutter button halfway down. This mode is great for taking photos of subjects that are stationary.

✦ **Automatic.** This mode is a combination of the Single-Shot Autofocus and Continuous Autofocus modes. In Automatic, the Autofocus mode switches between the Single-Shot and Continuous Autofocus modes, depending on if the subject is moving when the Shutter button is pressed halfway down.

✦ **Continuous Autofocus.** In this mode the camera continues focusing when you press the Shutter button halfway down. This mode is best for shooting moving subjects.

Follow these steps to change the Autofocus mode setting on the A200:

1. **Press the Function button on the back of the camera.** The camera's Quick Navigation menu appears on the LCD.

2. **Use the Multi-selector to navigate to the Autofocus mode setting and press the Multi-selector center button.** The Autofocus mode menu appears.

3. **Use the Multi-selector to navigate to your choice of Autofocus modes and press the Multi-selector center button.** Your Autofocus mode selection is now active.

Playback

The A200 lets you view the images that you have taken on the 2.7-inch LCD on the back of the camera. When you finish shooting and lower the camera, the last image taken is visible on the LCD.

You can always access the last image taken by pressing the Playback button on the rear of the A200. After the image appears, you can look at previous photos by using the Multi-selector to scroll through the images on the memory card.

 Cross-Reference *There are other playback modes and they are discussed in detail in Chapter 2.*

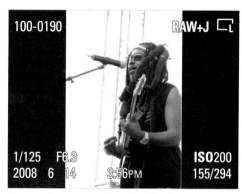

QT.11 The screen showing the last image taken with the shooting data superimposed over the image. The camera also rotates images taken in portrait mode, as shown here.

Using the Sony Alpha DSLR-A200

◆　　◆　　◆　　◆

◆　　◆　　◆　　◆

Exploring the Sony Alpha DSLR-A200

Knowing your camera is one of the keys to being a better photographer. It could be argued that it is more important than understanding exposure or even composition. The A200, after all, has a great auto setting that sets the exposure for you, and composition can be a matter of opinion, but not knowing where to set the Flash mode or how to access the white balance setting can severely hinder your photography. Knowing your camera enables you to adjust the white balance settings, change the ISO, switch metering and autofocus modes, and adjust any setting without having to spend a lot of time finding the right button, switch, or menu option.

Chapters 1 and 2 help you learn about all the settings, controls, and menus of the A200. It takes time and can seem daunting, especially because some controls have more than one function. But the first step is to learn where all those buttons and switches are located on the camera.

One of the things that always seems to impress people when I am photographing is that I know where and how to change the settings I want, quickly. If the time comes to switch between Single image drive mode and Continuous drive mode, I know that it can be done with a single button. And you will, too.

Camera Controls

Holding the camera as you would when shooting, you can see that the layout of the buttons and the controls all are well thought out. Use the following figures as a guide to the locations of all the various controls on your A200. After time, accessing your most commonly used controls should be second nature.

On the front

The most important part on the front of the A200, shown in figure 1.1, is the lens mount opening. This is the most vulnerable part of the camera, so if a lens is not attached, a body cap needs to be used. The less time this is open to the elements, the better. I leave a lens attached most of the time. This keeps the camera ready to be used at a moment's notice and doesn't let any dust and dirt into the camera when stored in my camera bag.

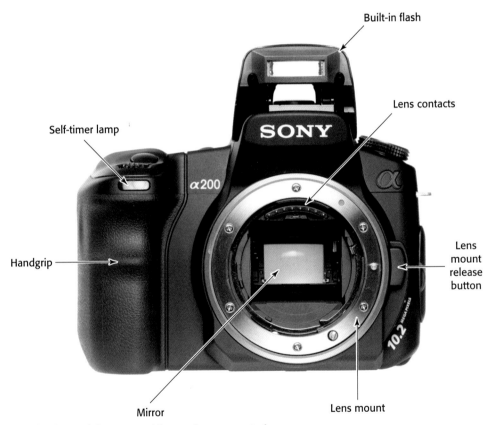

1.1 The front of the A200 without a lens mounted

The features on the front of the camera also include:

✦ **Built-in flash.** Pressing the flash button on the left side of the flash manually opens the flash. The flash also automatically opens when the camera is in Auto mode and the built-in light meter determines that the scene is too dark and the flash is necessary. To close the flash, just push down from the top until it locks into place. Figure 1.1 shows the flash in the open position.

✦ **Self-timer lamp.** The Self-timer lamp flashes when either the 2-second or the 10-second Self-timer mode is used. The Self-timer is accessed in the Drive mode, which is covered later in this chapter.

✦ **Handgrip.** The ergonomic handgrip houses the battery. The grip is comfortable and secure for horizontal and vertical shooting.

✦ **Mirror.** The mirror reflects the light that comes through the lens up to the viewfinder letting the photographer see the same view as the camera. When the Shutter button is pressed, the mirror flips up out of the way so that the light can reach the sensor. The mirror is located inside the camera body and should not be touched.

✦ **Lens contacts.** These are the contacts that communicate between the camera body and the camera lens.

✦ **Lens mount release button.** This button, when pressed, unlocks the lens from the body and makes it possible to remove the lens.

✦ **Lens mount.** This is where you attach the lens. The Sony lens mount is based on the Minolta

A-type lens mount and can accept all Sony camera lenses and a variety of older Minolta A-type lenses. You can read more about lenses in Chapter 5.

On the top

The top of the A200 has three of the most important controls you'll use, the Mode dial, the Control Dial, and the Shutter button. There are also dedicated buttons for the drive mode and ISO along with a hot shoe for external flashes.

✦ **Hot shoe.** The hot shoe lets you attach an external Sony flash unit such as the HVL-F58AM, HVL-F56AM, HVL-F42AM, or HVL-F36AM, along with flashes from third-party vendors such as Promaster, Metz, and Sigma.

✦ **Mode dial.** This is where you set the recording mode on the camera. The choices are Auto, a fully automatic mode; P, Program Auto mode; A, Aperture Priority mode; S, Shutter Priority mode; M, Manual mode; one of the six scene modes; and an Auto mode with no flash.

✦ **Control dial.** The control dial is where the photographer changes the shooting settings. When in P, Program Auto mode, rotating the dial adjusts the shutter speed. When in A, Aperture Priority mode, the dial controls the aperture. When in S, Shutter Priority mode, the dial controls the shutter speed. When in M, Manual mode, the Control dial alone controls the shutter speed, and when combined with pressing the Exposure Compensation/AV button, it controls the aperture.

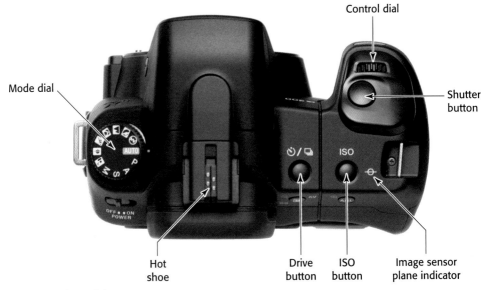

1.2 A top view of the camera

✦ **Shutter button.** When you press this button all the way down, the shutter releases and the photo is taken. When pressed halfway down, the camera autofocuses using one of the nine autofocus sensors.

✦ **Drive button.** This button opens the Drive mode menu on the LCD screen.

✦ **ISO button.** This button opens the ISO menu on the LCD screen.

✦ **Image sensor plane indicator.** This marking on the camera body is used if you need to measure the exact distance from the subject to the image sensor.

On the back

The back of the A200 is intelligently laid out with the Function button, Multi-selector, Super SteadyShot switch, Exposure compensation/Enlarge button, and AEL Lock

button all easily accessed with your thumb. This lets you change the picture-taking settings without having to change your grip.

✦ **Power switch.** This turns the camera on and off. The A200 has a built-in sensor-cleaning mode that vibrates the sensor to shake off any dust every time the power is turned off. The slight vibration when turning the camera off is normal.

✦ **Menu button.** The Menu button opens the Main menu on the LCD screen.

✦ **Display button.** The Display button enables you to switch between the detailed display and the enlarged display in the Recording mode. The Display button also cycles through the different display modes when in the Playback mode. The brightness of the LCD screen can be adjusted by pressing the Display button for a few seconds.

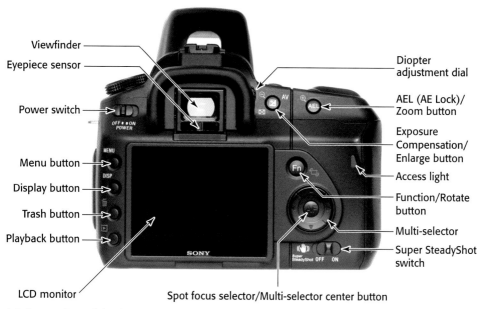

Viewfinder

Eyepiece sensor

Power switch

Menu button

Display button

Trash button

Playback button

LCD monitor

Diopter adjustment dial

AEL (AE Lock)/ Zoom button

Exposure Compensation/ Enlarge button

Access light

Function/Rotate button

Multi-selector

Super SteadyShot switch

Spot focus selector/Multi-selector center button

1.3 A rear view of the A200

✦ **Trash button.** When you are reviewing images on the LCD screen, pressing this button opens the Delete Image screen. There is a choice to delete the image or to cancel, which returns the display to reviewing images mode.

✦ **Playback button.** The Playback button is pressed to view on the LCD screen the images already taken.

✦ **LCD screen.** The 2.7-inch LCD screen displays different information depending on the mode.

✦ **Viewfinder.** The viewfinder shows a bright clear view of the scene shown through the lens.

✦ **Eyepiece sensor.** This sensor right below the viewfinder can determine if you are looking through the eyepiece. The default setting is for the LCD screen to turn off when the sensor determines that you are looking through the viewfinder.

✦ **Diopter adjustment dial.** This lets you compensate for farsightedness and nearsightedness. Adjust the dial while looking through the viewfinder until the image is sharp. If you are farsighted, rotate the dial downward; if you are nearsighted, rotate the dial upward.

✦ **Exposure Compensation/Enlarge button.** Pressing this button opens the Exposure Compensation menu. When in Viewing mode, pressing the button enlarges the image on the LCD screen.

✦ **AEL (AE Lock)/Zoom button.** This button has two purposes depending on which mode the camera is in. When the camera is in Shooting mode, this button locks in a certain exposure. When you focus on an area or subject that you want to be metered for exposure, even if it is not going to be the main subject of your photograph, and press the AEL

button, those exposure settings are then locked. You can reframe the image and take the photograph. This setting is cancelled when the button is released. When in Playback mode, this button zooms into a photograph.

✦ **Function/Rotate button.** When in Shooting mode, the Function button switches between the Recording Information screen and the Quick Navigation screen. In Playback mode, this button opens the Rotate Image menu that is then controlled by the Multi-selector.

✦ **Access light.** This red light is on when the camera is writing information to the memory card. Do not turn the camera off while this light is on as it can disrupt the writing of the data from the camera's internal buffer to the memory card and you can lose your images.

✦ **Spot focus selector/Multi-selector center button.** This button is used to enter choices that are selected in menu choices. When in Shooting mode, pressing this button causes the focus spot to be set back to the center focus point.

✦ **Multi-selector.** The Multi-selector lets you select and execute a variety of different functions. The Multi-selector works like a miniature joystick: It can be moved left, right, up, and down. It is used to navigate the Quick-navigation screen and the A200's menu choices. The Multi-selector is also used to select a focus point when the autofocus area is set to Local.

✦ **Super SteadyShot switch.** This turns the Sony Super SteadyShot vibration-reduction technology on or off.

On the bottom

The bottom of the A200 houses the battery and a tripod mount. Even with the A200's compact size, the bottom has a nice flat surface that allows you to use even the biggest tripods.

✦ **Battery compartment.** The battery compartment is accessed by a recessed latch on the bottom of the camera. When the battery is fully inserted into the camera, it is held in place with a small blue latch so that even if the battery door is opened, the battery will not fall out. The battery compartment is spring loaded, so when the latch is pushed in the battery pops right out.

✦ **Threaded tripod socket.** The Sony Alpha A200 comes with a standard tripod socket that is aligned with the center of the lens.

On the left side

On the left side of the camera is a rubber door that covers the remote terminal and the DC power in. The left side is also the location of the Focus mode switch, where you can change from manual to autofocus.

✦ **Remote terminal.** The RM-S1AM Remote can be used with the Sony Alpha A200 by opening the cover and inserting the plug of the remote. The remote lets you release the shutter without touching the camera or the Shutter button.

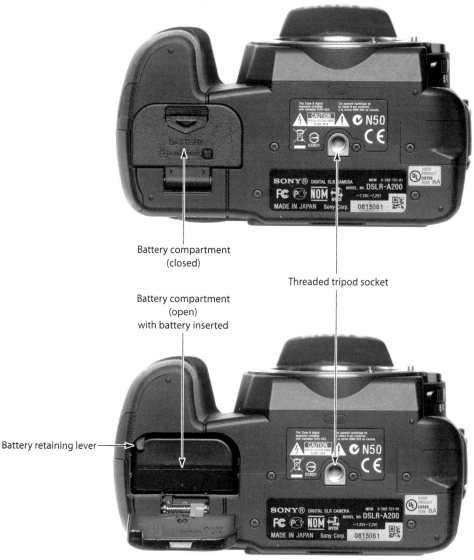

Battery compartment
(closed)

Threaded tripod socket

Battery compartment
(open)
with battery inserted

Battery retaining lever

1.4 A bottom view of the camera

✦ **DC-in terminal.** The optional
AC-VQ900AM AC adapter/battery
charger can be used to power the
camera using an ordinary house-
hold power outlet. To use the
adapter, first turn off the power to
the camera and then plug the
power cord into the DC-in terminal.
You can then turn the camera on.

✦ **Focus mode switch.** This is where
the focus mode for the camera is
set. The focus can be set to manual
focus (MF) or autofocus (AF).

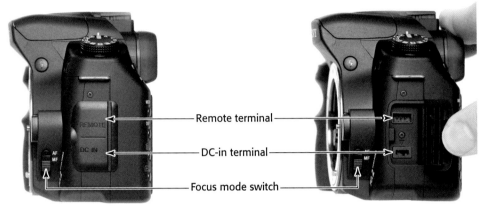

Remote terminal ———

DC-in terminal ———

Focus mode switch ———

1.5 The left side of the A200

On the right side

The right side of the camera houses the memory of the camera. This is the place where the digital "film" goes. It also is the location where the camera can be connected to a computer or a television.

✦ **Memory card cover.** Sliding it toward the back of the camera opens the memory card cover. The door is spring loaded and opens easily. To close the cover, fold it back toward the camera and slide it forward until it clicks into place.

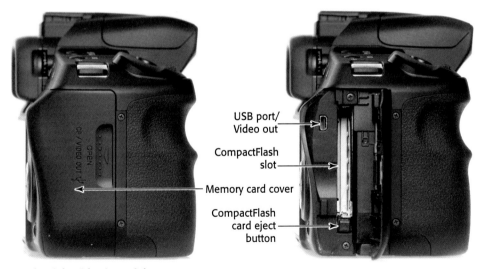

USB port/
Video out

CompactFlash
slot

Memory card cover

CompactFlash
card eject
button

1.6 The right-side view of the camera

✦ **CompactFlash slot.** The Sony Alpha A200 can use CompactFlash media, and this is where it is inserted into the camera. The CompactFlash card needs to be inserted with the label toward the back of the camera. Push the card until it is firmly seated.

✦ **CompactFlash card eject button.** To eject a CompactFlash card, push down on this button until the card can be removed from the slot.

✦ **USB port/video out.** The camera can be connected directly to a computer or television using a USB cable with a mini USB jack to plug into the camera and a regular jack to plug into the computer, or the supplied mini-USB-to-video RCA plug that enables the A200 to be connected to a regular television.

Viewfinder Display

The viewfinder in the Sony A200 enables you to compose the scene by seeing 95 percent of the view through the lens. The viewfinder display is broken into two parts — the main viewing area and the information display along the bottom of the viewfinder. The A200 does not have a Live View preview, and you cannot use the LCD screen to preview the images before taking a photo, so the only way to compose an image is to use the viewfinder.

The main display

The main display is where you compose your photograph. Being able to see what the sensor will record makes composing your photo easy.

✦ **AF area.** There are nine autofocus indicators: two on the left, two on the right, four around the center, and the Spot autofocus area in the center.

✦ **Spot AF area.** This is the small square directly in the middle of the viewfinder. It is the focus indicator for the Spot autofocus setting. When the focus has locked on, the indicator turns red for a moment, indicating that the setting is in use. This autofocus sensor is different from the other eight as it is a cross-type sensor that senses focus on both the X and Y axes, making it capable of achieving focus slightly more quickly than the other sensors.

✦ **Spot metering area.** The circle around the Spot AF area defines the spot metering area. This is the total area of the scene used in spot exposure metering.

✦ **16:9 shooting area guidelines.** These crop guidelines are there to help when composing in the 16:9 aspect ratio Crop mode. Any information above or below the crop marks is not recorded when the 16:9 aspect ratio is set.

The data display

The data display across the bottom of the display gives you instant access to the most important settings without having to take your eye away from the viewfinder.

✦ **Flash compensation.** When using the flash, you can adjust the amount of light without changing the exposure. When any flash compensation is used, the flash compensation indicator is visible in the viewfinder.

✦ **Flash symbol.** When the flash symbol is flashing, the flash is being charged. When the light turns solid, the flash is charged and ready to fire.

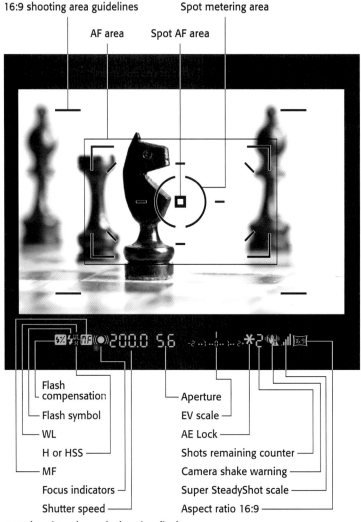

16:9 shooting area guidelines

Spot metering area

AF area

Spot AF area

Flash compensation

Flash symbol

WL

H or HSS

MF

Focus indicators

Shutter speed

Aperture

EV scale

AE Lock

Shots remaining counter

Camera shake warning

Super SteadyShot scale

Aspect ratio 16:9

1.7 The view through the viewfinder

✦ **WL.** When an external flash is used in Wireless mode, the WL indicator is lit.

✦ **H.** Some external flashes can use a High Speed Sync mode. When in the High Speed Sync mode, an H appears in the viewfinder.

✦ **MF.** When in Manual focus mode, this indicator lights up.

✦ **Focus indicators.** The focus indicators show whether the focus is locked and ready to shoot, focused on a moving subject and ready to shoot, in the process of focusing, or unable to focus on the subject.

✦ **Shutter speed.** This shows the current shutter speed.

✦ **Aperture.** This shows the current aperture.

✦ **EV scale.** The EV or Exposure Value scale in the viewfinder shows the exposure set by the photographer and what the camera's metering system believes to be the correct exposure. The small bar over the scale shows the current exposure setting in regard to what the camera believes is the correct setting. The EV scale also indicates when the bracketing is active by showing three bars above the scale.

✦ **AE Lock.** When the AEL button is pressed, the exposure value currently determined by the camera becomes the standard value. The AE lock indicator is visible in the viewfinder when the AEL button is pressed.

> **Cross-Reference** *Exposure Value is covered in detail in Chapter 2.*

✦ **Shots remaining counter.** This shows how many photos can still be taken. The display starts at 9 when shooting large fine JPEG, 6 when shooting in RAW only, and 3 when shooting RAW & JPEG, and counts down as the photos are taken; as the images are written to the memory card, the counter goes back up. When the memory card is full and no more images can be saved, the counter reads 0. If you try to take photos after the card is full, the word "FULL" flashes across the display and the counter reads 0.

✦ **Camera shake warning.** This indicator flashes even if the Super SteadyShot is turned on. The camera calculates the likelihood of camera shake using the focal length and shutter speed.

✦ **Super SteadyShot scale.** The scale is shown when the Super SteadyShot is activated. The higher the scale, the more shaking is present. To get the sharpest image possible, there should be as few bars as possible all the way down to only one bar. When the Super SteadyShot is turned off, there are no bars even visible.

✦ **Aspect ratio 16:9.** This indicates when the camera is set to the 16:9 aspect ratio.

LCD Screen

The LCD screen on the back of the A200 provides a single display area that keeps all the pertinent information in one place. This means that the display changes depending on which mode the camera is in. Because the LCD screen is the only display on the camera, it does double duty. In the recording information mode, it shows the current camera settings; in the Playback display mode, it shows a review of the images already taken.

Recording information display

The recording information mode shows the current settings of the A200. When you turn on the camera, the recording information display automatically opens. This display is visible for 5 seconds and then turns off. This can be adjusted using the info.disp.time. setting located in the Setup Menu 1.

> **Cross-Reference** *Chapter 2 has more details on changing menu settings.*

The recording information display has two modes — a Detailed mode and an Enlarged mode — that are cycled through by pressing the Display button. The Enlarged mode shows some but not all of the information in the Detailed mode. In the Enlarged mode, the information is presented in a larger format, making it easier to read quickly.

One of the great little touches of the A200 is that when the camera is rotated from horizontal to vertical, the display changes its orientation automatically, so you can easily read it no matter how you are shooting. When you use the Display button to cycle through the recording information modes, a third option is for the display to be turned off completely.

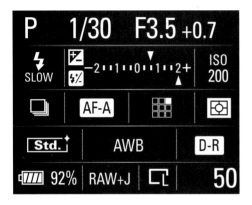

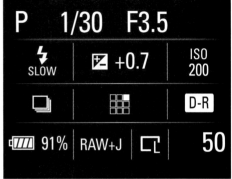

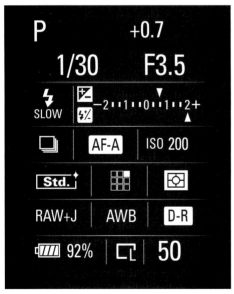

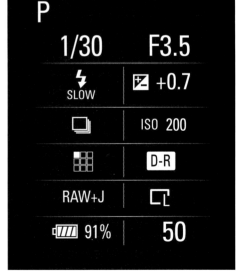

1.8 The LCD screen's detailed recording information display in the horizontal mode and in the vertical mode — the display rotates to match the orientation of the camera.

1.9 The LCD screen's enlarged recording information display in the horizontal mode and the vertical mode has less information visible than in the Detailed mode, so it is easy to read even in low light.

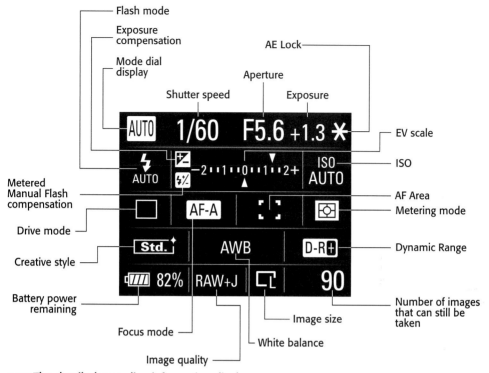

1.10 The detailed recording information display

✦ **Mode dial display.** The display here shows the Mode dial's setting.

✦ **Shutter speed indicator.** Displays the current shutter speed.

✦ **Aperture indicator.** Displays the current f-stop.

✦ **Exposure.** This display is blank unless the photographer has made any exposure compensation adjustments; then it shows the amount of exposure compensation set.

✦ **AE Lock indicator.** Displays an asterisk when the AE Lock is pressed and the AEL is in use.

✦ **Flash mode.** The indicator shows whether the Flash mode is set to Autoflash, Fill-flash, Rear sync, or Wireless mode. It also shows if Red-Eye Reduction has been set or if the flash has been turned off.

✦ **Exposure compensation/Metered manual indicator.** The display shows a small arrow above the EV scale that shows what the camera believes is the difference between your exposure and the correct exposure. When the arrow is above the 0, the EV scale, the camera meter, and the photographer's settings agree. The arrow appearing toward the right indicates overexposure, which causes the photo to be too light. The arrow appearing to the left indicates underexposure, which causes the photo to be too dark (not shown in the Enlarged mode).

✦ **Flash compensation indicator.** If any flash compensation is set, a small arrow appears under the EV Scale, showing the amount of compensation (not shown in the Enlarged mode).

✦ **EV scale.** The EV or Exposure Value scale shows what the camera believes is the correct exposure, which is set at 0. The scale also shows 2 stops of overexposure and 2 stops of underexposure. The scale is also used as a guide for exposure compensation and flash compensation (not shown in the Enlarged mode).

✦ **Drive mode indicator.** The Drive mode indicator shows what Drive mode the camera is in. There are six modes that can be set.

✦ **Focus mode indicator.** This shows which of the four focus modes is selected: AF-S, when the camera is set on Single-Shot Auto Focus; AF-A, when the camera is set to Automatic Auto Focus; AF-C for Continuous Auto Focus; and MF for Manual Focus.

✦ **Creative style.** There are eight creative style settings: Standard, Vivid, Portrait, Landscape, Night view, Sunset, B/W, and Adobe. The Creative Styles are discussed in depth in Chapter 2 (not shown in the Enlarged mode).

✦ **ISO setting.** The current ISO setting is shown here below the word ISO. The ISO is shown as a number from 100 to 3200. The word AUTO appears if the ISO is set to Auto.

✦ **Metering mode indicator.** Shows if the Multi-segment, Center-weighted, or the Spot-metering mode is being used (not shown in the Enlarged mode).

✦ **Auto focus (AF) area indicator.** Shows if the Wide, Spot, or Local Auto Focus area is selected.

✦ **White balance indicator.** This shows the current white balance setting (not shown in the Enlarged mode).

✦ **D-Range Optimizer setting.** When the D-Range Optimizer is turned on, the mode it is set for is shown here — D-R for Standard, D-R+ for Advanced Auto, or blank when it is turned off.

✦ **Battery power remaining indicator.** The remaining power in the battery is shown as both a graphical representation and a numerical percentage.

✦ **Images quality setting.** This display shows the image quality setting as RAW, RAW+J, FINE, or STD.

✦ **Image size setting.** This displays the size of the image: Large, Medium, or Small in either the 3:2 aspect ratio or the 16:9 aspect ratio.

✦ **Shots remaining counter.** This is pretty self-explanatory. Shows the amount of shots that can still be saved on the memory card using the current settings.

Playback screen

Digital cameras let you review the images that you have just taken. This ability to look at the images you have just taken means that you can see immediately if you got the shot. The A200 has six display options.

Pressing the Playback button on the rear of the camera accesses the Playback display mode where you can review your images. When in Playback mode, press the Display button to cycle through four Viewing modes: the image alone, the image with shooting data, the histogram view, and the image with a thumbnail display of the last five images taken. There are also two other views that are accessed using dedicated buttons and can be used at any time when reviewing your images, these are the Index view and the Zoom view.

To access the different display modes, press the display button when viewing an image. The order of the display modes is:

✦ Image alone view

✦ Image with shooting information view

✦ Histogram view

✦ Single image with thumbnail strip view

Image alone view

In this view, the entire display is filled with a single image. The Control dial or the multi-selector can be used to cycle through the images on the memory card in the camera. This view is great for a quick review of your images and the best way to display images when attached to a television.

 Cross-Reference *For more on connection and viewing images on a television, see Chapter 7.*

Image with shooting data view

When the display is in the Image with shooting data view, the shooting data is superimposed across the top and bottom of the displayed image. This gives you basic information on the image, including the shutter speed, f-stop, ISO, and date and time the image was recorded.

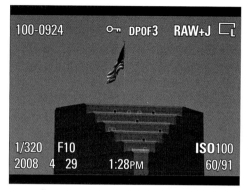

1.11 The screen in the Playback mode showing an image with the shooting data

✦ **Folder and file number.** This shows the folder number followed by the file number.

✦ **Protect display.** If the image is protected, the protect symbol appears.

✦ **DPOF.** Images can be marked for future printing. If the image has been selected to print, the DPOF3 symbol appears; the number — 3 in this example — indicates the number of prints you want of that image.

✦ **Image quality.** The image quality of the photo appears.

✦ **Image size.** The image size of the photo appears.

✦ **Image.** The image appears.

✦ **Shutter speed.** The shutter speed of the current image appears.

✦ **Aperture.** The f-stop of the current image appears.

✦ **ISO sensitivity.** The actual ISO of the current image appears, even if the photo was taken using AUTO ISO.

✦ **Date of recording.** The date and time that the image was taken are shown.

✦ **File number/total number of images.** This shows the sequence number of the selected image and the total images taken.

Histogram view

The histogram view has the most amount of information about your image. The Histogram display has a full set of shooting data on the left side of the display with the histograms on the right.

✦ **Folder and file number.** This shows the folder number followed by the file number.

✦ **Protect display.** When the image is protected using the protect menu, the key symbol is displayed.

✦ **DPOF.** This symbol appears, along with the number of prints that have been selected, when images have been marked for future printing.

✦ **Image quality.** This shows the image quality of the photo.

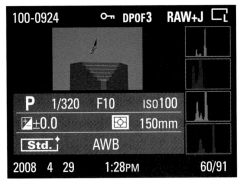

1.12 Image review with the Histogram view shown

✦ **Image size.** This shows the image size of the photo.

✦ **Image.** The image appears. Both overexposed and underexposed areas blink between black and white.

✦ **Mode indicator.** This shows the mode that was set when the image was taken. The display matches the setting on the Mode dial.

✦ **Shutter speed.** This displays the shutter speed of the current image.

✦ **Aperture.** The f-stop of the current image appears.

✦ **ISO sensitivity.** The actual ISO of the current image appears, even if the photo was taken using AUTO ISO.

✦ **Exposure Value.** This displays how much over or under the exposure compensation was set, compared to the 0 of the standard exposure.

✦ **Flash compensation indicator.** This displays the flash compensation, if any, used in creating the photo.

✦ **Metering mode indicator.** This displays the metering mode that was used to capture that image.

✦ **Focal length indicator.** The focal length that was used appears.

✦ **Creative style.** The creative style used when the image was captured is shown.

✦ **White balance.** The white balance used for this image is shown.

✦ **D-Range Optimizer.** The D-range setting is shown.

✦ **Date of recording.** The date and time that the image was taken are shown.

✦ **File number/total number of images.** This shows the sequence number of the selected image and the total images taken.

✦ **Histogram.** This histogram itself is broken into four graphs. They are, from top to bottom: Luminance, Red, Green, and Blue. Each shows the luminance distribution from darkest to lightest across the bottom of the graphs, with the amount of pixels being affected in the heights of the graphs. The overall luminance of the scene is shown in the top graph, and each of the color graphs shows the luminance for that color. The more information that appears on the left of the chart, the darker the image, and the more information that appears on the right on the chart, the brighter the scene.

Image with thumbnail strip view

This view has a five-image thumbnail strip across the top of the image and a limited set of shooting data across the bottom.

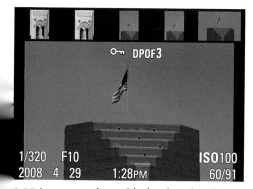

1.13 Image preview with the thumbnail strip shown

The top area has a thumbnail strip that holds up to five images. The image that is currently selected has a red bar beneath it. The Multi-selector can be used to navigate between images. The bottom area has the following shooting data:

✦ **Shutter speed.** The shutter speed of the current image appears.

✦ **Aperture.** The f-stop of the current image appears.

✦ **ISO sensitivity.** The actual ISO of the current image appears, even if the photo was taken using AUTO ISO.

✦ **Date of recording.** The date and time that the image was taken are shown.

✦ **File number/total number of images.** This shows the sequence number of the selected image and the total images taken.

Index view

The index view is opened by pressing the Exposure compensation/Index button when in any of the playback modes. Pressing this button will not display this view when the Zoom view is being used. The view changes to an index screen showing nine images — three columns of three images. Navigating through the images can be done with the Multi-selector, and pressing the Multi-selector center button selects that image and opens it in the Playback screen.

If you are looking for a particular image on a card with many images, this is the easiest way to do it. This is also a great view for looking through the images when connected to a television.

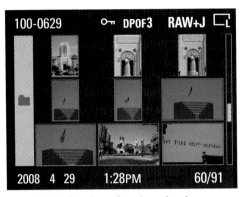

1.14 The index view showing nine images

Zoom view

The Zoom view is one of the most useful modes for checking your work. Being able to zoom in on a specific section of the image helps to make sure the image is in focus. To zoom in on any photo, press the AEL/Zoom button.

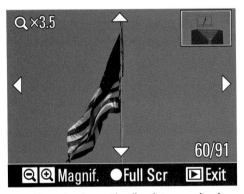

1.15 Zooming in on the flag lets me check that it is flying the way I want it to.

When in Zoom mode it is possible to do the following:

✦ **Zoom in.** Pressing the Zoom button zooms in more until the view is x12.

✦ **Zoom out.** Pressing the Zoom out button will zoom until the view goes to the Index view.

✦ **Move around.** The Multi-selector moves the view around in the direction the Multi-selector is pushed.

✦ **Full screen.** Pressing the Multi-selector center button displays the full image on the screen with an orange box around the zoomed area. The area in the orange box can be adjusted by pressing the Zoom in and out buttons and can be moved around the image by using the Multi-selector. Pressing the Multi-selector center button a second time displays the zoomed view of the selected area.

ISO Sensitivity

The ISO settings determine how sensitive the image sensor is to light. ISO on film cameras used to be set by using different ISO films. The higher the ISO of the film, the less light was needed to get a properly exposed image. With film, the ISO was changed by using larger grains of silver halide, which gives the film a higher sensitivity to light. In digital photography, the ISO is adjusted by setting how much the light hitting the sensor is amplified. The more this signal is amplified, the lower the amount of light that is needed to create a proper exposure. The downside is that the more the signal is amplified, the more digital noise is introduced into the image. Digital noise appears in your images as unwanted spots of random color in areas that should have a smooth color. This shows up more in dark areas than in light.

The A200 has an ISO range from 100 all the way up to 3200, with 100 being the least sensitive to light and 3200 being the most sensitive to light. The A200 also has an Auto ISO mode that sets the ISO value between 200 and 1600.

To set the ISO on the A200, follow these steps:

1. **Press the ISO button to open the ISO menu.**
2. **Press the Multi-selector to select the desired ISO.**
3. **Press the Multi-selector center button to select the highlighted ISO.**

I like to use the lowest possible ISO in any given time, but the Auto ISO setting is great, especially for times when the light is changing often. The camera will try to use the lowest ISO setting but starts to use higher ISOs as the light gets lower.

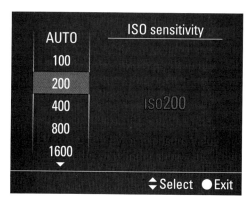

1.16 The ISO menu

Metering Modes

The A200, like all modern cameras, has a built-in light meter that reads the light in the scene and determines what the proper exposure should be. For example, when you photograph using the Shutter Priority mode, you set the shutter speed and the A200 uses the built-in light meter to set the aperture. The A200 has three metering modes, each reading a different part of the scene to

determine the proper exposure. The Sony A200's three metering modes are Spot metering, Center-weighted metering, and Multi-segment metering.

✦ **Multi-segment metering.** The A200 uses a 40-segment metering system. There are 39 sensors in a honeycomb pattern for the main area and one sensor that covers the surrounding area. The metering system is linked to the autofocus system so that the main subject is exposed correctly.

✦ **Center-weighted metering.** The entire scene is metered, but the center of the scene is given greater emphasis over the outer areas.

✦ **Spot metering.** This mode uses the light measured in the center area to calculate the exposure. This is used when the exposure of a part of the subject is more important than the whole scene. The center area used to calculate this exposure is shown on the viewfinder.

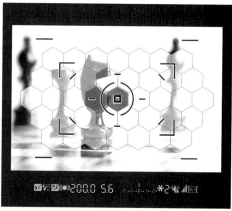

1.17 Multi-segment mode uses all 39 of the honeycomb sensors and the outside area as the 40th sensor. Center-weighted metering mode uses the red and yellow segments, and Spot metering uses the red center sensor area.

I usually keep the metering mode set to Multi-segment metering as this mode works for the majority of situations. To set the metering mode on the A200, follow these steps:

1. **Press the Function button on the rear of the camera to open the Quick navigation menu.**

2. **Use the Multi-selector to navigate to the Metering modes menu choice and press the Multi-selector center button.** The Metering mode menu gives you the choice to pick one of the three metering modes.

3. **Press the Multi-selector center button or the Shutter button to select the highlighted choice.**

1.18 The Metering mode menu with the Multi-segment mode highlighted

Drive Modes

The A200 has six drive modes. The drive modes control what happens when you push the Shutter button. Want to take a sequence of photos without taking your finger off the Shutter button or set the camera

to use the Self-timer mode? This is the place to do it. The drive mode is also the spot where the bracketing modes are set. The bracketing modes take a three-image sequence with the exposure of each shot adjusted slightly, automatically.

✦ **Single frame advance.** In this mode, the camera takes one exposure every time the Shutter button is pressed.

✦ **Continuous advance.** In this mode, the camera continues taking photos as long as the Shutter button is held down and there is room in the buffer and on the memory card. The A200 can take unlimited photos when shooting using the JPEG file format, six images in a row when shooting in RAW, and three images when shooting in the RAW+JPEG format.

✦ **Self-timer.** There are two modes in the Self-timer mode: a 2sec timer mode and a 10sec timer mode.

● **2-second mode.** This mode moves the mirror up just before taking the photograph, making it useful in reducing camera shake. After you engage the 2-second mode, it can be cancelled by pressing the Drive button before the photograph is taken.

● **10-second mode.** This mode is useful when you want to be in the photograph. The self-timer lamp located on the front of the camera flashes before the shot is taken in the 10-second mode. The 10-second mode can be cancelled by pressing the Drive button before the photograph is taken.

✦ **Continuous bracketing.** There are two Continuous bracketing modes available on the A200. Holding the Shutter button down takes three shots in rapid succession.

- **0.3ev.** This setting lets you take three photos continuously with the exposure shifted by 0.3 stop. The order of the images is correct exposure, underexposed by 0.3 stop, and overexposed by 0.3 stop.

- **0.7ev.** This setting lets you take three photos continuously with the exposure shifted by 0.7 stop. The order of the images is correct exposure, underexposed by 0.7 stop, and overexposed by 0.7 stop.

✦ **Single frame bracketing.** Single frame bracketing is the same as Continuous frame bracketing except that the Shutter button must be pressed for each photo. When shooting in the Single frame bracketing mode, make sure you take all three photos of the same scene. If you don't, you end up with exposure problems.

- **0.3ev.** This setting lets you take three photos, one at a time, with the exposure shifted by 0.3 stop. The order of the images is correct exposure, underexposed by 0.3 stop, and overexposed by 0.3 stop.

- **0.7ev.** This setting lets you take three photos, one at a time, with the exposure shifted by 0.7 stop. The order of the images is correct exposure, underexposed by 0.7 stop, and overexposed by 0.7 stop.

1.19 The Drive menu is accessed by pressing the Drive mode button.

✦ **White balance bracketing.** White balance bracketing takes three photos every time the Shutter button is pressed. The three images are identical except that the first photo has the set white balance, the second has less red and is paler, and the third has more red. The amount of change between the three can be set in the Drive menu using the Lo and Hi choices. The Hi setting adds and subtracts greater amounts of red than does the Lo setting.

To change the drive mode, follow these steps:

1. **Press the Drive button on top of the camera.**

2. **Select the desired drive mode by pushing up or down using the Multi-selector.**

3. **Push the Multi-selector left or right to adjust the selected drive mode.**

4. **Push the Multi-selector center button to activate the selected drive mode.**

Setting Up the Sony Alpha DSLR-A200

My first SLR camera didn't have any menus, it had a place for the film and a dial to set the shutter speed. The aperture was set on the lens, and to advance to the next image, a lever had to be moved — twice — to advance the film. Focusing the camera was done by manually twisting the focus ring on the lens. I still have the camera sitting on a shelf high in my office. It is a constant reminder how far photography has come.

The A200 has eight menus all accessed from the Menu button along with a Quick Navigation menu accessed from the Function button. Understanding what these menus do and where the settings are located is the basis of this chapter.

The starting step is to set the exposure mode to match the type of image you want to capture. The exposure mode is controlled by the Mode dial on the top left of the A200.

Choosing the Exposure Mode

The exposure modes on the A200 are broken down into two distinct types: the Basic exposure modes and the specialized Scene exposure modes. The dial has 12 settings, and picking the right one is very important to getting the image you want.

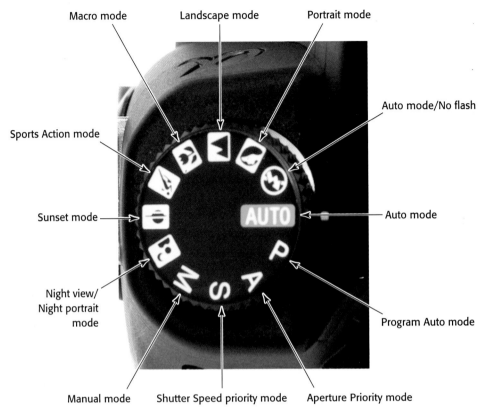

Macro mode | Landscape mode | Portrait mode
Auto mode/No flash
Sports Action mode
Sunset mode — Auto mode
Night view/ Night portrait mode
Program Auto mode
Manual mode | Shutter Speed priority mode | Aperture Priority mode

2.1 The Mode dial makes it easy to quickly switch among exposure modes. The Basic and Scene exposure modes are labeled here.

Basic exposure modes

There are six basic exposure modes, these are accessed quickly by turning the Main Mode dial on the top left of the A200. The six basic exposure modes are Auto (Auto) mode, Auto with no Flash (no flash symbol), Program Auto (P) mode, Aperture Priority (A) mode, Shutter Speed Priority (S) mode, and Manual (M) mode. Selecting any of these modes is done by rotating the Mode dial to the corresponding letter, or in the case of the Auto with no flash, its symbol.

✦ **Auto mode.** Setting the camera to the Auto mode (Auto on the Mode dial) gives control of all exposure settings to the camera. You can

change the white balance, ISO, Creative Style, D-Range Optimizer, Flash mode, exposure compensation, flash compensation, focus mode, drive mode, image quality, and image size. When the dial is moved from the Auto setting to any of the other mode settings and then back to Auto, all the changes except for image quality, image size, and aspect ratio are reset to the default settings.

✦ **Auto mode/No flash.** This setting is the same as the Auto mode with one key difference: The flash does not activate even when the camera thinks there is not enough light. This is a great setting for taking

photos were using a flash is not allowed or would be a distraction.

✦ **Program mode.** Although the Program mode (P on the Mode dial) and the Auto mode might seem similar, they differ in some very important ways. In the Program mode, the shutter speed or the aperture can be adjusted after the camera selects the proper exposure for the scene. After you press the Shutter button halfway, the camera selects both the shutter speed and the aperture as it does in the Auto mode. At this time, in the default mode you can rotate the Control dial to change the shutter speed. The aperture setting automatically adjusts. It is possible to use the Control dial to change the aperture by setting the Control dial setup to Aperture in the Custom Menu 1. Any changes that are made to shutter speed and aperture in this mode are reset if the Mode dial is moved, the camera is turned off, or 5 seconds elapse without the Shutter button being pressed.

✦ **Aperture priority mode.** In the Aperture priority mode (A on the Main Mode dial), you set the aperture, and the camera sets a shutter speed to achieve proper exposure based on the metering mode. The aperture is set by using the Control dial. Any aperture that is set here will be here the next time you set the Main Mode dial to A.

✦ **Shutter speed priority mode.** In Shutter priority mode (S on the Main Mode dial), you set the shutter speed and the camera sets the aperture to achieve proper exposure based on the metering mode. The shutter speed is set by using

the Control dial. Any shutter speed you set will be there the next time you set the Main Mode dial to S.

✦ **Manual mode.** In this mode, you set both the aperture and the shutter speed. You set the shutter speed by using the Control dial alone, and the aperture by holding down the Exposure Compensation / AV button and turning the Control dial. As the aperture and shutter speed change, the camera displays how close your selected exposure is to the metered exposure on the EV scale.

Scene exposure modes

There are six Scene exposure modes, and they can easily be set by turning the Mode dial to the desired Scene exposure mode. Any changes that you make while in one of the Scene exposure modes resets if the Mode dial is moved. These specialized scene modes make it possible to quickly set the camera for specific photographic situations.

✦ **Portrait mode.** Setting the Exposure mode to Portrait sets a larger aperture (smaller number), which decreases the depth of field. This keeps the subject in focus but the background pleasantly blurred. Portrait mode also sets the D-Range Optimizer to Advanced mode.

✦ **Landscape mode.** In Landscape mode, the camera sets a smaller aperture (larger number), which increases the depth of field. Using the smallest aperture possible helps keep everything from the foreground to the background in acceptable focus. The Flash mode is set to flash off. Because the subject in landscape photography is

usually out of the range of the flash, turning it off helps get a proper exposure.

✦ **Macro mode.** Macro mode sets the shutter speed as high as possible and tries to keep the aperture at f/5.6 if possible. Macro mode also sets the Autofocus mode to Single Shot autofocus because most times, the subject of a macro photograph is not moving. If the subject is closer than 3.3 feet, turn the flash off.

✦ **Sports/Action mode.** Sports photography is all about stopping the action, and this setting tries to use the fastest shutter speed possible. It also sets the drive mode to Continuous Advance, and it changes the focus mode to Continuous Autofocus. Sports/Action mode also sets the D-Range Optimizer to standard. In this mode, the flash is turned off.

✦ **Sunset mode.** In Sunset mode, the camera sets a smaller aperture (larger number), which increases the depth of field. Sunset mode turns the D-Range Optimizer off. It also turns the flash off and automatically adjusts the color to bring out the reds and oranges.

✦ **Night view/Night portrait mode.** The camera sets a slower shutter speed to try to capture the night scene. The difference between Night view and portrait is the use of the flash; the flash is activated in Night portrait mode and turned off for Night view mode.

Using the Function Button

The Function (Fn) button on the back of the A200 makes it quick and simple to change the Flash mode, Metering mode, Autofocus mode, autofocus area, white balance, and D-Range Optimizer.

Pressing the Function button opens the Quick Navigation menu. Your options are as follows:

✦ **Flash mode.** This is where the flash mode can be set.

✦ **Autofocus mode.** The autofocus modes of the A200 are set here. The choices are AF-S, AF-A, and AF-C. Setting the autofocus is covered later in this chapter.

✦ **White balance.** The White Balance menu is located here, and setting it is covered later in this chapter.

✦ **Metering Mode.** The A200 has three metering modes: Multi-segment, Center-weighted, and Spot.

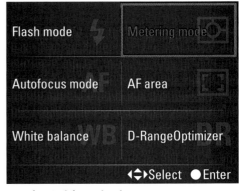

2.2 The Quick Navigation screen

✦ **Autofocus area.** The A200 has three autofocus areas, and they are selected using this menu. Each of these areas, Wide, Spot, and Local, are covered later in this chapter.

✦ **D-Range Optimizer.** The DRO is set here. It can be set to Off, Standard, or Advanced. The DRO is covered later in this chapter.

Cross-Reference
For more on the different flash modes on the A200 and additional details on white balance, see Chapter 4. For more detail about metering modes, see Chapter 1.

File Quality, Size, and Aspect Ratio

Digital cameras introduced a whole new set of challenges to photographers, and one of the most confusing is the image quality and size. The digital sensor captures the photo information, and it is up to the photographer to decide how the data is stored by the camera on the CompactFlash card. The A200 has three settings that affect the file that is produced when an image is saved to the memory card: file quality, file size, and aspect ratio. These settings can be changed at any time and do not reset if the camera is turned off or the Mode dial is moved. The default settings are to save your image in the Fine JPEG quality, with a file size of Large and an aspect ratio of 3:2.

Tip
It is always possible to reset the camera to these defaults by using the Rec.Mode reset in Recording Menu 2, which is covered later in this chapter.

Choosing the file quality

File quality can have a huge impact on the way you set up your digital workflow. There are positives and negatives to each of the file qualities, and knowing these before you start to take photos is important. The two file types the A200 produces are JPEG and RAW. And, there are four different JPEG/RAW settings you can choose from when setting the file quality of the images you capture.

✦ **RAW.** When using this setting, each image is stored in the basic RAW format. This mode saves the image as an uncompressed Sony RAW file. The information from the A200's sensor is saved without any processing by the camera. Images taken in this mode cannot be used without first being converted into a useable format.

✦ **RAW & JPEG.** This setting stores the photo in both the RAW and JPEG formats simultaneously. This is my favorite mode as I feel it is the best of both worlds — you have the RAW file if major work needs to be done to the image, but you also have a JPEG version that is usable right out of the camera. The downside is that this takes up more space on the memory cards than just using RAW or just using JPEG, and the continuous shooting is reduced. If you have never used the RAW file type and want to start, this is a great place to start.

✦ **Fine.** This is the bigger of the two JPEG modes and is the default for the A200. This mode is very useful when you need to shoot in continuous modes and especially for fast-moving subjects.

Digital Workflow

The digital workflow describes the process from downloading your images to the computer to getting a final product. Everybody will have a slightly different workflow. My basic workflow is as follows.

I download the images from the CompactFlash to my computer using a card reader. It is possible to download directly from the camera, but I use the time when the images are being downloaded to clean off my camera and lenses. I then sort the images using software, review the images, and select the best to be worked on. I adjust the best images for printing or use on the Internet, sometimes both. I then back up all versions of the files to make sure that they are safe. The finished photos are then displayed either as prints or on the Internet. I make sure that the original files, that is the RAW files and/or the JPEG files, are safely stored on good-quality DVDs and are labeled with the subject and date so that I can easily find them again.

✦ **Standard.** This JPEG mode uses more image compression to make the smallest file sizes. The only time I ever use this is when I am absolutely, positively sure that the image will only be used on the Internet or in e-mail.

JPEG versus RAW

The two different types of file qualities are JPEG and RAW. Advances in software and hardware have started to blur the lines between the two file formats. It is now possible to correct the white balance of a JPEG file in the same manner as a RAW file by using Adobe Photoshop CS3 and Adobe Camera Raw, and while this can help save files, it does change the file and can cause image degradation, which does not happen with the original RAW file.

Setting the image quality is done by following these steps:

1. **Press the Menu button to open the A200's menu screen.**

2. **Use the Multi-selector to navigate to Recording Menu 1 and press the Multi-selector center button to open the menu.**

3. **Use the Multi-selector to navigate to Quality and press the Multi-selector center button to open the menu.**

4. **Select the Image size using the Multi-selector and press the Multi-selector center button to start using the selected image quality.**

5. **Press the Menu button to return to shooting.**

JPEG

The JPEG (Joint Photographic Experts Group) file format was created in 1992 and approved in 1994 to create a standard way to compress photographic files. The advantages to JPEG files are that they are relatively small and universally readable. The JPEG format is also used to store and display images on the World Wide Web, and images stored in this format do not need any other

processing before they can be used. Because of their smaller size, more images can be stored on a memory card and less space is needed on a computer to store them.

The downside to the JPEG format is that the image is compressed, removing data that cannot be recovered later, to make the file size smaller. JPEG files are saved as 8-bit data RAW files, which are 12-bit files that can store 4,096 intensity values for each pixel, whereas the 8-bit JPEG file can only store 256 values. The image settings you apply when you take the photo, especially the white balance, can't be easily changed after the fact without a lot of post-processing work.

RAW

RAW files contain the raw unprocessed data taken directly from the camera's sensor. The biggest advantage that RAW files have over JPEG files is the ability to change the settings the image was taken with after the image has been captured.

The downside of the RAW format is that the file needs to be processed before it can be used. The RAW file needs to be processed by a computer using special software that can read the RAW file. The image can then be saved as a file that is useable by the Internet or printer. RAW file formats are usually proprietary formats created by each individual camera company, and the RAW file format in the A200 is ARW. These files have all the information that the sensor captured, making the files much bigger than their JPEG counterparts. This increase in size means that fewer images can be stored on a memory card, and it takes longer to write the information from the camera buffer to the memory card.

 Note *The new UDMA CompactFlash cards like the Lexar UDMA 300x Professional series let information be written to the memory cards faster than ever before, and with card sizes of 8GB, you can store more than 400 RAW files to one card.*

Setting the image size

The A200 has three file size settings: Large, Medium, and Small.

The image size is applied only to the JPEG files. When the file quality is set to RAW & JPEG, the image size is set to Large and cannot be changed. There are three image sizes available on the A200: Large, Medium, and Small. All image sizes are described using M, which stands for megapixel or 1 million pixels.

✦ **Large.** The large image size is 10MB when in Large mode, creating file sizes of 3872 × 2592 pixels in the 3:2 aspect ratio. When in the 16:9 aspect ratio, the large image size is 8.4MB, creating a file with 3872 × 2176 pixels.

✦ **Medium.** The medium image size is 5.6MB when in Medium mode, creating file sizes of 2896 × 1936 pixels in the 3:2 aspect ratio. When in the 16:9 aspect ratio, the medium image size is 4.7M, creating a file of 2896 × 1632 pixels.

✦ **Small.** The small image size is 2.5MB when in Small mode, creating file sizes of 1920 × 1280 pixels in the 3:2 aspect ratio. When in the 16:9 aspect ratio, the small image size is 2.1M, creating a file with 1920 × 1088 pixels.

2.3 These three images show the difference in the amount of pixels used in the Large, Medium, and Small file sizes in the 3:2 aspect ratio. As you can see, there is a big difference in the overall size of the images.

Setting the image size is easily done. Follow these steps:

1. **Press the Menu button to open the A200's menu screen.**

2. **Use the Multi-selector to navigate to Recording Menu 1 and press the Multi-selector center button to open the menu.**

3. **Use the Multi-selector to navigate to Image size and press the Multi-selector center button to open the menu.** If Image size is grayed out, the image quality is set to RAW and Image size cannot be set.

4. **Select the image size using the Multi-selector and press the Multi-selector center button to start using the selected image size.**

5. **Press the Menu button to return to the Recording images screen.**

Setting the aspect ratio

The aspect ratio is the width-to-height ratio of the image. The Sony Alpha A200 lets you choose between two aspect ratios — 3:2 and 16:9. The aspect ratio also affects the final size of the image; because the 16:9 ratio doesn't use the full area of the sensor, the file sizes are slightly smaller.

✦ **3:2 aspect ratio.** This is the standard ratio for 35mm film cameras and 6-×-4-inch prints. This is the aspect ratio to use to get the same dimensions as traditional film and print sizes. This is the default aspect ratio, and is what I recommend for most photos. If you plan on printing your images using any standard printer or paper, this is the ratio to use.

✦ **16:9 aspect ratio.** This ratio is used to describe wide-screen televisions. The 16:9 aspect ratio is the standard for high-definition televisions. Any image taken in this aspect ratio must be severely cropped to fit a standard photo size.

2.4 The difference between the image taken using the 3:2 and the 16:9 aspect ratios is shown in this photo of our cat. Using the 16:9 aspect ratio cuts off part of the image on the top and the bottom.

To set the aspect ratio, do the following:

1. **Press the Menu button to open the A200's menu screen.**

2. **Use the Multi-selector to navigate to Recording Menu 1 and press the Multi-selector center button to open the menu.**

3. **Use the Multi-selector to navigate to Aspect Ratio and press the Multi-selector center button to open the menu.**

4. **Select the aspect size using the Multi-selector and press the Multi-selector center button to start using the selected aspect ratio.**

5. **Press the Menu button to return to shooting.**

White Balance Setting

Setting the white balance can have a profound impact on your images. With film photography, most of the time, people used daylight-balanced film and used filters to adjust for different types of light. Digital photography changed all this by allowing the camera to set the white balance.

The color of an object changes depending on the color of the light that reflects off of it. The human eye and brain translate this when looking at objects in different color light. Hold a white piece of paper outside in sunshine and it looks white, and then hold that same piece of paper in the shade and it

looks white. The human brain naturally adjusts because you know the paper should be white. The sensor in the A200 records the values as it sees them, not knowing what the situation is. It is up to the photographer to set the white balance, and in doing so, tell the camera what color the light in the scene really is.

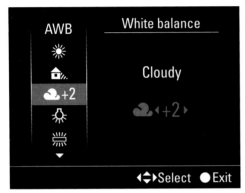

2.5 The White Balance menu is clear and easy to read and can easily be navigated using the Multi-selector.

White balance choices

The A200 has a wide range of white balance choices that can be set to cover a broad range of lighting situations. Most of the settings can also be fine-tuned to achieve more natural-looking colors.

✦ **Auto white balance.** Auto white balance or AWB sets the white balance automatically.

✦ **Daylight.** This setting is for photos taken in the bright direct sunlight outdoors. You can fine-tune the setting by adding or subtracting up to 3 stops. Adding increases the red tone, and decreasing results in a paler image.

✦ **Shade.** This is for when the subject is in the shade on a bright, sunny day. This setting can be fine-tuned by 3 stops, where adding increases the red tone and decreasing reduces the red tone.

✦ **Cloudy.** This setting is best used for shooting outdoors under a cloudy sky. This setting can be fine-tuned by 3 stops, where adding increases the red tone and decreasing reduces the red tone.

✦ **Tungsten.** Tungsten lights are used mainly in incandescent lighting, and are used in everything from household lamps to flashlights to commercial lighting. This setting can be fine-tuned by 3 stops, where adding increases the red tone and decreasing reduces the red tone.

✦ **Fluorescent.** Fluorescent lighting is very common, and can seem harsh and displeasing. When shooting in fluorescent lights, not setting the white balance can cause a loss of reds in the image. The white balance can be fine-tuned from a positive 4 to a negative 2. Adding increases the amount of red. Because fluorescent lights can cause a subject to look pale to begin with, adding red is more important than subtracting it.

✦ **Flash.** This is color balanced for using the built-in flash and Sony external flashes. This setting can be fine-tuned by 3 stops, where adding increases the red tone and decreasing reduces the red tone.

✦ **Color temperature/Color filter.**
The white balance can be set using
a color temperature. The color tem-
perature can be set between 2500K
and 9900K. Once the color temper-
ature is set, it can be adjusted from
Green (G) to Magenta (M) the
same way a color compensation fil-
ter is used in film photography.
There are a total of 18 steps of
adjustments, 9 for green and 9 for
magenta.

Cross-Reference *Color temperature is covered in greater detail in Chapter 4.*

✦ **Custom white balance.** Using a
Custom white balance is great for
scenes with multiple types of light.

Tip *If you shoot RAW, the white bal-ance can be changed after the photo is taken. And although getting the correct white balance in the first place is preferred, the ability to adjust the white bal-ance later is one of the best rea-sons to use the RAW file type.*

Setting the white balance

Setting the white balance is done using the
White Balance menu. Follow these steps:

1. **Press the Function button to
open the Quick Navigation
screen.**

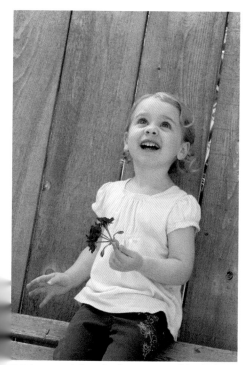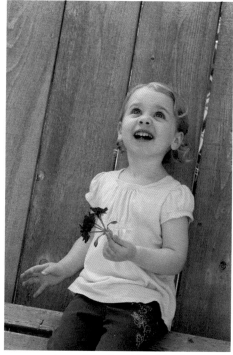

2.6 Images taken in the wrong white balance can cause dramatic color shifts. The image on
the left was taken with the white balance set to auto (AWB), which rendered great colors.
On the right is the same image taken with the white balance set to Tungsten, which makes
the colors look unnatural with a strong blue cast.

2. **Use the Multi-selector to navigate to the White Balance setting and press the Multi-selector center button to open the menu.**

3. **Use the Multi-selector to choose one of the nine white balance settings and press the Shutter button or the Multi-selector center button to activate it.**

4. **Fine tune the Daylight, Shade, Cloudy Tungsten, Fluorescent, or Flash settings by pushing the Multi-selector left or right after you make your setting selection.**

5. **If you selected the Color Temperature white balance setting, you can adjust it or have a color filter applied to the setting.** Rotate the Command dial or push the Multi-selector left or right to set the Color Temperature from 2500K to 9900K. After the Color Temperature is set, push the Multi-selector down to allow for a color filter to be applied to the white balance.

Cross-Reference | *For more on color temperatures, see Chapter 4.*

If you have multiple types of light in your scene or the lighting type differs from the standard options, you can set a Custom White Balance as follows:

1. **Follow Steps 1 through 3 in the previous set of steps, selecting Custom White Balance as your white balance option.**

2. **Push the Multi-selector left or right until the word SET appears and press the Multi-selector center button.** The LCD displays the following message: "Use spot metering area. Press shutter to calibrate."

3. **Aim the camera at an area of solid white that is being lit in your scene.** Make sure that the spot-metering circle is fully filled with white. The image does not have to be in focus.

Tip | *Any piece of white paper will work. I carry a folded piece of 8.5 × 11 paper in my camera bag just in case I need to set a custom white balance.*

4. **Press the Shutter button.** The LCD changes to show the image you just took with the color temperature on the bottom.

5. **Press the Shutter button or the Multi-selector center button to set the Custom White Balance.** If the color temperature is outside of the range that the A200 can record, a "Custom WB error" message appears in the center of the LCD. It is still possible to save this as a Custom White Balance, but the white balance will not be as accurate.

Note | *If the flash is used when setting the Custom White Balance, the light from the flash is used in calculating the color temperature, and to get the same results when using the Custom White Balance, the flash needs to be used.*

Your Custom White Balance settings are saved and you can use them again later simply by choosing Custom White Balance from the White Balance menu. The last Custom White Balance that you set is the one that will be available for you to use. The A200 only stores one Custom White Balance at a time.

Setting the Dynamic-Range Optimizer

Sony has developed a system called Dynamic-Range Optimizer (DRO) that analyzes the scene and automatically adjusts the image to improve the image quality. The dynamic range of the camera refers to its ability to capture both shadow detail and highlight detail at the same time. The D-Range Optimizer in the A200 works to recover shadow detail and highlight detail by automatically adjusting the brightness and contrast of the image.

Note *The DRO can be applied to RAW images using the Sony Image Data Converter SR software. For more on the Sony software and RAW file conversion, check out Appendix B.*

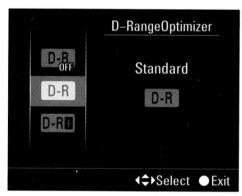

2.7 The D-Range Optimizer menu

The D-Range Optimizer is accessed through the Quick Navigation screen. Follow these steps:

1. **Press the Function button to open the Quick Navigation screen.**

2. **Use the Multi-selector to navigate to the D-RangeOptimizer menu choice and press the Multi-selector center button to open the menu.**

3. **Use the Command dial or the Multi-selector to choose one of the three DRO settings:**

 • **Off.** When the DRO is off, no adjustments are made to the brightness or contrast.

 • **Standard.** Adjusts the brightness and contrast of the whole scene overall.

 • **Advanced.** Adjusts the color and contrast of the whole image by only adjusting the areas in the scene that are too dark or too light.

4. **Press the Multi-selector center button or the Shutter button to set the selected D-Range Optimization.**

Focusing the A200

There are two ways that the A200 focuses: auto and manual. The autofocus system in the A200 has nine sensors that drive a fast autofocusing motor. Combined with the Eye-Start focusing system, which starts focusing before your eye is all the way to the viewfinder, the A200 is able to focus very quickly resulting in fewer missed shots.

Note *The Eye-Start focusing system dramatically cuts down on the time it takes to focus. There is a sensor under the viewfinder that starts the focusing system when the camera is brought up to your face. This sensor can be turned off in the A200 menu system.*

Selecting the autofocus area

The A200 has three autofocus area settings, each useful for different types of photography.

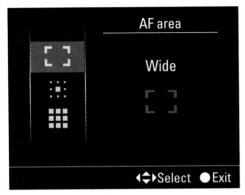

2.8 The A200 autofocus area menu

The three area choices are:

✦ **Wide Area.** This is the default setting for all modes and scenes on the A200. When the Wide Area autofocus mode is active, the camera decides which of the nine autofocus sensors to use. This mode works surprisingly well and works for most scenes. It is possible to quickly shift to Spot autofocus by pressing the Multi-selector center button when in the Wide Area mode.

✦ **Spot.** Spot focusing uses only the center autofocus spot, the small box in the center of the viewfinder.

✦ **Local.** The Local setting lets you decide which of the nine autofocus sensors to use. This is the most versatile setting because it gives the photographer the ability to decide exactly where in the frame to focus. To pick the sensor, just use the Multi-selector to move among the nine autofocus spots. Pressing the Multi-selector center button resets the autofocus spot to the center spot.

2.9 The nine focus areas are shown in red. They will not all be red when the camera is in use; only the selected spot turns red for a moment.

To select the autofocus area, do the following:

1. **Press the Function button to open the Quick Navigation screen.**

2. **Use the Multi-selector to navigate to the autofocus area and press the Multi-selector center button to open the menu.**

3. **Use the Command dial or the Multi-selector to choose the autofocus area and press the Shutter button or the Multi-selector center button to activate the selected autofocus mode.**

Autofocus modes

The A200 has three autofocus modes. To use the autofocus modes on the A200, slide the Focus Mode selector that is located on the left side of the camera to AF.

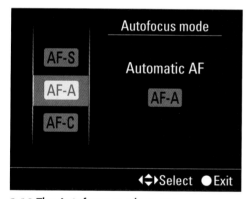

2.10 The Autofocus mode menu

The three autofocus modes are:

✦ **Single Shot autofocus.** When the A200 is set to AF-S, the camera focuses and locks on when the Shutter button is pressed halfway. This mode is best for shooting stationary objects. If the subject moves after the focus is locked, the image will be out of focus.

✦ **Automatic autofocus.** When the A200 is set to AF-A, the camera automatically switches between the AF-A and the AF-C (continuous autofocus) modes. When the subject is not moving, the focus is locked when the Shutter button is pressed halfway; when the subject is moving, the camera continues to focus.

✦ **Continuous autofocus.** The AF-C mode continues to focus as long as the Shutter button is pressed halfway. This mode is best for photographing moving subjects and is the default setting for the Sports Action mode.

To switch among the three autofocus modes, follow these steps:

1. **Press the Function button to open the Quick Navigation menu.**

2. **Use the Multi-selector to navigate to the Autofocus mode menu and press the Multi-selector center button to open the menu.**

3. **Use the Multi-selector to choose a mode:**

 • **AF-S.** Single-shot autofocus

 • **AF-A.** Automatic autofocus

 • **AF-C.** Continuous autofocus

4. **Press the Multi-selector center button or the Function button or press the Shutter Release button halfway to set the selected autofocus mode.**

Manual Focus mode

The A200 has a Manual focus mode, which is accessed by sliding the Focus Mode selector to MF instead of AF. At certain times, manual focus can be very useful; for

example, when taking macro photographs or selectively keeping subjects out of focus for abstract images.

In Manual focus mode, you can focus the lens by turning the focus ring on the actual lens. If you are using a teleconverter, the focusing action might not be as smooth as when the lens alone is used.

 Cross-Reference *Teleconverters are discussed in more detail in Chapter 5.*

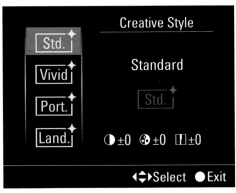

2.11 The Creative Style menu

Selecting a Creative Style

The Sony A200 has eight preprogrammed styles called Creative Styles. You can use these styles with optimal results for various situations. Each of these affects the image in a different way. It is important to remember, however, that they affect images stored only in the JPEG format if you are using any software other than the Sony Image Data Converter SR. If you are shooting and saving the images in RAW mode, the Creative Styles are visible when opening the RAW file in the Sony Image Data Converter SR.

The Creative Style menu is where the Creative Styles are set and modified. You can open them by following these steps:

1. **Press the Menu button to open the A200's menu screen.**

2. **Use the Multi-selector to navigate to Recording Menu 1 and press the Multi-selector center button to open the menu.**

3. **Select the Creative Style menu choice and press the Multi-selector center button to access the Creative Style menu.**

The eight Creative Styles available on the A200 are:

✦ **Standard.** This mode is good for all basic shooting. The colors are rich without being oversaturated and the colors look natural.

✦ **Vivid.** The saturation and contrast are both boosted when shooting in this mode. Vivid mode works well for shooting scenes with bright colorful subjects. This mode does not reproduce skin tone well and is not recommended for shooting people.

✦ **Portrait.** This is the mode designed to use when shooting people. The Portrait color mode is best used with soft skin tone.

✦ **Landscape.** This mode boosts the contrast, saturation, and sharpness of the image and helps make landscapes "pop" more. This mode does not work well for shooting people, as the boosted contrast and saturation make skin tones look unnatural.

2.12 The same image taken using the Portrait Creative Style and the Black & White Creative Style.

✦ **Night view.** This style is specialized for shooting at night without a flash. The camera adjusts the contrast for a more natural looking image at night. This mode is not great for shooting people as it can cause unnatural colors to be present.

✦ **Sunset.** This mode boosts the reds and oranges of the early morning and late afternoon sunlight.

✦ **Black & White.** This turns the image into a black-and-white image.

✦ **Adobe RGB.** This uses the Adobe RGB color space for the images taken with the A200. This mode has a wider range of colors than the others, but it needs to be adjusted using image-editing software before it looks right on a computer or the Internet. Photographers usually use this

mode when they know the image will be processed for printing, as the colors can look a little muted on a screen.

The eight Creative Styles available on the A200 can be fine-tuned by adjusting the contrast, saturation, and sharpness. To fine-tune the Creative Styles, follow these steps:

1. **Open the Creative Style menu following the previous set of steps.**

2. **Use the Multi-selector to select the Creative Style you want to fine-tune.**

3. **With the selected Creative Style highlighted, push the Multi-selector to the right.**

4. **Use the Multi-selector to modify the following:**

 • **Contrast.** The contrast can be increased or decreased by three steps for each of the Creative Styles.

 • **Saturation.** The saturation increases the vividness of the colors in each of the Creative Styles except for Black & White.

 • **Sharpness.** If you increase or decrease the amount of highlighting in your image, it gives the image a crisper or sharper look.

5. **After you make all the adjustments you want, press the Shutter button to return to shooting or the Menu button to return to the Recording Menu 1 screen.**

Creative Styles can only be applied when shooting in the Auto, Program, Aperture priority, Shutter speed priority, and Manual modes. The Creative Styles cannot be applied when shooting in any of the scene selection modes.

Reviewing Your Images

The great advantage to digital photography is the ability to see the image you just captured and make adjustments if necessary and shoot again. The default setting on the A200 is for the last photo taken to be displayed after you stop taking photos. This shows you the last image taken for 2 seconds. This can be changed to 5 or 10 seconds or even turned off using the Auto Review setting in the Custom menu.

 Cross-Reference *The Custom menu is covered later in this chapter.*

To look at the other photos stored on the CompactFlash card, use the Multi-selector to cycle through the images. The different modes used to examine the images are covered in Chapter 1.

To see the images at any time, press the Playback button located on the rear of the camera. This displays the last image viewed or the last image taken.

A200 Menus

There are eight menu screens on the A200 that are broken down into four categories: Recording Menus 1 and 2, Custom Menu 1, Playback Menus 1 and 2, and Setup Menus 1, 2, and 3. The A200 uses icons instead of text labels to show which menu is open. There are four tabs across the top of the menu screen. When the menu is selected, the corresponding tab is outlined in white and the menu number is shown as a white number on an orange background.

Pressing the Menu button on the back of the camera accesses the menus on the A200. The first menu that appears is the

Recording Menu 1. Use the Multi-selector to navigate through the other menus. Pressing the Multi-selector left and right scrolls through the menus, while pressing the Multi-selector up and down scrolls through the individual menu choices. It is also possible to rotate through the menu choices by using the Control dial. Turning the dial left or right scrolls through the individual menu items. To activate a menu item, press the Multi-selector center button.

At times, certain menu items are grayed out and not selectable — it depends on several factors that can include the mode you are in or the Image Quality selected.

Recording menu icon

Custom menu icon

Playback menu icon

Setup menu icon

2.13 The icons and corresponding menu descriptions

Recording Menu 1

The Recording menu is the default menu when the Menu button is pushed for the first time after the camera is turned on. The icon for the Recording menu is a small camera. When in Recording Menu 1, the number 1 next to the camera icon in the Recording Menu tab on the top of the LCD is in an orange box.

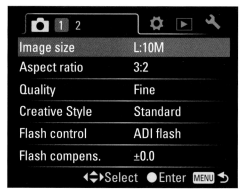

2.14 The Recording Menu 1 on the A200

Image size

This is the setting that determines the size of the image. The default is L:10M, which is the largest file size. The other choices are M:5.6M and S:2M. These choices change depending on the aspect ratio. When in the 16:9 aspect ratio, the choices are L:8.4M, M:4.7M, and S:2.1M. This menu choice is grayed out and not available if the Quality setting is set to RAW or RAW & JPEG. The Image size setting only affects the JPEG file type.

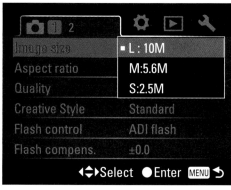

2.15 The Image size menu choices

Pressing the Multi-selector center button activates the Image size menu; the choices appear on the right side of the menu display and can be selected by using the Multi-selector. My A200 is usually set to RAW & JPEG mode, so this menu choice is usually not available on my camera, and in the rare times it is, I always set the Image size to the largest possible size. It is easier to make an image smaller than it is to make it larger.

Aspect ratio

There are two choices for the aspect ratio: the traditional 3:2 aspect ratio, and the wide-screen ratio of 16:9. Unless there is a specific reason to set the ratio to 16:9, I recommend that the camera is always set to the 3:2 aspect ratio.

Quality

This is where the image quality is set. The default is Fine, which is the highest JPEG file quality. Other choices are RAW, RAW & JPEG, and Standard.

Creative Style

This is where one of the eight creative styles can be set. The choices are Standard, Vivid, Portrait, Landscape, Night, Sunset, Black and White, and Adobe.

Flash control

There are two flash control modes: ADI flash and pre-flash TTL. When the camera is set to ADI or advanced distance integration flash control, the camera takes distance information between the camera and the subject into consideration when determining the power of the flash. This method offers increased accuracy when using the flash. The second method, TTL, or through the lens, determines the amount of flash output by getting a reading from a series of pre-flashes fired by the flash before the image is taken. When a flash is used in Wireless mode, or the distance to the subject cannot

be determined when using an external flash, the camera automatically selects the pre-flash TTL control. Because the A200 can automatically change when the distance cannot be determined, I recommend that the setting be left on ADI flash.

Flash compensation

Adjusting the power output of the flash is done here. Moving the Multi-selector to the right increases the flash power, while moving the Multi-selector to the left decreases the flash power.

 For more on the flash and adjusting flash compensation, see Chapter 4.

Recording Menu 2

The icon for the Recording menu is a small camera. When in Recording Menu 2, the number 2 in the Recording Menu tab at the top of the LCD is in an orange box.

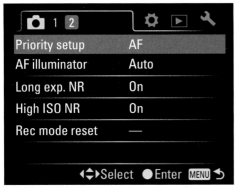

2.16 Recording Menu 2

Priority setup

The Priority setup selects a setting used for the shutter release. With the default setting, AF, the shutter cannot be released until focus has been confirmed. You can set the

Priority setting to Release, which allows the shutter to be released even if the focus is not locked.

AF illuminator

The autofocus illuminator helps the camera achieve autofocus in low light by firing a quick burst from the flash to quickly light the scene. This does not work when the autofocus mode is set to AF-C or if the subject is moving and the autofocus mode is set to AF-A. If an external flash is attached, the camera uses that for autofocus illumination. The autofocus illumination can also be turned off using this menu selection.

Long exp. NR

When the camera shutter is open a long time, noise can be introduced into the image. When Long Exposure Noise Reduction is turned on, as it is by default, any exposure of 1 second or longer is subject to noise reduction after the image has been captured. The LCD displays "Processing" while the noise reduction is being applied. You cannot use the camera to take another photo until the noise reduction processing is complete. If the Drive mode is set to Continuous shooting or Continuous bracketing, Long Exposure Noise Reduction is not performed no matter what this menu choice is set to. The noise reduction time is equivalent to the exposure time. For example, if your exposure is 2 seconds, then the time it takes to apply the noise reduction is 2 seconds.

High ISO NR

When you photograph at ISO speeds of 1600 and above, High ISO Noise Reduction is applied automatically. When this setting is turned on, the camera spends more time in the noise reduction phase, creating better-looking images, or it can be turned off to

speed up the shooting of continuous images. There is no noise reduction performed on images when taken using Continuous Shooting drive mode or shooting Continuous Bracketing.

Rec Mode reset

This resets all the menus in Recording Menus 1 and 2 back to the factory defaults, including the file size and image quality. This does not reset any of the changes you might have made in the Custom menu or the Setup menus.

Custom Menu 1

The Custom menu icon is a small gear. When in the Custom Menu 1, the number 1 next to the gear icon in the Custom Menu tab on the top of the LCD is in an orange box. The Custom menu lets you decide how the certain buttons and dials function on the A200.

Eye-Start AF	On
AEL button	AEL hold
Ctrl dial setup	Shutter speed
Red eye reduc.	Off
Auto review	2 sec
Auto off w/ VF	On

◀✚▶Select ●Enter MENU ↩

2.17 Custom Menu

Eye-Start AF

When Eye-Start autofocus is set to On, the Eye-Start focus sensor is active and the camera starts to focus when the camera is brought up to your eye. The default setting

is On. Having this turned on also means that the camera can and does start to focus automatically when anything gets close enough to the sensor, including your shirt when the camera is hanging around our neck. This can use up the battery power prematurely and should be taken into consideration when setting this menu item.

AEL button

The Auto Exposure Lock button has two functions: AEL hold and AEL toggle. The default is for the AEL hold setting, which locks the exposure value that the camera is currently calculating as long as the button is being pressed. There is also an AEL toggle mode, which locks the current exposure when the AEL button is pressed, and unlocks the exposure when the button is pressed a second time.

Ctrl dial setup

When shooting in P (Program Auto) mode and M (Manual) mode, you can set the Control dial to control the shutter speed or the aperture, but not both. The default is for the Control dial to be set for shutter speed, which then means that to change the aperture in M (Manual) mode you need to hold down the Exposure Compensation button while turning the Control dial. When the setting is changed to Aperture, changing the shutter speed in M (Manual) mode is done by holding down the Exposure Compensation button and rotating the Control dial. When shooting in P (Program auto) mode, the default is for the Control Dial to change the Shutter speed. When this menu is set to aperture, the Control dial controls the Aperture in P (Program auto) mode.

Red eye reduc.

Red-eye reduction is available only with the built-in flash. The options here are On and

Off. When it is turned on, the built-in flash fires a quick, low-light burst to try to minimize red eye. Red-eye reduction is turned off by default.

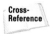 **Cross-Reference** *For more on Red-eye reduction, see Chapter 4.*

Auto review

After the photograph is taken, it can be displayed on the LCD for a predetermined amount of time. The default setting displays the image for 2 seconds, but it can be set for 5 seconds or 10 seconds. The review can also be turned off. To save battery power, turn this off so that the LCD only displays the image when you press the review button.

Auto off w/VF

When the Auto off with viewfinder is set to On, the default setting, the LCD turns off when the Eye-Start sensor is triggered. This turns the display off when you look through the camera viewfinder. Changing this to Off lets the LCD stay on even when you look through the viewfinder.

Playback Menu 1

The Playback menu icon is a right-facing arrow in a small square. Playback Menu 1 houses the Delete and Format menu choices, both important when using a new CompactFlash card or making space on an older card.

Delete

The Delete menu has two options — Marked images, which deletes only the selected images; or All images, which deletes all the images on the memory card. Any image that is protected will not be deleted.

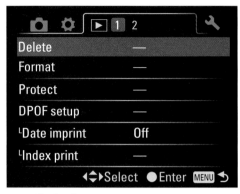

2.18 Playback Menu 1

 Caution *Once an image is deleted, it cannot be recovered easily.*

Selecting Marked images causes the most recently taken image to appear on the LCD. Scroll through the images using the Multi-selector; pressing the Multi-selector center button marks an image for deletion. A green trashcan symbol superimposes over the middle of the image. On the bottom left of the display there is a trashcan icon followed with the number of images that have been selected for deletion. When all the images that you want to delete are marked, press the Menu button to open a menu choice that lists the number of photos that are about to be deleted and the choice to delete or cancel. Use the Multi-selector to continue with the deletion or to cancel the process. If the process is cancelled, the LCD shows the last image that was marked for deletion. You can either continue to mark images for deletion or cancel completely by pressing the Playback button.

Selecting All images gives you the option to delete all the images on the memory card. Use the Multi-selector to either select Delete or Cancel and then press the Multi-selector

center button to execute your choice. Selecting Cancel returns the display to the Playback Menu 1. Selecting Delete deletes all the images on your card.

If there are no images on the memory card, the Delete menu is grayed out.

Format

This formats the camera's memory card and prepares the card to be used with the A200. A memory card needs to be formatted before its first use and should periodically be reformatted.

Caution *Formatting erases all images on the card, including the protected images and any images or files that may be on the card from any other source. Cards that are accidentally formatted might be able to have the information retrieved, but it is best to be sure before formatting.*

Protect

You can protect images to stop them from being accidentally deleted. The Protect menu offers three choices: Marked images, All images, and Cancel all. The first choice is to protect the marked images. When this is selected, the LCD shows the most recent photo taken, and the Multi-selector can be used to scroll through the photos. The Multi-selector center button can then be used to protect the displayed image. When an image is protected, a green key icon is superimposed over the middle of the image. When you are done selecting images you want to protect, press the Menu button, which then gives you the choice to protect the images or cancel.

Protecting an image stops it from being accidentally deleted, but it does not stop the image from being lost when the card is formatted.

DPOF setup

With modern digital camera technology it is possible to print directly from the A200. The DPOF (Digital Print Order Format) menu allows you to mark which images you want to print and how many copies of each image to print. The DPOF does not work with RAW images, and you can print only up to nine copies of each image. The three menu choices are Marked Images, All Images, and Cancel All.

When you choose Marked Images, the LCD shows the last image taken. You can then scroll through the images using the Multi-selector. When you find an image that you want to mark for printing, press the Multi-selector center button. DPOF1 appears in green superimposed on the center of the image. Each subsequent click of the Multi-selector center button increases the number until DPOF9. The option then resets and the image is no longer selected. When all the

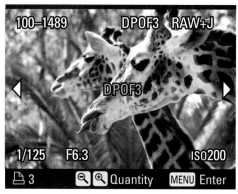

2.19 The photo of the giraffes with the DPOF set to 3 prints

images that you want to print are marked, press the Menu button. You are asked if the amount of prints is correct, and you are given two choices: Accept or Cancel.

If you select the All Images menu choice for printing, a Number of Copies menu appears and asks for the number of prints per image. You can then press OK and go back to the Marked Images menu and change the individual number for each image. Cancel All removes any DPOF markings from all images on the memory card.

Date imprint

You can imprint the date when printing images directly from the camera. The position of the date depends on the printer used. The default is for the camera not to print the date. The position, size, and orientation of the date depend on which printer used. Check your printer manual for more information on printing directly from the camera.

Index print

You can create an index print of all the images on the memory card. The number of images that can be printed on a sheet depends on the printer and the size of paper used. RAW files do not print on index prints.

Playback Menu 2

Playback Menu 2 is where the Auto rotate menu and Slide show menu are located. It is possible to play back the images saved on your memory card in slide show form on the A200 LCD or on a television when the camera is connected through the supplied USB-to-video cable.

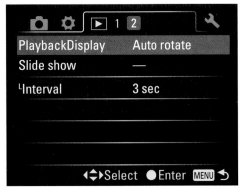

2.20 Playback Menu 2

Playback Display

The two settings here are Auto rotate and Manual rotate. The Auto rotate setting rotates photos taken in the portrait mode so that they are displayed in portrait orientation. When the setting is set to Manual rotate, the images all appear in landscape mode. When the camera is connected to a television, this setting is ignored and all images appear according to the orientation of the image.

Slide show

The slide show function plays back the images on the memory card in the order that they were recorded. Select Slide show from the menu and press the Multi-selector center button. This starts the slide show, which runs until the last image appears. To pause the slide show, press the Multi-selector center button again. Pressing the Menu button stops the slide show.

Interval

The amount of time each slide is shown during the slide show is set here. The options are 1 second, the default 3 seconds, 5 seconds, 10 seconds, and 30 seconds.

Setup Menu 1

The Setup menu icon is a small wrench. The Setup Menu 1 deals with the LCD and the display output of the camera. It is also the place to set the date and time.

LCD brightness

The LCD brightness level can be adjusted to suit different lighting conditions. Using the Multi-selector, the LCD can be adjusted by two steps brighter or two steps duller.

Info. disp. time

When shooting, the LCD displays the shooting information, which appears for a default of 5 seconds. It can be changed to 10 seconds, 30 seconds, or 1 minute.

Power save

This setting controls the amount of time it takes for the camera to go into the Power save mode. The default is 1 minute, but it can be set for 3 minutes, 5 minutes, 10 minutes, or 30 minutes.

When the camera is connected to a television using a regular video cable, the camera goes into Power save mode after 30 minutes regardless of this setting.

Video output

The video output format can be set to NTSC, for use in Japan and the United States, or PAL, the video setting for Europe.

Language

You can select the language that the menus use. The language choices are English, French, Spanish, Italian, Chinese, and Japanese. If you end up setting the camera to a different language by mistake, look for the "A," it will be the fifth menu option on the Setup Menu 1, and the choices will be in their respective languages.

Date/Time setup

The date and time can be adjusted using the Multi-selector.

Setup Menu 2

When in Setup Menu 2, the number 2 next to the wrench icon is lit in orange. Setup Menu 2 deals with where the images are stored on the memory card and how the images are numbered.

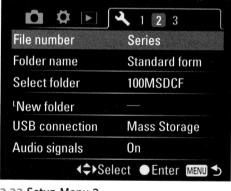

2.22 Setup Menu 2

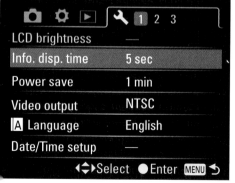

2.21 Setup Menu 1

File number

The camera uses two methods to assign file numbers to images as it takes pictures. The default is the Series method. In this method, the file numbers start at 0001 and increase with each image taken until 9999, and then it starts over.

The second method is the Reset method. In this mode, the file numbers start at 0001 each time the folder is changed, the recording date changes, or the memory card is formatted. The file numbers also restart at 0001 when the memory card is changed. If there are already files in a folder, the next number in the sequence for that folder is used.

Folder name

There are two folder name modes: Standard form and Date form. In the Standard form the folder name does not change, and all photos taken are stored in a single large folder. In the Date form, a new folder is created every time the recording date changes. The format shows a folder number, followed by the last digit of the year and then the month and day. This is useful when you want to organize your images by date and can make it much easier when photographing on vacation, for example.

Select folder/New folder

When the Standard folder mode is used, you can select which folder to store the images in, and you can create new folders if you want to. Each new folder gets a new sequential number up to 999. When a new memory card is inserted and a new folder is created, it has the next sequential number of the folders on that memory card.

USB connection

When a USB cable is plugged into the camera, there are two modes that the camera can be in. The first is Mass Storage, the default setting. This setting lets images stored on the memory cards be copied to the computer, and the camera acts as a regular external storage device. The other option is PTP, which lets the camera be connected to a PictBridge-compliant printer so that prints can be made directly from the camera.

Audio signals

When this is turned on, as it is by default, the camera produces sound when in use. These sounds include the countdown chime for the self-timer and when the shutter is locked. When the menu setting is set to Off, the camera does not produce these sounds. The sounds created by taking the photo and the shutter sounds cannot be turned off.

Setup Menu 3

When in Setup Menu 3, the number 3 next to the wrench icon is lit in orange. The two menu choices here are not used very often, but they are important. There are times when I have made so many changes to the settings of the camera that it is just a good idea to start over, and that's what the Reset default is all about.

Cleaning mode

You must select this mode when you plan to clean the sensor in your camera. The cleaning mode moves the mirror out of the way and allows for the sensor to be cleaned. Dust and dirt can cause spots to appear or your images, and when this happens, it is time to clean the sensor.

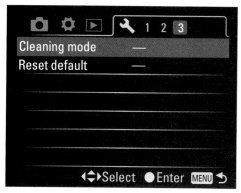

2.23 Setup Menu 3

 For more on sensor cleaning and the Cleaning mode, see Appendix A.

Reset default

This option resets all the menus and functions of the camera back to the factory defaults. The only items not reset are the date and time.

Creating Great Photos with the Sony Alpha DSLR-A200

P A R T

II

Photography Essentials

The basics of photography don't change when it comes to digital photography. It doesn't matter if the camera is your new A200, an old-fashioned film camera, or a basic point-and-shoot camera, exposure and composition are essential components to creating great photographs. While the basics of photography can be understood in an afternoon, they can take many years to master. This chapter covers what you need to get started, and can act as a refresher if it has been a while since you have been out shooting.

If you have upgraded to this camera from the Sony A100 or one of the older Konica Minolta cameras, you most likely have a good understanding of the basics of photography, but give this chapter a look. There just might be some useful information here. Or just use the chapter as a quick review.

If the Sony A200 is your first camera or an upgrade from a point-and-shoot camera, this chapter gives you the information needed to help you take the best photographs possible. Understanding exposure and the basics of composition can help you create the images you want, aid your understanding of what makes a good image, and help you turn good images into great images.

Understanding Exposure

The A200, like all digital cameras, creates images by focusing light through a lens onto the sensor. Proper exposure is achieved when the amount of light that reaches the sensor is enough to show details in the darkest areas, but not so much that the lightest parts are too bright. When I first picked up a camera many years ago, I had to use a separate light meter to get an accurate measurement to determine what settings to use. The idea that the light meter built into the camera could accurately determine the settings needed for a good exposure

was ludicrous. Today's digital cameras have extremely accurate built-in light meters, and trusting the exposure settings determined by the camera has become second nature. Because the light meter in the A200 is always on, even when shooting in Manual mode, the camera lets you know what the light meter thinks is the correct exposure.

Understanding the factors that affect exposure gives you greater control over how your images look, which in turn allows you to improve on the rest of your photographic skills.

The four factors that affect exposure are as follows:

✦ **Light.** The amount of light reaching the lens affects how you approach a shot. This can be any light that you see, from the sunlight illuminating an outdoor scene to a candle's soft glow lighting an intimate indoor scene. It makes no difference to the sensor what the source of the light is or how much light is there.

✦ **Aperture.** The opening in the lens — called an aperture or diaphragm — can be made larger and smaller to control the amount of light that passes through — this is the aperture. The aperture in the lens works a lot like the iris of the human eye. The iris controls the size of the pupil. When the pupil is larger, more light gets in so that you can see in darker situations; making the pupil smaller lets in less light so that you can still see in very bright situations. The relative size of the aperture is called the f-stop.

3.1 The details in the flower are still visible, even though it is the brightest item in the scene; while the water is dark, at no point does it turn into black.

✦ **Shutter speed.** The amount of time that the shutter is open is referred to as shutter speed. The longer the shutter is allowed to stay open, the more light is allowed to reach the sensor.

✦ **ISO.** The sensor in the A200 acts like film does in traditional film cameras. The sensitivity of both film and digital sensors is measured using the International Organization for Standardization (ISO) rating. The higher the ISO rating, the lower the amount of light needed.

These four factors work together to produce an exposure, and by changing any one or more of these things, you can control the exposure.

Controlling Exposure

As the photographer, you control the amount of light reaching the sensor by changing one or more of the four factors that affect the exposure. If all these factors did was affect exposure, photography would be simple; but changing the light, aperture, shutter speed, and ISO all have other consequences.

Light

Determining the amount of light in your scene is the starting point when evaluating your exposure settings. Light is the most important part of evaluating the scene you want to capture. For example, is the subject of your photograph in bright light or in the shadows? Where does the light fall, and what is the quality of the light? Is the light a soft glow from a candle or harsh, direct light from the sun? Is part of your artistic vision the actual color of the light? The color of the light at a sunset is different from the color of

the light inside a concert hall. Although the light in your scene is the most important part of the exposure equation, it can also be the most difficult exposure factor to change. Without extra equipment, increasing or decreasing ambient light is difficult. It might be possible to physically move yourself or your subjects, but this likely changes the composition of your photograph. Luckily, many products are available to help shape, modify, increase, or decrease the light in your scene.

 Light is such an important factor in photography that Chapter 4 is devoted entirely to light.

Aperture

Aperture is measured in f-stops and is described as f/1.4, f/2.0, f/2.8, f/4, f/5.6, f/8, f/11, f/16, f/22, and so on. The bigger the f-number (for example, f/22), the smaller the opening in the lens, allowing less light to reach the sensor. The smaller the f-number (for example, f/2.8), the bigger the opening in the lens, allowing more light to reach the sensor. While this seems to be counterintuitive, it makes sense when you think of the f-stop as what it is: a ratio between the diameter of the hole in the lens and the focal length of the lens. For example, on a 100mm lens, f/2 means that the diameter of the opening is 50mm, while f/4 is 25mm. The size of the opening decreases as the ratio increases.

The difference between each f-number is known as a stop and either doubles or halves the amount of light that is let through the lens. For example, f/5.6 lets in half as much light as f/4, while f/2.8 lets in twice as much light as f/4. While changing the f-stop results in more or less light getting through the lens, this action has other consequences, as explained in the following sections.

Setting the camera's exposure mode to Aperture Priority mode (A) lets you concentrate on setting the aperture while the camera adjusts the shutter speed.

✦ **Depth of field.** When you change the f-stop, not only do you change the exposure, you also change the depth of field. The depth of field (DOF) is the distance in front of and behind the subject that appears to be in focus. Because only one plane of an image is in exact focus, everything else is technically out of focus, but the area in front of and behind this focus plane that is still acceptably sharp is called the depth-of-field area. The depth-of-field area starts one-third in front of the focus point and extends two thirds behind it.

Using a smaller f-number (larger aperture opening) results in a shallower depth of field. A larger f-number (smaller aperture opening) results a greater depth of field. This depth-of-field control lets you selectively focus on different items in the same view. Landscape photographs and big group portraits need to have a greater depth of field; both the foreground and the background need to be in focus. The depth of field is also affected by the distance of the camera to the subject of your photo. The greater the distance the subject is from the camera, the greater the depth-of-field area, while the closer the camera is to the subject, the smaller the depth-of-field area.

3.2 Using f/1.4 creates a very shallow depth of field, where only the subject is in focus.

3.3 Using f/16 creates a much deeper depth of field so both the subject and the background are in focus.

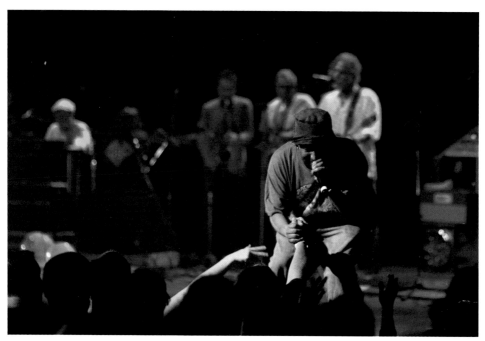

3.4 Using an f-stop of f/1.4 and focusing on the handshake between the performer and the fan causes the background to be blurred and not compete with the subject of the image.

To increase the depth of field, use a smaller f-number, move farther away from the subject, and use a shorter focal length. To decrease the depth of field, use a larger f-number, move closer to your subject, and use a longer focal length.

✦ **Sharpness.** Most lenses today are slightly sharper in the middle range of f-stops, not at the smallest or largest openings. The optimal f-stop for sharpness is usually two stops up from the smallest f-stop. If your lens has a range from f/2.8 to f/22, the optimal f-stop would be f/5.6.

✦ **Focal length.** The focal length of a lens is the distance from the optical center of the lens when it is focused at infinity to its focal plane (sensor) and is described in millimeters (mm). The amount of area in front of the camera that can be captured on the sensor using that lens is called the angle of view. For example, a telephoto lens captures a smaller amount of the scene than a wide-angle lens, so it has a narrower angle of view.

✦ **Diffraction.** When you use the highest f-stops available on any given lens, f/22 for example, an effect called diffraction occurs. This is a reduction in the sharpness of the overall image. The aperture opening is so small that you are using very little of the lens, and the glass in the lens, to focus your image. It is best to avoid these extreme f-stops if possible.

Aperture Terminology

There are terms that professional photographers use in describing aperture and lenses.

✦ **Shooting wide open.** Using the smallest f-number (the widest aperture opening) possible on any given lens, which lets the most amount of light through the lens

✦ **Stopping the lens down.** Changing from a small f-number to a larger f-number, reducing the amount of light that passes through the lens

Shutter speed

Shutter speed controls the amount of time the shutter is open allowing light to reach the sensor. Changing the shutter speed changes the amount of light reaching the sensor, which has a direct affect on exposure. The shutter speeds of the A200 range from 30 seconds to 1/4000 second in stops

of 1/3. The camera also has a Bulb setting that enables you to keep the shutter open as long as the Shutter button is held down.

Increasing the shutter speed (making it faster) reduces the amount of time that the shutter is open, letting in less light. Decreasing the shutter speed increases the amount of time the shutter is open, increasing the

3.5 Using a shutter speed of 1/1600 froze this skater in midair during a skateboarding demonstration.

amount of light that is allowed to reach the sensor. When you increase the shutter speed by 1 stop, you reduce the amount of light that reaches the sensor by half; decreasing the shutter speed by 1 stop doubles the amount of light that reaches the sensor.

Changing shutter speed alters the way movement is captured in the photograph. When the subject of your photo is moving, you need to decide if you want to freeze the action or show the motion. A faster shutter speed, such as 1/2000, freezes the action; a slower shutter speed, such as 1/15, produces motion blur.

✦ **Freezing action.** To capture a moment in time, the shutter of the camera opens and closes in a fraction of a second. The faster the action, the faster the shutter speed needs to be. For example, to freeze a horse running around a track or a car rushing by, the shutter needs to be open for a very small amount of time to avoid blur. The general guide for stopping motion is 1/60 second or faster. When shooting a fast-moving scene, setting the camera's exposure mode to Shutter Priority mode (S) lets you concentrate on freezing the action while the camera adjusts the f-stop.

Tip *If you are shooting at a low ISO and the camera still tells you that the scene is underexposed, you can always increase the ISO to make sure that the whole scene is properly exposed and the action is frozen.*

✦ **Motion blur.** At times, you may prefer to show motion in your photographs. When you leave the shutter open longer, objects that are in motion in your scene will not appear in sharp focus; instead they look blurred, while the nonmoving objects in the scene will be in sharp focus. You can use longer shutter speeds and follow the action with the camera. Keeping the camera moving at the same speed as the subject while the shutter is open keeps the subject in focus while the background blurs. This technique is called panning.

ISO

The A200 has an ISO range from 100 to 3200. In film photography, using different films changed the ISO; those with a higher ISO rating were more sensitive to light. In digital photography, the information captured from the camera's sensor is amplified

Camera Shake

One issue that affects the choice of shutter speeds you use, that has nothing to do with your subject, is camera shake. This is the slight blurring that occurs when you hand hold a camera when the shutter speed is too slow, resulting in a softening of your image's focus. The longer the focal length of your lens, the worse the camera shake. The rule to avoid camera shake is to use a shutter speed that is 1 divided by the focal length of the lens. For example, if you use an 80mm lens, the minimum shutter speed needs to be 1/80 second. Using a tripod will avoid camera shake by keeping the camera rock-steady. The A200 has built-in vibration reduction technology called Super SteadyShot. When Super SteadyShot is turned on, you can use shutter speeds that are 2 to 3 stops slower without any camera shake.

to capture more information in lower light. The higher the ISO the more the signal is amplified and less light is needed to produce a correctly exposed photograph. However, because the signal from the sensor is amplified when using higher ISOs, digital noise can be introduced into the image. Digital noise appears as random pixels of unwanted color in areas where there should be only smooth color. This is usually more noticeable in areas like blue skies and shadow areas. Always try to use the lowest ISO possible, thus reducing the amount of digital noise as much as possible.

When an image is overexposed, the entire image appears to be too light, and the lightest parts of the image can become too light,

3.6 These peppers shot at ISO 100 (top) show no signs of digital noise, while the same shot at ISO 3200 shows a great deal of digital noise especially in the darker areas.

turning them a solid white with no detail at all. This happens when too much light reaches the sensor. When too little light reaches the sensor and the image is underexposed, the opposite happens. The image appears too dark and loses detail in the darkest areas of the image.

Each photo opportunity presents you with choices: use a long or short shutter speed, increase or decrease the f-stop to get the desired depth of field, or adjust the ISO to achieve better low-light images. As the photographer, you have to decide the best settings to capture the image.

Capturing the image with the proper exposure is a balancing act among the four factors. When the amount of light increases, you can decrease the ISO, increase the shutter speed, or use a bigger f-number (smaller opening). Because you understand the advantages and disadvantages to each of these, you now have the ability to capture the image in the way you want and not be at the mercy of the A200 Auto mode.

A bright sunny day provides plenty of light, enabling you to pick from a variety of f-stops and shutter speeds. A more challenging situation occurs when there is not a lot of light. Getting the correct exposure is a balancing act: As the amount of light decreases, you can increase the ISO, decrease the shutter speed, or use a smaller f-number (wider opening). Because you know the pros and cons of each, you can now decide what settings you want to change.

By keeping the ISO as low as possible, you avoid introducing noise into the photograph. By keeping the f-stop at the optimal f-stop, you get the sharpest focus in your photos and not too shallow a depth of field. By keeping the shutter speed high, you can freeze the action and avoid motion blur.

Equivalent exposure

Certain combinations of shutter speed, aperture, and ISO give you the same exposure. In other words, the same amount of light will reach the sensor. A scene properly exposed at ISO of 100, a shutter speed of 1/500, and an f-stop of f/2.8, would also be properly exposed with an equivalent exposure of ISO of 100, a shutter speed of 1/60, and an f-stop of f/8. This means that the light reaching the sensor is the same. When you decrease the aperture, you are letting less light in through the lens; to get proper exposure, you need to increase the amount of time that the shutter is open.

Fine-Tuning Exposure

There are times when using the values supplied by the A200's built-in light meter will result in an exposure that needs a little fine-tuning. There are different ways that this can be done as explained in the following sections.

Exposure compensation

The A200 has an exposure compensation adjustment that can increase or decrease the overall exposure from –2 to +2 exposure equivalents (EV) in one-third step increments, in all exposure modes except Manual mode. This setting is very useful when you want to slightly over- or underexpose the scene.

Manual mode

The easiest way to adjust exposure is to shoot in Manual mode. Being able to set the f-stop and shutter speed to any combination

3.7 These two images appear to be the same, but the first was taken at ISO 200, f/13, and 1/80 second. The second was taken at ISO 200, f/9, and 1/160 second. The increase of shutter speed and the decrease in aperture cancel each other out, resulting in equivalent exposures.

you want lets you decide exactly what the exposure will be. You can still see what the camera believes the correct exposure should be and you can use it as a guide, but the camera does not set or change anything.

While this mode offers the greatest flexibility, it does not take into account any changes in the scene. If the light changes at all, the camera does not adjust anything.

Exposure metering mode

The A200 has three metering modes, and picking the correct one can help in getting the correct exposure. The Spot metering setting ignores everything outside of the spot-metering circle, while the Center-weighted metering uses the whole scene with a strong emphasis placed on the readings from the spot-metering circle. The Multi-segment metering takes the light from the whole scene into consideration.

Cross-Reference *To read more about changing the exposure mode, see Chapter 2.*

Bracketing

Bracketing lets you take multiple photographs of the same scene with different levels of exposure. This method lets you slightly under- and overexpose a scene. The time to use bracketing is when you are shooting a static subject and you have the camera in the same position so as not to change the composition. When this is the case, you can shoot multiple photographs at different exposures to ensure you get the result you want.

There are two ways to bracket your shots. The first is to do it manually by changing the exposure compensation or by adjusting the shutter speed or aperture while shooting in Manual mode. The second is a lot easier: the A200 can bracket automatically. This is done by setting the drive mode of the A200 to one of the two automatic bracketing modes.

Cross-Reference *Chapter 2 has more detail on setting the drive mode.*

Note *When photographing a moving subject, using bracketing is not a good idea because the best exposure may not be the one with the best composition.*

3.8 A three-bracket exposure shows slightly underexposed (top), correctly exposed (middle), and overexposed (bottom) images, all automatically adjusted by the camera.

There are times when the metering system of the A200 can be fooled, and you may want more light to reach the sensor than the camera thinks is necessary. These are the times when you should overexpose the scene slightly:

✦ **Large areas of bright sky.** Scenes with large areas of bright sky can cause the rest of the scene to be underexposed.

✦ **Direct sunlight.** When you shoot into the sun, the strength of the light causes other areas of your scene to be underexposed, unless you are trying to create a silhouette.

✦ **Bright light sources in the scene.** Scenes that have a light source in them can cause the scene to be underexposed. This could be a streetlamp in an evening street scene or a very bright reflection on water at the beach.

✦ **Lots of light tones.** Scenes that have large areas of very light tones also need to be overexposed.

A scene shot in snow or on a bright sandy beach tends to be underexposed if left up to the camera.

✦ **Brides.** The bright white of a bride's wedding dress can also throw off the metering. The large white area of the dress can cause the camera to underexpose the rest of the scene, including the bride's face.

Sometimes you may also want to underexpose your photographs to have less light reach the sensor:

✦ **Lots of dark in a scene.** There are times when a large portion of dark area fills the scene — a groom and his wedding party all wearing black tuxedoes, or the dark fruit in figure 3.10, for example.

3.9 Shooting up at the face of this statue presented a problem to the camera's built-in light meter with the very bright direct sunlight behind the statue's head. I needed to overexpose the scene to get the correct exposure of the face.

3.10 These apples at a street-side market in New York needed to be underexposed slightly to make the reds and greens stand out.

✦ **Darker-complexioned subjects.**
Portraits or headshots of dark-skinned people often need to be slightly underexposed.

✦ **Dark foreground with subject in the background.** If the foreground contains a large dark area but the subject is farther back, you should underexpose the scene.

Using the histogram

One of the fundamental ways in which digital photography differs from traditional film photography is the feedback that is available immediately after you take a photograph. One of the best tools in determining

the exposure is the Histogram view. The Histogram view on the A200 displays not only the histogram for the whole scene but the histograms for the Red, Green, and Blue channels as well.

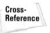 **Cross-Reference** *To read more about accessing the Histogram view, see Chapter 1.*

The histogram is a basic bar graph that shows the amount of pixels that fall into each of the 256 shades, from pure black to pure white. When you look at the histogram, the far left is black and the far right is white. One thing to remember is that there is no right or wrong histogram; it is just a representation of how the camera captured the scene.

Each of the photos has good exposure, even though the histograms for each one are very different. I use the histogram to see if there are any areas of absolute black or white in my image. When I photographed the orchids in figure 3.11, I checked the histogram after every shot to make sure I wasn't overexposing the photograph and ending up with pure white in the image.

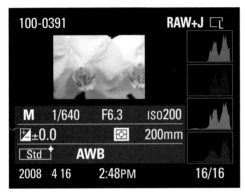

3.11 These orchids are white, but they also have texture and tones in the flowers. Checking the histogram of this image shows that there is more information in the lighter areas of the image, but no part of the image is pure white.

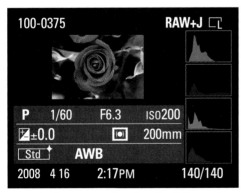

3.12 The histogram showing the information for this photo of a rose shows that the image has more dark areas than light, but none of the data is in the pure black or pure white area.

3.13 The histogram shows that this image has a full range of values from dark to light.

Composition Basics

The biggest difference between a good photograph and a great photograph is often the composition. Composition is what goes into, what is left out of, and the placement of the objects within the photograph. With an understanding of what it takes to get a proper exposure, it is also important to understand what it takes to get a good composition.

The first and most important job of the photographer is to decide what the subject of the photograph is. Without knowing what you want to say with the photograph, composing the scene successfully is impossible. Is your subject the entire landscape or the lone tree on the horizon? When you know what your subject is, you can decide the best way to represent it.

One of the most common mistakes that beginning photographers make is to not look past the subject at the rest of the scene. Check to see if there are other elements in the scene that can distract the viewers from the actual subject of your photograph. Many

3.14 There is no doubt what the subject of this photo is. This cute, furry friend was framed to fill the frame, and the two chairs that were set up to the right of the dog were not included—they didn't add to the subject of the photograph.

of my images were ruined when I was starting out because I didn't notice something in the background that impacted my subject in a negative way. Having a streetlight or tree in the background seemingly sprout from the top of cousin Bob's head changes a good family portrait to a wasted opportunity. While it is possible to use a shallow depth of field to keep the background out of focus, often it is just a better idea to recompose the scene to minimize the background distractions.

One way to keep your subject the center of attention is to decide the best orientation of the image. I always ask myself if the scene will look better in a portrait or landscape orientation. At times, the answer might not be so obvious, and in these situations I take

photos in both. With the large capacity CompactFlash cards, I don't worry about running out of space and would rather take a couple of extra photos to make sure I get the best image.

At times it might be as simple as taking a photograph that you want to display in a certain location. I have a wall in my home where an image taken in the portrait orientation just fits better than one taken in landscape orientation, and I purposely take photographs for this area.

As the photographer, you have control of your image, and as such, you get to choose the viewpoint, shooting distance, and angle which all help to bring your unique view to

3.15 This surfer was shot in Landscape mode to give the viewer a sense of the wave and the action. Had the same image been shot in portrait mode, the feeling of the ride would have been lost.

your images. When shooting children, consider getting down to shoot from their height to get a different perspective on the situation. Always shooting from your height can limit your vision and creativity. Move closer or stand on a ladder, shoot from one knee, or move sideways and change your angle from your subject.

Composition has some basic rules, but think of these more as guidelines. These rules can help you compose pleasing-looking photographs, but sometimes breaking the rules is just fine. Once you know what the rules are, you can break them as often as you want.

3.16 Photographing the new construction, I chose to frame the crane in a portrait orientation giving the image a feeling of height.

The Rule of Thirds

The Rule of Thirds is one of the most common and popular composition rules for photographers. This rule is applicable to all types of photography from portraits to landscapes. It is a very simple rule to follow and can really help improve your photographs.

To follow the rule, imagine lines that divide your image into thirds both horizontally and vertically, just like a tic-tac-toe board. The idea is to place the important elements of your image at one of the four points where these lines intersect. This simple rule can make the difference between a good photograph and a great photograph.

Tip *Place the horizon line in your photograph one-third of the way from the bottom of the frame or one-third of the way from the top of the frame, depending on the subject.*

Placing elements of your photo a third of the way up or down, or a third of the way in from the left or right, creates more interesting compositions, and with a little practice, it's easy to accomplish.

Using the Rule of Thirds helps to produce nicely balanced photos. It is a great starting point when evaluating a scene to find the best composition.

3.17 Placing the sunflower using the Rule of Thirds makes for a more pleasing composition.

Other compositional tips

These tips can help to create stronger images and more pleasing compositions. Consider them guidelines, and while they will usually lead to producing better looking photographs, they can all be ignored if they don't suit your artistic vision.

✦ **Leading lines.** Any line in the scene that can be used to lead the viewer's eye to the main subject results in a stronger composition.

✦ **Diagonals.** Placing the subject on a diagonal line from one of the corners of your photograph helps draw the eye to the subject.

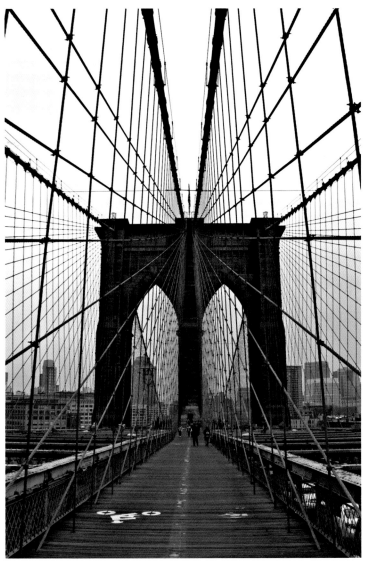

3.18 The cables of the bridge naturally draw the eye to the focal point of the bridge upright.

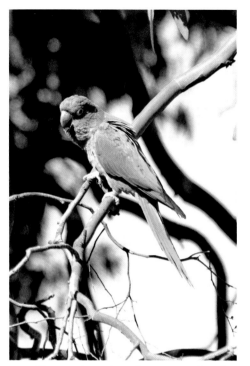

3.19 The tree branch makes a natural path for the viewer's eye to follow to the parrot.

3.20 The tree creates a natural frame for the cross that sits on the grounds of the Junipero Serra Museum, the site where the Spanish first colonized California.

✦ **Look inward.** Subjects should face in toward the center of the frame or toward the camera. This goes for all subjects, but the rule is broken more when it comes to human and animal subjects.

✦ **Human scale.** When shooting very large objects, you can sometimes lose perspective by not including another object in the frame that acts as a point of reference. Including an object whose size is readily identifiable lends scope to the image.

✦ **Frame the image within the image.** Framing one element in a photograph with another can help to emphasize the subject and can create depth in a static scene.

✦ **Contrast.** Lighter objects stand out against a darker background, and darker objects stand out against a lighter background. While this seems very simple, it can be one of the most technically challenging things to do because of the exposure problems discussed earlier in the chapter. A large light object against a dark background works only if the subject is exposed correctly.

✦ **Direction of movement.** With subjects that are moving or that can move, you should leave more space in front of the subject than behind. It is better for the subject to be moving into the frame than out of it.

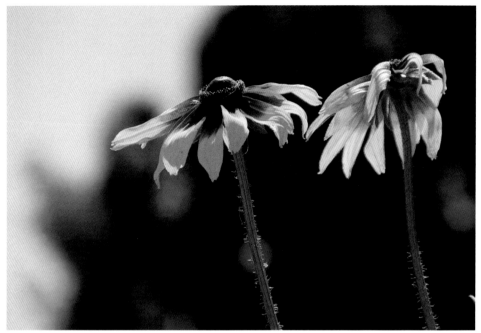

3.21 Using a small f-number to create a shallow depth of field is one way to reduce the background clutter of an image. These flowers were photographed in a busy park, but by using f/6.3 along with a 200mm lens and shooting as close as possible to the flowers, the background is pleasantly out of focus.

✦ **Simplify.** Keeping the image simple helps to make your subject stand out. Try to compose the image with the least amount of clutter in the scene. Ask yourself if there are any elements in the scene that distract from the main subject. If there are, try to recompose the scene in a way that reduces the amount of distractions.

Break the rules

All the previous rules can and should be broken in certain circumstances. Just remember that these rules are more like suggestions, and because the final composition is all about your choices, feel free to do whatever you want to convey your vision. The idea is to start with one of the rules, but if you feel the composition does not work using the rule, it is time to break the rule.

While the Rule of Thirds suggests that the strongest composition occurs if you place the subject of your photograph one-third of the way from the top, bottom, or sides of the photograph, sometimes, placing the main subject in the dead center of the image works better. The subject in the center of the photograph can give the image a punch that it doesn't have when following the rule. This can work well for everything from landscapes to portraits.

3.22 The still water made it possible to get this photograph, and even though there are no leading lines, the subject is centered in the frame, and there is not more space in front of the bird than behind, this image still works for me.

Leaving more space behind a moving subject can show where the subject was instead of where it is going, and at times having the subject look away from the camera can change the tone and mood of the photograph for the better.

Composition is subjective; don't let anyone tell you what is right or wrong. If everybody took photos the same way, the uniqueness and individuality that makes this a great art form would be lost. All I have tried to do is to pass on some of the basics to help give you an understanding of what seems to work in the majority of situations. The more you go out and photograph, the easier it will become to create photographs with strong composition.

 Chapter 6 goes into more depth about composition and exposure for a variety of specific situations.

All About Light

Photographs capture a moment in time by recording the light in a scene. The lenses on the A200 focus the reflected light rays into an image that is then recorded by the sensor. In Chapter 3, I discussed controlling the amount of light that is allowed to reach the sensor to create a proper exposure by adjusting the shutter speed or changing the aperture, but light has qualities that go beyond just illuminating the scene.

Light can set a tone or mood for your photograph, reveal or hide details in your subjects, and if understood and used correctly, improve your photography a great deal.

Light is divided into two types of light in this chapter: available light and supplemental light. Available light can be the sun, a street lamp, or even a candle, but the unifying thing is that it is not a light source placed in the scene by the photographer, it is light existing naturally in the scene.

The second type of light, supplemental, is light that you as a photographer bring to the scene to supplement the available light. This supplemental light can be the small built-in flash on the A200, a bigger dedicated flash unit, or even a set of studio lights.

As a photographer, there are also tools that you can use to modify the light so that it better suits your needs. These light-modifying tools can help diffuse and redirect both available and supplemental light allowing you more control over the light in your scene.

However, before I cover those topics, there are four characteristics of light that need to be covered: intensity, direction, color, and diffusion.

The Intensity of Light

The intensity of light, or how bright the light in your scene is, depends on two factors: the size of the light source and the distance between the light source and the subject. The closer the subject is to the light, the more intense the light will be. Move your subject closer to a light source and the intensity of the light increases; move your subject away from the light and the intensity decreases.

It is very difficult to control the intensity of available light, and especially the intensity of the biggest available light source, the sun. There is no way to move the sun closer or farther away from your subject except for waiting. When it comes to supplemental light, moving the light closer or farther away is a little easier. When the light is attached to the camera, as in the case of the built-in flash, just moving the camera closer or farther away can result in a big change in the intensity of the light. In a studio, you can control the

intensity of multiple lights, giving you a great deal of control over the intensity of the light. In either case, it is up to the photographer to gauge how intense the light is. Is the light from the bright noonday sun, or a single table lamp? When the intensity of the light is high, it is possible to use faster shutter speeds, lower ISOs, and smaller apertures to achieve the best exposure. When the intensity of the light is lower, then you need to slow down the shutter speed, use a wider aperture, or raise the ISO.

The Direction of Light

The direction of the light determines where the shadows fall in your scene. Shadows are important because they create depth in a scene. The direction of the light can also determine what is revealed and what is hidden in a photograph.

Light can hit a subject from any angle, but the five most common are as follows:

4.1 It was easy to see the intensity, direction, and color of the light at this concert.

✦ **Front lighting.** This the most common form of lighting and the least flattering, especially when photographing people. Front lighting is most commonly used because the lens in most consumer point-and-shoot cameras needs as much light as possible to get a good exposure. And while this trend is changing, the years and years of being told to stand in the direct sunlight have taken a toll. This is one trend that should be broken. Front lighting happens when you shoot with the sun or other main light source directly behind you so that the main light strikes the subject straight on. Light striking the subject straight on tends to remove all shadows from your subject, leaving it looking flat and dull, with no character. If the light is hitting your subject straight on, try to adjust your position or the position of the light source to create a more pleasing photo. Everyday examples of front lighting include passport photos and driver's licenses, neither of which is very flattering.

✦ **Backlighting.** Although it can create some of the most dramatic photos, backlighting is one of the trickiest forms of lighting. Metering becomes difficult when the scene is lit with a bright light directly behind the subject, and capturing the details in the lightest and darkest areas is impossible. A good example of backlighting is the classic silhouette, where your subject appears as a black shape against a bright background. Sunsets are a great time to take backlit photos.

✦ **Overhead lighting.** When the only light source is from directly overhead, as can be the case with landscape photography, the subject can have very little character due to the lack of shadows. Most studio shoots will have a dedicated overhead light, but it is used in combination with other light sources to help create pleasing shadows.

✦ **Up lighting.** Up lighting is when the light source is below the subject and is aimed upward, lighting the subject from below. This does

4.2 Front lighting

not happen often with available light but is used often to create harsh shadows particularly associated with horror movie posters.

✦ **Side lighting.** When the light is off to the side and strikes the subject from the side, this creates shadows that emphasize the form and texture of the subject.

The Color of Light

Light has color, and while this doesn't always seem to be obvious to the naked eye, it makes a big difference to the sensor in the camera. Different light sources have different colors, and these colors are described by photographers using color temperature. The Kelvin scale is used to measure the color temperatures of different light sources; the lower the number on the scale the more

orange and red, while the light on the higher end has a distinctly blue color to it.

The color of light can determine the mood and tone of your images. The more red or orange the light in an image, the warmer the image will feel, while the more blue in the light, the cooler the image will feel. For example, the approximate color temperature of the light on an average day at noon is about 5200 Kelvin while the color temperature of the light in shade on the same day is approximately 7500 Kelvin, which gives your image an overall cold cast. When the scene is lit by a light source that is on the lower end of the Kelvin scale, the scene takes on a warm glow; for example, candlelight has an approximate color temperature of 1800 Kelvin.

The color of light is important in one other way: to get correct color representation. The A200 needs to be told what the color of the

4.3 The candles give off a soft warm light.

light in your scene is. This is done by setting the white balance on the camera. When the white balance of the camera is matched to the color of the light, the color in your image is more likely to look natural, but can also change the warm or cool tones of the image.

Cross-Reference *Setting the white balance of your A200 is covered in Chapter 2.*

The Diffusion of Light

Light is diffused when the light rays are scattered as they pass through translucent material or are bounced off a reflective surface. When light is diffused, it is spread out and made softer. Light-modifying tools such as diffusers, umbrellas, and reflectors can be used to diffuse both available light and any supplemental light. When shooting outdoors, the best diffuser is cloud cover, which acts as a natural diffuser by scattering the sun's rays and creating a more even, softer light.

The quality of diffused light is softer and creates softer-edged shadows in your images. This occurs because the diffused light has a different size and intensity compared to the actual light source. For example, consider the sun as your light source; it is very bright and far away. The shadows created when photographing in direct sunlight are hard and very sharp. When shooting in the same sunlight after it is diffused by the clouds, the shadows are softer and the light is more even. This is due to the light source no longer being the small, bright sun, but a larger, more spread out light source. Overcast and cloudy days are great when you want to shoot outdoors. People, buildings, flowers, gardens, all look better when photographed under a diffused light source.

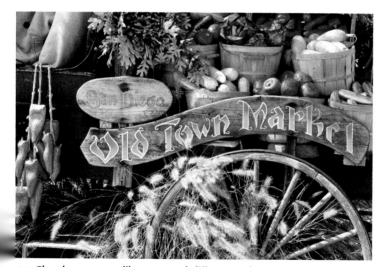

4.4 Cloud cover acts like a natural diffuser and creates even, soft light while a few brighter shafts of light add some highlights to the vegetables in the cart.

Available Light

Any light that occurs in a scene naturally and is not placed there by the photographer is available light. Available light can be sunlight, a candle, a neon sign, even the headlights from a car. As a photographer, you have very little control over the available light. Common types of available light are daylight, electrical light, and mixed light.

Daylight

Daylight is the most common form of available light, and as a photographer it is most likely your most common light source. Daylight is always changing because the Earth is always moving. As the Earth rotates around the sun, the available light changes from moment to moment. Knowing the different types of light at different times of the day can help you plan your photographs, which in turn helps you to produce better images. Each time of day has a different quality of light.

Sunrise and sunset

The light at sunrise and sunset has been called the best light of the day, and I must agree. With the sun lower in the sky, the light produces long, low shadows that create depth in a scene, but more importantly to most photographers is the color of the light at sunrise and sunset. The position of the sun during the sunrise and sunset means that less white light is allowed to pass through the atmosphere, giving the light a more red and yellow hue. This is great light and most photographers find this light highly desirable. You may hear this time of the day referred to as the golden hour or the sweet light.

As the sun rises in the morning, the color temperature rises and the shadows get shorter until midday when the process reverses itself and the color temperature

starts to drop and the shadows stretch out in the opposite direction. Early morning and late afternoon are still really good times to shoot. For example, I shoot most of my flower and macro photography using the natural light in the afternoon.

 Chapter 6 contains more on shooting sunrises and sunsets.

Midday

Midday is not the best time to photograph. The shadows are at their shortest and most scenes end up looking flat and dull. Photographing landscapes and buildings at midday can cause the subjects to lack any type of texture due to the small shadows and direct overhead light.

Photographing people at midday can cause very unflattering images. The harsh overhead light can cause shadows to fall under your subject's noses and eyes. If you are left without a choice and have to use the midday sun to photograph people, consider using a reflector or diffuser to modify the light as much as possible.

Electrical light

The second type of available light is electrical lighting. Electrical lights are everywhere, but the different types of electrical lights produce different colored lights and need to be handled differently. The light produced by a table lamp is very different from the light produced by sodium-vapor streetlights. Dealing with electrical lights can actually be easier than dealing with daylight because, unlike daylight that fluctuates based on a variety of factors, when an electrical light is on, the color and intensity are relatively constant. While there are many different electrical lights, they can be broken down into three basic types: fluorescent, incandescent, and vapor discharge lights.

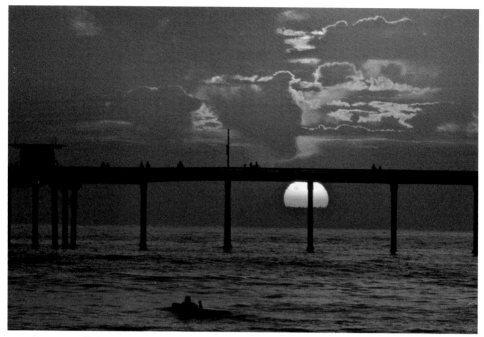

4.5 The sunset light creates a warm overall color.

Fluorescent lights

Fluorescent lights create light by passing an electrical current through a gas in a sealed tube. The electrical current excites chemical phosphors that coat the inside of the tube causing them to emit light. Different chemical phosphors used in making fluorescent lights emit different color light. Manufacturers use a variety of chemical phosphors so that the overall output of the light seems to be white to the human eye. The problem is that the light does not seem white to your camera's sensor. If not corrected, the light from a fluorescent light gives everything a green cast. As with all electrical light, fluorescent light does have slight fluctuations, however it is still more predictable than daylight. Fluorescent lights are becoming more commonplace as businesses and homeowners switch from incandescent bulbs due to the cheaper cost and lower power consumption.

When shooting in fluorescent light, there are two ways to correct for the green colorcast.

✦ **Set the correct white balance.** Make sure that you set the white balance to Fluorescent.

✦ **Shoot in RAW.** Photographing using the RAW file type enables you to adjust the white balance using the supplied Sony software or other photo-editing software.

Incandescent lights

Incandescent lights create light by burning. The first modern incandescent light bulbs worked by using an electrical current to burn a filament without destroying the filament in a bulb in which all the air has been sucked out. Modern light bulbs are filled with an inert gas, such as argon, and the filament is usually made of tungsten. The tungsten

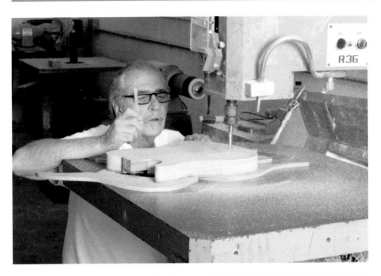

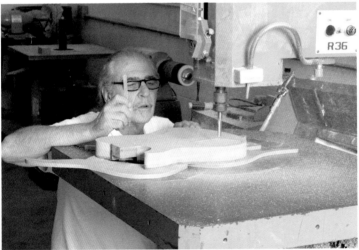

4.6 Fluorescent lights

lamps that are made for photographic purposes have a constant color temperature of 3200 Kelvin, but the majority of incandescent bulbs used in businesses and homes vary greatly in their color temperature and output. These incandescent bulbs usually have a lower color temperature and produce a warmer colorcast than the bulbs made for photography.

To adjust for the red/orange warm colorcast when shooting using incandescent bulbs to light a scene, there are two methods that can be used:

✦ **Set the correct white balance.** Setting the white balance to Tungsten can help to counteract the warm light from incandescent bulbs.

4.7 This indoor shot was lit by the incandescent bulbs lighting the room. Setting the white balance correctly resulted in natural-looking lighting.

✦ **Shoot in RAW.** Using the RAW file type lets you adjust the white balance in post processing using either the supplied Sony software or a third-party, image-editing program such as Adobe Photoshop.

Vapor discharge lights

Vapor discharge lights work the same way as fluorescent lights, by sending an electrical charge through a gas in a sealed tube. There are a variety of gasses used in the manufacture of vapor discharge lights, and each of these gasses produces different colored light. Mercury-vapor, sodium–vapor, and multivapor lights are commonly used today due to their low energy consumption and their high output. The light that is output from vapor discharge lights usually results in a green or blue colorcast. The big problem with shooting in vapor discharge light is that the light produced by the lamps does not have a natural light color because they only emit wavelengths from parts of the visible light spectrum. This means that there is no easy way to set the white balance to overcome any colorcast, and the images recorded under this type of light look unnatural. These type of lights also flicker or pulse as the power to them cycles, which can cause a shift in the color when a photograph is taken.

While you should check the color using the preview on the camera's LCD to see if the image looks close to the way you want, the only good way to deal with this type of lighting is to set a custom white balance or correct using software in post-processing as detailed here:

✦ **Custom white balance.** Setting the custom white balance can fix some of the problems with the unnatural colorcast, but to play it safe, shoot in RAW as well so that it is possible to fine-tune the color in post-processing.

Cross-Reference *Setting the custom white balance is covered in detail in Chapter 2.*

✦ **Software adjustments.** Using an image-editing software package that can adjust each of the colors in your image can help you achieve natural looking colors in your image. This can take some time to get right, so don't be disappointed if it doesn't look right the first time.

Mixed light

Mixed lighting is one of the hardest things to deal with in photography. Mixed light occurs when a scene is lit by two or more light sources that each has a different color temperature, and while the human eye can deal with mixed lighting automatically, the camera sensor cannot. The A200 needs to have a white balance set so that the colors are reproduced correctly. But what happens when there are two light sources each with its own white balance setting in the same scene? You need to decide which of the light sources you want to correct for. For example, if you are shooting an indoor scene, and the subject is lit with daylight coming in through the window, but the rest of the room is lit by incandescent lamps, what would you do?

In situations like this, there are three options:

✦ **Set the white balance for the main subject.** I set the white balance to make the main subject of the image reproduce correctly.

✦ **Set the white balance to Auto and hope for the best.** Setting the white balance to Auto white balance (AWB) allows the camera to try to correctly set the overall white balance so that the entire scene looks normal. This can work well, especially if one light source is stronger than the other. It doesn't hurt to use this setting first just to get an idea of where the problem color areas are.

✦ **Correct the color in post-processing.** Use Adobe Photoshop or other software-editing packages to adjust the individual colors in the image. This process is the most time consuming and difficult of the three options. I recommend trying the first two methods before resorting to color correction in software.

 Note *Always try to get the image in the camera rather than relying on software to fix the problem later.*

Supplemental Light

Supplemental light is any light that the photographer provides to help illuminate the scene. This light can range from the small, built-in flash on the A200 to a full set of studio lights and anything in between. The lights that you bring to the scene let you light the scene in the way you want. This gives you an amazing amount of control over the final image because you can control the intensity, direction, diffusion, and color of the light.

4.8 Place settings at a medical review board photographed using the mixed available light and corrected using software in post processing.

The built-in flash

The built-in flash on the A200 means that you are never without a light source. This is very helpful for shooting when there just isn't enough available light to achieve a proper exposure. The problem with the built-in flash is that the position of the flash causes the light it produces to look unnatural and unflattering. The position of the flash, right above the lens, means that the light hits the subject straight on and washes all detail from the image. The built-in flash also causes hard shadows right behind the subject, which is immediately recognizable as a flash photograph. The small size and limited power of the built-in flash can also produce overexposed foregrounds and underexposed backgrounds.

Photographing people and animals using the built-in flash usually results in a phenomenon called red-eye that can ruin even the best photograph.

There are some positives of having a flash built right into the camera. Because the built-in flash is an integral part of the camera, it is always available and can be used easily by just opening it with a flick of the finger. There is never a worry about leaving it behind or not having the right batteries because it is powered by the camera battery. The built-in flash is easily programmable, and the camera can automatically adjust the flash, depending on the situation.

Red-Eye and Red-Eye Reduction

Red-eye is a phenomenon that has affected every photographer at some time or another and is caused when the light from a flash is reflected off the blood vessels in your subjects' retina causing their eyes to glow red. Red-eye can ruin even the best photo. The closer the flash is to the lens, the more likely there will be red-eye. This is why red-eye is a very common problem in photos taken with point-and-shoot cameras. As the distance between the flash and the lens increases, the chance of red-eye decreases. Red-eye also occurs in pet photography, even though the color of the eyes might not be red.

The red-eye reduction feature tries to negate the red-eye by firing a quick burst from the flash prior to taking the photo. This burst of light causes the subject's iris to contract, making the pupil smaller and allowing less light to reach the retina so less light is reflected back.

The A200 has a Red-Eye Reduction feature built in. To access the Red-Eye Reduction feature, follow these steps:

1. **Turn the camera on.**

2. **Press the Menu button to open the A200 menu screen.**

3. **Use the Multi-selector to navigate to the Custom Menu 1.**

4. **Select Red eye reduc. from the menu screen, and press the Multi-selector center button.**

5. **Choose On from the menu and press the Multi-selector center button to enter your choice.**

The red-eye reduction setting is only available when using the built-in flash.

Dedicated flash units

Using a dedicated flash unit can greatly enhance your flash photography. The dedicated flash units open up vast new possibilities. At this time, Sony sells four dedicated flash units: the HVL-F58AM, the HVL-F56AM, the HVL-F42AM, and the HVL-F36AM, all for the Alpha series of cameras. Any of these flashes are better than the built-in flash.

Three of the best reasons to use an external dedicated flash are as follows:

✦ **The flash can be aimed in a different direction to the lens.** The head of the flash unit can be set from 45 to 90 degrees.

✦ **The dedicated flash can be used in a wireless mode.** The flash can be removed from the camera and in this way can be used to direct light.

✦ **The dedicated flash is more powerful than the built-in flash.** It is also easily controlled by the camera and has its own power, so it doesn't use any of the camera's battery life.

4.9 The Sony HVL-F36AM flash attached to the A200 camera. Dedicated flash units can be set at an angle and don't have to shoot straight on.

Creating professional looking images using flash is easier with an external dedicated flash than with the built-in flash. The next sections discuss four ways to use an external dedicated flash to get better results from your flash photographs.

Diffuse the light from the flash

While it is very difficult to diffuse the light from the built-in flash, it is much easier to do so with the external dedicated flash. Here are two ways to diffuse the light. All of these methods produce superior results to using just the built-in flash:

✦ **Bounce the light.** Bouncing the light from a flash is done by aiming the flash at a nearby wall or ceiling instead of directly at the subject. The light then bounces off the wall or ceiling and the light that reaches your subject is softer and more natural looking. It also reduces the

hard shadow that can appear behind someone when photographed with a direct flash. One warning: The light that is bounced takes the color of the surface it is being bounced off of. For example, if the wall is blue, the light will have a blue cast.

✦ **Add a diffusion dome to the flash.** A diffusion dome is an accessory that fits over the end of the flash unit and diffuses the light that is produced. This great piece of photo gear comes in a variety of sizes and shapes, from the simple Omni-Bounce made by Sto-Fen, which is available for less than $20, to the Gary Fong Lightsphere for more than $50. When the diffusion dome is attached to the flash, angle the flash upward at 45 degrees or more; the results will amaze you.

The same flash that produced harsh light now produces a softer, more flattering light.

Slow down the shutter speed

When you slow down the shutter speed, you use more of the available light in the scene, which helps to stop the background from being too dark and your subjects from looking like they have been caught like a deer in headlights. When you use a slower shutter speed, more light from the entire scene reaches the camera's sensor, and the flash lights the main subject. Set the mode dial to Program mode (P) and compose the scene through the viewfinder. Press the Shutter button halfway down until the camera picks a shutter speed and aperture value. Change the Mode dial to Manual mode (M), set the aperture to the value from the automatic reading, and then set the shutter

4.10 A makeup artist working with a model photographed using a Sony flash with an Omni-Bounce diffusion dome attached makes for a softer more even light.

4.11 Dragging the shutter lets the light from the background be seen while the model is lit with the flash.

speed slower than the one the camera set. For example, if the camera sets the shutter speed to 1/60 second and the aperture to f/6.3, set the shutter speed to 1/15 second and the aperture to f/6.3. This slower shutter speed allows for more of the ambient light to be in the scene, but the flash still freezes any motion in your subject. This technique is also called "dragging the shutter." It is possible to get the same effect by using the Slow Sync setting on the A200. The Slow Sync setting is discussed a little later in this chapter.

Use color gels to match the available light color

Gels are polyester sheets that are a specific color. The name comes from the thin dried sheets of colored gelatin used in the early days of theater lighting. Placing the gel in front of the light source changes the color of the light produced. Matching the light being output from the flash to the color of the ambient light is very important. When shooting inside, other light sources need to be taken into account. When two different types of light are used to light the same scene, problems arise. The camera cannot figure out what the white balance should be. The answer to this is to place a gel in front of the flash so that the color of the light that the flash outputs matches the color of the ambient light in the scene. Lumiquest produces an FX Color Gel pack and holder that you can purchase for less than $30. Yellow gels balance out the light from incandescent lights found in most homes, and green gels balance out fluorescent light.

Remove the flash from the camera

I love the ability to remove the flash from the A200. It is so simple to do that I find myself coming up with reasons why I need to do it. Using the flash off-camera means that the direction of the light and the direction of the camera no longer have to be the same. Setting the flash to be used in a wireless mode is covered in the next section. Just remember that the built-in flash needs to be open to trigger the external flash unit.

Flash sync modes

The A200 has different modes that control how the light from the flash is produced. These modes control either the built-in flash

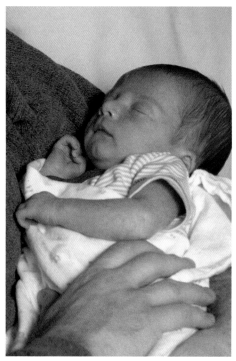

4.12 With the flash removed from the camera, the light was positioned off to my left and shot through an umbrella to create soft lighting on the newborn baby in the hands of his father.

or an external flash unit. Each mode does something different and can be used to create different lighting effects. Changing the flash mode is done by pressing the Function button to display the Quick Navigation menu and then selecting the Flash mode menu.

✦ **Flash off.** In this mode, the flash does not fire even if the built-in flash is open. This choice is not available when shooting in Program Auto mode (P), Shutter Priority mode (S), Aperture Priority mode (A), or Manual mode (M).

✦ **Auto mode.** In this mode, the flash fires when the camera believes the scene needs more light. This is very similar to the way a flash behaves on a point-and-shoot camera. The Auto mode is a good starting point and can be used with the built-in flash and a dedicated flash unit. This mode is not available when shooting in Program Auto mode (P), Shutter Priority mode (S), Aperture Priority mode (A), or Manual mode (M).

✦ **Fill-flash mode.** This mode fires the flash every time the Shutter button is pressed. This adds light from the flash to the existing light no matter how much light already exists in the scene. The Fill-flash mode can be used with the built-in flash and with any dedicated flash unit.

✦ **Slow Sync mode.** When the flash is set to the Slow Sync flash mode, the camera triggers the flash every time the Shutter button is pressed, but exposes the scene for a longer time so that the available light is also used to expose the scene.

✦ **Rear Sync mode.** When the A200 is set to Rear Sync mode, it fires the flash right before the shutter is

about to close at the end of the exposure. In the other modes, the flash fires at the beginning of the exposure, no matter how long that exposure is. When the flash is fired at the beginning of an exposure it causes the subject to be frozen by the flash, and any subsequent movement that is captured by a long shutter release is in front of the subject. This creates unnatural-looking images. In the Rear Sync mode, the flash freezes the action at the end of the exposure. This causes moving images to be captured in a more realistic way.

✦ **Wireless mode.** The A200 has the ability to trigger a Sony external flash unit when it is not attached to the camera. Follow these steps as a guideline:

1. **First attach the flash to the camera and turn both the camera and the flash on.**

2. **Press the Function button on the A200 to open the Quick Navigation screen.**

3. **Select Flash modes with the Multi-selector and press the Multi-selector center button.**

4. **Choose Wireless from the menu choices and press the Multi-selector center button.** The external flash can now be removed from the camera.

5. **Open the built-in flash by pressing the Flash button on the side of the viewfinder.** The external flash will now be triggered by the built-in flash each time the Shutter button is pressed.

4.13 This image of a red-colored water drop caught in midair was taken using the A200 with an external flash in High-speed sync mode using a shutter speed of 1/4000 second.

Cross-Reference *Wireless mode is great for taking portrait shots and is covered more in Chapter 6.*

✦ **High-speed sync mode.** When a Sony dedicated flash unit is used with the A200, it is possible to use the flash when using shutter speeds up to 1/4000 second. This mode is set on the flash and is not available with the built-in flash.

Flash Exposure Compensation

At times, you might want to change the amount of light that the built-in flash or a dedicated flash unit produces when you press the Shutter button. Adjusting the Flash Exposure Compensation can do this. You can increase the amount of light produced by adding up to 2 full stops of light power, or you can reduce the amount of light by 2 full stops.

Changing the Flash Exposure Compensation on the A200 is pretty simple. Just follow these steps:

1. **Turn the camera on.**

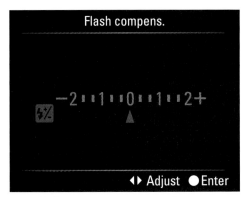
4.14 Flash Exposure Compensation screen

2. **Press the Flash button to open the built-in flash, or attach a dedicated flash and turn it on.**

3. **Press the Menu button to open the Menu screen.**

4. **Use the Multi-selector to navigate to the Flash Compensation menu then press the Multi-selector center button.**

5. **Use the Multi-selector to adjust the flash compensation by up to 2 stops.**

6. **Press the Multi-selector center button to set the flash compensation.**

Studio lights

There are two types of studio lights: strobe lights and continuous lights. For the beginning photographer, continuous studio lights are better because they are much easier to use. Strobe lights require separate triggering systems and separate light meters to get a good photograph.

Continuous studio lights are, by definition, always on, so there is no need to trigger the lights. There is no flash of light that is usually associated with studio lights. Continuous studio lights have made huge leaps forward in technology, and the newer continuous studio lights take advantage of cooler fluorescent bulbs that enable them to be on for longer periods of time without producing too much heat. This lets your models stay cool even while under the lights.

The biggest advantage that continuous studio lights have for photographers is the ability to use the camera's built-in light meter to help get the proper exposure, and because the light is always on, composing the frame becomes a "what you see is what you get" exercise.

4.15 A continuous light setup was used to take this model's photo in the studio. Because the light was on, I was able to position the model and use the built-in metering to get the proper exposure.

The biggest disadvantage to continuous lights is that they are not as powerful as studio strobes and you do not have the ability to freeze things with the flash of a strobe. This means that the subject needs to be still. Lights like the Westcott Spiderlite and Photoflex Starlite both use cool color-balanced lights and are easy to set up and use.

Accessories to Control Light

There are tools that can be used to control and modify light. These tools can be used to control and modify both available light and supplemental light. When the light isn't just right, using a reflector, diffuser, or, on studio lights, an umbrella or softbox can help you get the light you want. The most common light modifiers are reflectors and diffusers.

Reflectors

Reflectors can be used to reflect the light from the main light source onto your subject. Reflectors come in a variety of shapes, sizes, and colors. The bigger the reflector surface, the more light is reflected back at the subject.

The different colors of reflector surfaces all change the color and quality of light.

✦ **Silver.** A silver reflector reflects the most amount of light and doesn't change the color of the light. This is useful in the studio because it

4.16 A silver reflector held by the model under her face bounced the light up and helped to smooth out any harsh shadows.

doesn't change the color of the light produced by your studio lights and there is no reason to worry about a mixed lighting situation.

✦ **Gold.** A gold surface on a reflector reflects a lot of light, but not quite as much as a silver surface. The gold color also adds a warmer tone to the light and looks more like the light at sunrise and sunset. The gold surface when used in the studio can produce a yellow light that looks unnatural especially when combined with the white light of the studio lights. The gold surface reflector is best used outdoors with natural light.

✦ **White.** A white surface reflects less light than a silver or gold surface and produces a soft even light. This works well in both the studio and with natural light, and the white surface doesn't add any color to the light.

Collapsible reflectors are very useful for location work. The reflector material is sown around a sprung steel hoop, which keeps the material taut but still allows for the reflector to be collapsed and stored in a much smaller space. Many reflectors come with multiple covers, including silver, white, and gold, so that the same reflector can be used in multiple situations.

To add more light to the shadow portions of the subject, the reflector needs to be positioned directly opposite the main light source and aimed toward the subject. The biggest challenge in using reflectors is positioning them in the right place and still being

able to take the photograph. If you have an assistant or just a helpful friend around, this isn't much of a problem because he or she can help to hold the reflector at the correct angle. When you are alone, try to find something to lean the reflector against. You can also hold a small reflector and still take the photograph, but this is not easy to do. Some reflectors now come with a handgrip to help keep the reflector steady. If it isn't going to interfere with the composition, you can even have the subject hold the reflector for you.

One great use for a reflector is to minimize shadows under a subject's eyes. When a person is lit from above by natural or artificial light, shadows can form under the eyes, which is not a very pleasing look. Positioning a white or silver/white reflector in front of the subject, aiming up at the face, reflects some of the light back up at the subject and fills in those shadows.

Diffusers

Diffusers are light modifiers that are placed between the light source and the subject so that the light illuminating the subject is diffused. This softer light is more flattering and creates softer, more even shadows.

When photographing outdoors, the diffuser needs to be placed between the sun and the subject. This is difficult to do alone, and when using one outdoors you usually need the help of an assistant or a good light stand. Picture a diffuser as an artificial cloud that you have complete control over. Direct sunlight is not great light for portraits, and if you find yourself shooting in this light, consider using a diffuser to create a softer, more even light.

4.17 A helpful assistant holds a Lastolite trigrip diffuser to help soften the shadows on the model's face.

4.18 A close-up of the model's face showing the smoother shadows and more even light with the help of the diffuser.

When shooting indoors using daylight that is lighting the scene through an open window or door, a white bed sheet makes a great diffuser. Just tape the sheet over the window.

The output from studio lights can be modified using diffusers. Using a softbox or an umbrella in front of the flash head softens the light.

✦ **Softbox.** A softbox is a specialized light diffuser that is connected in front of a studio light. Softboxes come in a variety of sizes and shapes from small squares to very large octagons.

✦ **Umbrellas.** An umbrella used in photography to diffuse the light is very similar to the umbrella that you use to keep the rain off your head. The umbrella is positioned so that the light is aimed directly at the umbrella, and then the umbrella is aimed 180 degrees away from the subject, and the softer, more diffused light is bounced back at the subject.

All About Lenses

The ability to change lenses is what sets the dSLR apart from a point-and-shoot camera. Because the A200 is a dSLR, it uses a mirror and a prism to let the photographer see the scene through the lens in the same way that the sensor sees the scene. This lets you compose the scene so that it is recorded the same way as you see it. Because the light travels through the lens before it reaches the sensor, the lens is very important to the quality of your photos. It is more than likely that the lenses you have for your camera will outlast the camera body, but the good news is that all the lenses that work on your A200 also work on other Sony dSLRs like the A300, A350, and A700. You buy lenses with an eye to the future, which is important because some lenses cost more, sometimes a lot more, than the camera itself. Good lenses — or good glass, as photographers refer to it — can last a lifetime.

Camera lenses are constructed by placing different lenses in a tube. These lenses or lens elements can be adjusted to focus the light rays so that the in-focus image is projected onto the sensor. The higher the quality of these elements, the higher the quality of the final image. This is why lenses are so important to the overall quality of your images.

Sony Lens Basics

Sony currently has 24 lenses and two tele-converters that are produced under the Sony brand. While 24 lenses might not seem like a great many, this lens selection does a good job in covering the full focal ranges from the ultrawide-angle 11mm to the 500mm Reflex super telephoto lens.

The Sony lens range includes four high-end G family lenses, along with four Carl Zeiss lenses.

✦ **G series lenses.** Minolta originally created the G series lens designation. The G stood for gold, making the G lenses the gold standard in lenses. The original G lenses were manufactured to the highest standards and used the best available technology and optics, but instead of having an actual G on the lens, they had a gold ring around the lens barrel. When Sony took over the manufacturing of lenses for the Alpha cameras, the G series of lenses finally got a G engraved right on the lens.

✦ **Carl Zeiss lenses.** The Carl Zeiss Company partnered with Sony in 2006 to produce lenses specifically for the Sony Alpha mount. To date, there are four Zeiss lenses available, and while all these lenses cost more than the A200, they will last a lifetime if cared for. The Zeiss lenses are easily recognized by the blue Zeiss logo on the lens barrel.

5.1 The A200 lens mount showing the lens contacts, lens alignment markings, and the lens release

Compatibility

The versatility of the A200 is in the fact that it uses the Sony Alpha lens mount, the same lens mount as the Minolta A-type bayonet mount. This allows the A200 to not only use all the Sony-branded lenses, but also the older Konica Minolta A-type lenses, including the Maxxum and Dynax lenses.

Maximum aperture and focal length

Every lens has two very important qualities: the maximum aperture, or the maximum aperture range, and focal length or focal length range. These are the two qualities that are used to define the lens, and understanding them is important when choosing which lens to use or which lens to buy.

The SALs (Sony Alpha lenses) are marked on the lens barrel with the maximum aperture and focal lengths in the following format: 3.5-5.6/18-70 or 2.8/50. The number(s) on the left side of the slash show the maximum aperture value(s), and the numbers to the right show the focal length(s).

> **Tip** *Other lens manufacturers mark their lenses differently, so it pays to remember that focal lengths are measured in millimeters (mm), and the aperture can be shown as a ratio such as 1:2.8 or 1:5.6.*

The two most important qualities of every lens are as follows:

✦ **Maximum aperture.** The maximum aperture, or the maximum aperture range of a particular lens, describes the widest opening possible for that lens: The smaller the number, the bigger the opening, and the greater the amount of light that is let through to the lens. If the lens has a range of focal lengths, it can also have a range of maximum apertures. It is important to know

that the maximum aperture can change depending on what focal length is used. For example, the 18-70mm that comes with the A200 has a maximum aperture of f/3.5 when at 18mm but only f/5.6 at 70mm.

✦ **Focal length.** The focal point of a lens is the point where the rays of light that are passing through a convex lens all converge. The focal length of a lens is measured by the distance from the optical center of the lens to its focal point, which is located on the sensor (when the lens is focused to infinity) and is described in millimeters (mm). The focal length is important because it determines the angle of view of a lens. The greater the focal length, the narrower the angle of view and the less of the area in front of the camera that will be in the scene. This means that things that are far away, or seem to be taking up very little area in front of the camera, seem to be closer when viewed through a lens with a long focal length. In practical terms, the bigger the number, the closer things appear. To photograph items that are far away, it takes a longer focal length, while getting a wide view requires a shorter focal length.

Expanding your lens options

Just because you bought a Sony A200, it does not mean that you are tied to the Sony branded or older Konica Minolta lenses. There are numerous third-party lens manufacturers that build quality lenses that use the Sony Alpha mount or the Minolta A-type lens mount. Tamron and Sigma are two of

5.2 This sequence of photos shows the different focal lengths. The first photo was taken at 18mm, the second at 50mm, the third at 100mm, and the fourth at 200mm.

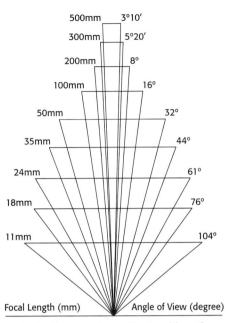

5.3 This diagram shows the focal lengths and the equivalent angle of view for an A200.

the biggest third-party lens manufacturers, and they both carry a wide variety of lenses that are compatible with the A200.

✦ **Tamron lenses.** Tamron produces a wide variety of lenses for digital photography. The A200 can use both the Di and Di II lenses, but it is important to remember that because Tamron produces lenses for a variety of cameras, when you look at purchasing a lens, make sure that it is available with a Sony mount. Lenses from Tamron include a 70-200mm f/2.8 zoom lens, an 11-18mm f/4.5-5.6 ultra-wide-angle lens, and a 17-50mm f/2.8 standard zoom lens.

✦ **Sigma lenses.** Sigma Corporation of America offers a wide variety of lenses and other camera equipment including flashes and cameras. The only products that are

compatible with the Sony A200 are the lenses that are specifically noted to work with the Sony mount. Lenses for the Sony include a 10-20mm f/4-5.6 super wide-angle zoom, a 70mm f/2.8 Macro, and a 50-500mm f/4-6.3 super telephoto lens.

Tip *Another lens available for the Sony Alpha mount is the Lensbaby, which has become very popular for those exploring the world of selective focus photography. This specialized lens lets the photographer keep one area of the image in sharp focus while the rest of the image becomes increasingly blurry. The Lensbaby allows for the area that is in sharp focus to be moved to any part of the photograph by simply bending the lens.*

Understanding the Lens Crop Factor

Much has been written about the size of camera sensors and the effect they have on photography. The A200 uses an APS-sized sensor that is smaller than a 35mm frame of film or a full-frame sensor. This smaller sensor causes lenses to appear to produce an image that is magnified when compared to the image produced by the same lens on a full-frame sensor. What is actually happening is that the smaller APS sensor is only capturing part of the information that a full-frame sensor does.

Some photographers like to know what the equivalent focal length would be on a 35mm full frame sensor, and this is relatively easy to do. The actual math used to calculate the equivalent focal length is to divide the diagonal of a 35mm frame by the

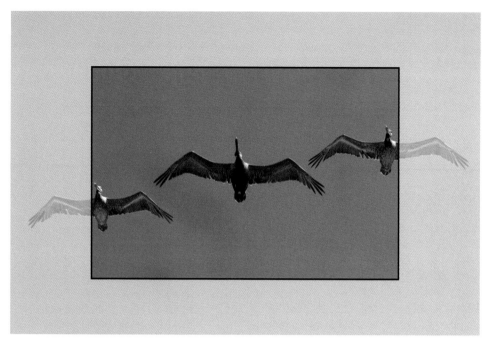

5.4 The outside edge is what you'd see with a 35mm film camera. The inside portion is what you see with the A200. As you can see, the image of the birds recorded on the A200's sensor is smaller than the same image recorded on a full-frame sensor, causing the birds to appear closer.

diagonal of the A200's sensor and then multiply the result by the focal length of the lens. Because the sensor diagonal is 1.5 times smaller than the diagonal of the 35mm frame, the quick way is to increase the focal length by half. For example, a 200mm lens now gives the angle of view to that of a 300mm lens (half of 200 is 100 and 200+100=300), and a 50mm has the equivalent angle of view of a 75mm lens (half of 50 is 25 and 50+25=75).

There is an advantage on the telephoto end of things, because your lenses on the A200 now get you closer to the action than they would if mounted on a 35mm or full-frame digital sensor camera. The downside occurs when using wide-angle lenses. Because they no longer cover all the area that they

would on a full-frame sensor, a 20mm lens functions as a 30mm lens, and that expensive 16mm now functions as a 24mm lens. To get the same wide-angle view that a 16mm lens offers on a full-frame sensor, a photographer using an A200 needs to use an 11mm lens.

Sony Lenses

The A200 is sold either with the 18-70mm zoom lens or with the 18-70mm zoom lens and the 75-300mm zoom lens. Either of these Sony kits is a good place to start. While neither of theses lenses is top-of-the-line Sony glass, they are good starter lenses and together cover the focal range from 18-300mm.

Choosing Between Prime and Zoom Lenses

Lenses come in two types: prime lenses and zoom lenses. Prime lenses have only one focal length, and are sometimes called fixed-focal-length lenses. The two names are interchangeable. Prime lenses are easier to make because they have to be sharp only at one focal length, making the optics a whole lot simpler than their zoom lens counterparts.

Zoom lenses cover a range of focal lengths, giving the photographer more options than a single focal length. There was a time when having a zoom lens meant sacrificing quality for convenience because they had a reputation for not being as sharp as fixed-focal-length lenses, resulting in poorer image quality. They

were also heavier and more expensive than prime lenses. This is not as true today. With modern manufacturing and lens design, zoom lenses as sharp as some fixed-focal-length lenses are now being produced. Modern zoom lenses are smaller, lighter, and sharper than ever. The Sony line of lenses has 12 prime lenses and 12 zoom lenses.

Prime lenses

Prime lenses have one serious advantage over zoom lenses: They are faster than zoom lenses. Due to the way that lenses are manufactured, prime lenses can have a greater maximum aperture than zoom lenses, making them much faster than most zoom lenses. Because modern zoom lenses are so much better and affordable than they used to be, many photographers don't use prime lenses much anymore. This is a real shame.

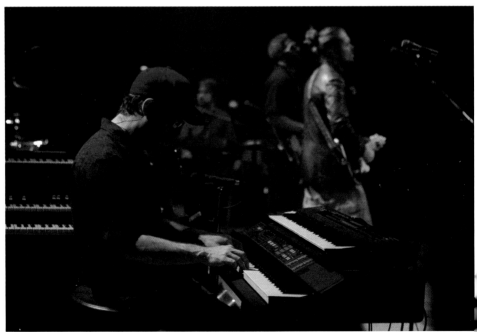

5.5 A 50mm prime lens with a maximum aperture of f/1.4 was used to capture this photo, which was taken indoors with available light. The f/1.4 maximum aperture on the 50mm lens allowed me to keep the keyboardist's hands in sharp focus while the band behind him is pleasantly blurred.

There was a time when the lens that would come with the camera was a prime lens, usually a 50mm lens that offered a normal view. Prime lenses are great tools and should not be dismissed quickly simply because they do not offer a range. One of my favorite "walk-around" lenses is the 28mm f/2.8. This prime lens is the smallest and lightest lens that Sony offers, yet it has an f/2.8 maximum aperture for great low-light shooting and amazing control over depth of field.

Zoom lenses

Zoom lenses used to be heavy, slow, and expensive, but that's all changed. Modern manufacturing and technology have made it possible to create zoom lenses that are lighter, faster, and better than ever. As a photographer, getting a lens with a wide range of focal lengths for approximately the same price as a single focal-length lens seems like an obvious choice.

It is much more economical to purchase a single lens that can do the job of multiple lenses. The ability to cover a wide range of focal lengths makes zoom lenses very useful for today's photographers. Instead of having to carry three or four lenses, stopping to switch every time you want a different focal length, the single zoom could be your answer. A lens like the 18-250mm f/3.5-6.3 covers focal lengths from 18mm all the way to 250mm. This makes the lens a wide-angle lens, a normal lens, and a telephoto all at the same time, depending on what focal length is used.

One downside is that most zooms have a range of maximum apertures, and none of them is as fast as a good prime lens. Other than the 70-200mm G series lens and the 24-70mm Zeiss lens, both of which have a constant maximum aperture of f/2.8, all the other Sony-branded zoom lenses have a wide range of maximum apertures. This can

5.6 This ability to get a wider-angle view and a close-up view with a zoom lens really works well showing how high the tree trimmer really was. The first image was taken at the 18mm focal length while the second was taken with the same lens at the 200mm focal length.

be a problem especially in low-light situations or when you want a shallow depth of field. Even the two zoom lenses with a constant aperture are still slower than the fastest prime lenses.

Wide-Angle Lenses

Wide-angle lenses cover an angle of view greater than 60 degrees, capturing scenes that are wider than normal. The wide-angle focal lengths also have the ability to expand the space between objects that are in the foreground and those in the background, making the whole scene seem bigger.

5.7 The 12mm focal length on this landscape creates a feeling of depth as the meadow stretches out toward the hills.

However, wide-angle lenses can cause perspective distortion. The closer to the camera an object is, the larger it appears in comparison to the rest of the scene. This is important to keep in mind if shooting people.

Wide-angle lenses from Sony include the following:

✦ **11-18mm f/4.5-5.6.** This super wide-angle lens was designed specifically for the APC sensor in the A200 and offers an amazing 104-degree angle of view. This is the widest lens that Sony makes.

✦ **16mm f/2.8 fisheye.** This lens has an angle of view of 110 degrees on a Sony A200 and can focus as close as 8 inches. A unique feature of this lens is the four built-in filters; Normal, 056 for improving contrast in black-and-white images, B12 for removing the red tones, and A12 for removing the blue tones. The filters can be selected by simply rotating a dial on the lens.

✦ **16-80mm f/3.5-4.5.** This Carl Zeiss lens was built specifically for Sony. This compact zoom was designed specifically for the APS sided sensor found in the A200. This lens has an auto clutch that stops the manual focus ring from rotating when in autofocus mode.

✦ **16-105mm f/3.5-5.6.** This compact zoom has an internal focusing system that moves elements inside the lens when focusing so that the length of the lens doesn't change. This is a great lens for portrait work as it can be used to capture a whole group or a single subject.

✦ **18-70mm f/3.5-5.6.** This wide-angle to mid-telephoto zoom lens is designed for the APS sensor in the A200. This lens uses Extra-low Dispersion glass to reduce chromatic aberrations. It comes standard with all A200 cameras and makes a good starter lens.

✦ **20mm f/2.8.** A wide-angle lens with excellent low-light capabilities. This lens utilizes a rear-focusing system that moves the rear lens elements when focusing, increasing focusing speed.

✦ **28mm f/2.8.** A medium wide-angle lens with great low-light capabilities. This is the smallest and lightest lens that Sony manufactures, and it spends a large amount of time mounted on my A200. This lens has a unique built-in sliding lens hood, which means fewer parts to worry about.

Normal Lenses

A normal lens is any lens where the angle of view is about 50 degrees. This used to be the 50mm lens when on a 35mm camera. With the lens crop factor, this is now closer to the 35mm lens, which is equivalent to a 52.5mm lens when used on the A200. Eight lenses in the Sony family have focal lengths of 35mm. Seven of the lenses are zoom lenses and one is a prime lens.

The normal lens is called that because the view through a normal lens is approximately the same as the view through your eyes. When a scene is shot using a normal focal length, everything in the photo seems to be in correct perspective. This is a great lens for portraits and group shots because the view is very familiar and can add a real sense of intimacy.

5.8 Using the 35mm focal length to photograph these two dogs on the landing gives a normal perspective, as if the viewer were standing at the bottom of the stairs.

Lenses from Sony that fall into the normal range include the following:

✦ **35mm f/1.4 G.** This is a super-fast lens with a maximum aperture of f/1.4. This is one of three lenses made by Sony that have a maximum aperture of f/1.4, the fastest that Sony makes. The 35mm has the equivalent focal length of 52.5mm when the lens crop factor is taken into account. This makes it the standard in normal lenses. Combined with the Super SteadyShot technology, this lens can be used in very low light.

✦ **50mm f/1.4.** This super-fast, bright prime lens works well for both candid scenes and portraits, even in very low light. This is one of the three fastest lenses made by Sony, and its low-light ability is fantastic. If you spend a lot of time shooting indoors or in low light, then this is the lens for you.

✦ **24-70mm f/2.8.** Released in 2008, this Carl Zeiss lens not only covers the normal focal ranges, but with a constant f/2.8 it is faster than any other normal zoom lens. This lens is equipped with an SSM (Super Sonic wave Motor) that increases focusing speed. With the Carl Zeiss T* coating that helps to cut down on lens flare, this is one seriously nice piece of glass.

✦ **24-105mm f/3.5-4.5.** A standard zoom lens covering the normal lens focal range. This lens features the auto-clutch feature, which stops the focusing ring from moving when the lens autofocuses.

Telephoto Lenses

Telephoto lenses get you closer to the subject. The longer the telephoto, the closer you can get. This is especially important when there is no other way to get closer. Trying to get a photo of a lion at the zoo, it isn't possible to just walk up closer, so a longer lens is needed. Using telephoto lenses is an absolute necessity when shooting sports, concerts, and wildlife because there is no way to physically get any closer to use normal lenses.

While most people think of telephoto lenses as a way to get closer, there are some other advantages to using a long lens. Long focal

5.9 Telephoto lenses let you photograph subjects that you might not be able to get close to. Without a 300mm lens, there would have been no way to fill the frame with this tiger.

lengths combined with a shallow aperture can be used to isolate a subject from the background. Using a 200mm lens and an f/2.8 aperture makes the background pleasantly out of focus, which makes the subject of your photo stand out.

Because the focal lengths of these lenses are longer than normal, the shutter speed needs to be increased to reduce camera shake. Remember the rule that the shutter speed needs to be at least 1/focal length used. For a 200mm lens, a 1/200 second shutter speed is needed, or turn on Super SteadyShot.

Other than the camera shake and shutter speed problems, a form of distortion also occurs when using a long focal length.

Because subjects are far away, distance among elements of your shot can seem to be compressed. When I was first learning photography, I was shown a photograph of a leopard lying on a tree branch with the setting sun right behind it. It was a stunning shot, with the sun so big, bright, and close to the cat. It turns out that the sun was a long way away, but because the shot was taken with a very long telephoto lens, the two items seemed to be right on top of each other.

Sony makes a wide variety of telephoto lenses. Some of the following lenses fall into more than one category of lens and could be considered both a wide-angle and a normal lens.

5.10 The 200mm telephoto lens used to shoot this photograph under a pier makes the pylons appear to be right next to each other. As you can see, the same pier shot with an 18mm lens shows the distance between the pylons.

✦ **85mm f/1.4.** A Carl Zeiss Planar T* lens that is one of the fastest lenses Sony makes. The f/1.4 maximum aperture makes this lens fantastic for any light conditions and a great choice for portraits. This lens is also equipped with a Focus Hold button, and in Autofocus mode, the focusing ring will not turn.

✦ **135mm f/1.8.** A Carl Zeiss lens that is only marginally slower than the 85mm f/1.4 but can actually focus closer than the 85mm f/1.4. This lens is great in any light and with its internal focusing system, it can focus quickly enough to catch the action.

✦ **135mm f/2.8.** This is a very specialized lens in the Sony lineup. It is the only lens to incorporate Smooth Transition Focus. The STF lets the subject of your photo stay in sharp focus, while the out-of-focus backgrounds and foregrounds are blurred smoothly and more importantly with a gradation that thickens toward the edge of the image. This smooth blurring of the out of focus areas makes the subject stand out more vividly and is mainly used for portraiture. This lens is rated at f/2.8, but because it incorporates a special element that distributes the light in the lens, the transitive brightness can be set from 4.5 to 6.7. A special manual aperture ring controls this transitive brightness. This lens is a manual focusing lens, and has an extra-wide focusing ring.

✦ **300mm f/2.8 G.** This is the fastest long lens that Sony makes. While there are other lenses that reach the 300mm focal length, none of them has a maximum aperture of f/2.8. That makes this lens the

most expensive lens Sony offers. This is the lens for serious wildlife or sports shooters. It has a built-in Super Sonic wave Motor to speed up focusing, and the ability to work well in low light, this lens is also one of the few that can be used with the Sony tele-converters.

✦ **500mm f/8 Relfex.** This is the only autofocus reflex lens on the market for any camera. Reflex lenses are made by using curved mirrors in place of some of the elements in the lens, creating a physically small lens with a large focal length. The reflex design creates a super-long telephoto lens, but because the maximum aperture is f/8, this is one slow lens and needs to be used in bright light. The f/8 aperture is fixed, and the exposure for this lens is controlled by changing the shutter speed and by adding a neutral density filter.

✦ **18-200mm f/3.5-6.3.** This compact zoom lens can be considered a wide-angle, normal, and telephoto lens. It covers a wide range of focal lengths, and because the focusing is done internally, it doesn't change length when focusing, but it does when zooming.

✦ **18-250mm f/3.5-6.3.** This lens builds on the 18-200mm by increasing the focal length range to 250mm on the telephoto end. Combine the huge focal length range with internal focusing and ED (Extra-low Dispersion) glass, and this makes a great multipurpose lens.

✦ **55-200mm f/4-5.6.** A great starter lens. This lens covers the normal to telephoto focal ranges, and being designed for the APS sensor in the A200 lets this lens be as compact

as possible. This lens also lets you get close, with a minimum focusing distance of 3 feet.

✦ **70-200mm f/2.8 G.** This G series lens is standard for concert shooting with its low light capabilities and Super Sonic wave Motor (SSM) for faster focusing. This lens is also great for sporting events and wildlife photography. This lens can also be used with the Sony teleconverters, extending its range up to 140-400mm.

✦ **70-300mm f/4.5-5.6 G.** This lens was released in 2008 and comes with the Super Sonic wave Motor (SSM) for fast autofocus capabilities, ED glass, Focus Hold button, and a minimum focusing distance of 4 feet.

✦ **75-300mm f/4.5-5.6.** This compact, lightweight zoom lens offers 4x zoom shooting. This is the perfect starter lens for someone interested in shooting outdoor sporting events and wildlife.

Macro Lenses

Macro lenses are specialty lenses that let you create extreme close-ups of your subject. There are two Sony-branded macro lenses: the 50mm f/2.8 and the 100mm f/2.8. Both macro lenses offer 1:1 magnification and f/2.8 maximum aperture. Because of the 1:1 rating, the image on the sensor is the same size as the object being photographed. These lenses demand a premium price for their close focusing ability and 1:1 magnification.

5.11 Flowers make great macro subjects. This rose was shot with a 100mm macro lens.

 For more information about macro photography, see Chapter 6.

When using Macro lenses, the depth of field is severely limited due to the distance between the lens and subject. The greater the magnification, the shallower the depth of field. When shooting macro photographs, it is not unusual to be shooting from merely inches away. To counteract this, it is not unheard of to use an aperture of f/32.

Sony offers two macro lenses — a 50mm and a 100mm.

✦ **50mm f/2.8 Macro.** The 50mm macro lens has a true 1:1 magnification. This lens lets you get in close with a minimum focusing distance of 7.8 inches. The 50mm macro also has a Focus Hold button that can lock autofocusing and a Focus Range Limiter than can speed up autofocusing by limiting the range of distances that are focused on. The limiting range can be set to Close-up Range or Telephoto Range. This lens has a fast f/2.8 maximum aperture and it makes a great normal prime lens.

✦ **100mm f/2.8 Macro.** The 100mm lens has a true 1:1 magnification. This lens lets you get macro shots without having to get as close as you would with the 50mm macro lens. The 100mm macro utilizes the same Focus Hold button, Focus Range Limiter, and auto clutch as the 50mm macro. Due to the fast f/2.8 maximum aperture, this lens makes for a great telephoto lens that can be used in pretty low light with great results.

With two choices for macro lenses, it is important to weigh the pros and cons of the focal length difference. The longer focal length on the 100mm macro lens let you work farther away and still achieve a true 1:1 representation. This is important if your subject is hard to get close to, like an insect or animal. If you have subjects that can be approached and let you get as close as you want — flowers, plants, and inanimate objects, for example — then the 50mm macro will suffice.

Tele-Converters

Tele-converters are specialized lenses that are mounted between the camera and a regular lens that increase the focal length of the lens while reducing the maximum aperture of the lens. Tele-converters used to be very popular before zoom lens manufacturing started to produce affordable compact zoom lenses that matched the quality of the prime lenses. Sony understands this, and the tele-converters fit only lenses that have a fast maximum aperture to begin with.

✦ **20TC.** This tele-converter doubles the focal length and reduces by 2 f-stops any of the lenses it is attached to. The 20TC only works with the three following lenses from Sony:

 • **300mm f/2.8 with the 20TC.** The 20TC turns the 300mm f/2.8 lens into a 600mm f/5.6.

 • **70-200mm f/2.8 with the 20TC.** The 20TC turns this lens into a 140-400mm f/5.6.

 • **135mm f/2.8 (STF Lens) with the 20TC.** The 20TC turns this lens into a 270mm f/5.6 lens.

✦ **14TC.** This tele-converter extends the range of the lens it's attached to by 1.4 and reduces the f-stop by 1 stop. The 14TC only works with the three following lenses from Sony:

- **300mm f/2.8 with the 14TC.** The 14TC turns the 300mm f/2.8 lens into a 420mm f/4.

- **70-200mm f/2.8 with the 14TC.** The 14TC turns this lens into a 100-280mm f/4.

- **135mm f/2.8 (STF Lens) with the 14TC.** The 14TC turns this lens into a 190mm f/4 lens.

If you have the opportunity to shoot with a tele-converter, it is important to either stabilize the lens with a tripod or use a shutter speed faster than the new focal length of the lens. Note that when you use a tele-converter, your images may not be as sharp as those shot without the converter.

Reducing Vibration

Vibration-reduction technology lets you take photos at slower shutter speeds than normally possible while handholding the camera. There have been two approaches to vibration reduction in the camera world. One has been to build vibration reduction into the lenses, and the other has been to build the vibration reduction into the camera body itself. Sony has gone with the second method, and in the A200 the vibration reduction technology is called Super SteadyShot.

When Super SteadyShot is turned on, the sensor moves in response to camera shake, letting the photographer use slower shutter speeds without any camera blur. The advantage to the Sony system is that the Super SteadyShot can be used with all lenses; there is no need to buy special vibration-reduction lenses.

Although the Super SteadyShot technology is great, it won't help in all situations. If the subject is moving, the slower shutter speed does not freeze the action. The main point is to avoid blur when holding the camera. I absolutely love this technology, and I am amazed at how it can save a photo opportunity no matter which lens is on the camera.

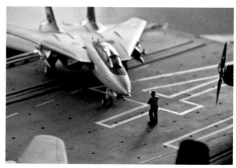

5.12 Shooting the model airplane at ISO 100, f/6.3, and 1/8 second produced a slightly blurry image. When I turned the Super SteadyShot on, the image sharpened dramatically with the exact same settings.

Photo Subjects

There are a great many photographic subjects out there for you to shoot. These photographic opportunities can range from those you know well to those you have never attempted. This chapter helps with those subjects that you are not familiar with and adds a few tips to those subjects you know well. Each subject includes a selection of example photos along with the shooting data. You are also given ideas to inspire you, along with a practice image with notes on how the image was taken, the type of lighting used, lens and exposure settings, and any accessories that were used. There is also a tip section at the end of each subject to help you get the photo right the first time.

All the images in this chapter were shot in RAW mode unless otherwise mentioned. This frees me up to shoot more and worry about the light later. On the subject of inspiration: I look at a lot of photographs, both in magazines and books, as well as on the Internet. I look to see what other photographers are doing and what images are being produced, and, more importantly, I try to figure out how they were done. There are many fantastic photographers out there, and many of them have books or Web sites where you can see their images. I read many publications including travel, photography, fashion, wedding, food, and sports magazines. These magazines and Web sites show what photographers are doing in the real world and inspire me more than any other single thing.

Abstract Photography

Photography captures the word in a realistic way: When you take a photograph of a tree, it looks just like a tree. At times, however, the purpose for creating an image is not to represent reality but to create an abstract piece of artwork. No one can tell you what is right or wrong in an abstract image, but using the basics of good composition, design elements, and selective focus all help to create a good abstract image.

 Composition basics are covered in Chapter 3.

Inspiration

The great part of abstract photography is that there are no limits, and any item, big or small, can be used. The tiny soap bubble used in figure 6.1 works just as well as the giant stairwell in figure 6.2 — both make excellent abstract photography subjects.

Look for opportunities to take abstract images in your everyday life. The mundane can become the extraordinary when examined in a new way. Glass, water, metal, and even plastic can all reflect reality and create interesting images.

6.1 This image, while it looks like it was taken on a different planet, is in reality light patterns on a soap bubble taken with a macro lens and cropped on the computer. This image is all about the color. Shot at ISO 200, 100mm, f/8, 1/250 second.

6.2 The curving stairwell design makes an interesting abstract image, as the repeating curves make for a strong composition. Shot at ISO 200, 22mm, f/5.6, 1/30 second.

Nadra Farina Hess

.3 The stern of a sailboat reflected in the rippled water of the marina becomes an image about shape and color. Shot at ISO 100, 180mm, f/5.6, 1/250 second.

Abstract photography practice

6.4 The light in a hotel conference room shot from below

Table 6.1
Taking Abstract Photographs

Setup	**Practice Picture:** I was photographing a conference at a big hotel when I looked up and saw this beautifully layered light on the ceiling, shown in figure 6.4. I stood directly below the light fixture and zoomed in until it filled the frame. The light fixture doesn't appear to be a light fixture, but instead is a geometric design that stands alone.
	On Your Own: Look at the world around you; you never know when you might see something that will make a great abstract image.
Lighting	**Practice Picture:** The light fixture was on, producing light, but because the photo was taken during the day, there was also light coming in from a nearby window. This created an image with a very flat, even light, with no direction to it.
	On Your Own: Light can be part of the image and the play of light can create interesting shapes and textures, all great for abstract images.

Lens	**Practice Picture:** This was taken with an 18-200mm lens in the 80mm focal length. I was able to fill the frame with the image by zooming in until the light filled the whole frame.
	On Your Own: Any lens can be used to take abstract images. Macro lenses let you get very close to your subject and can be used to make great abstract images, like the macro of the soap bubble in figure 6.1. If you don't have a macro lens, you can always use a zoom lens to get as close as possible, and if necessary, the image can then be cropped on a computer.
Camera Settings	**Practice Picture:** This image was shot in Auto mode, and I let the camera do the work. When I reviewed the image on the camera LCD, it looked great the first time.
	On Your Own: Every image situation is different, but the ability of the A200 to get great images in the Auto mode without a lot of fussing by the photographer is a great place to start. If the Auto mode isn't giving you the desired result, then decide what needs to be adjusted and switch modes. If the image is blurry, set the camera to Shutter Priority mode and set a higher shutter speed. If you want to change the depth of field, set the camera to Aperture mode and pick an aperture that gives you the desired effect.
Exposure	**Practice Picture:** ISO 200, 80mm, f/8, 1/200 second
	On Your Own: Abstract photography is one area of photography where anything goes. If you want the image to have some blur, turn off the Super SteadyShot and use a longer shutter speed. If you want the image to be darker or lighter than the proper exposure determined by the camera, then use exposure compensation.
Accessories	For close-up work I recommend a tripod and a cable release, but abstract photography can be done without any extra gear.

Abstract photography tips

✦ **Change your perspective.** The most important thing to remember when taking abstract photographs is to try anything. Turn the camera from landscape to portrait orientation and take the photo again. Get down on your knees and look to see if the change in height changes the photograph.

✦ **Use computer software.** Manipulating an image in the computer can produce great abstract images from otherwise ordinary photos.

✦ **Use manual focus.** At times, taking a photograph that is purposely out of focus can produce a great abstract image. Despite the great autofocus capabilities of the A200, sometimes switching to manual focus is a good idea to make sure the final image matches your artistic vision.

✦ **Look for reflections.** Images reflected in glass and water can distort the true image and produce a great abstract design. Look at the reflections of everyday images in puddles, pools, windows, and other reflective surfaces.

Architectural Photography

We are surrounded by architecture, yet many people don't pay much attention to it. The style of the buildings can help to define a region and can make great photographic subjects. In fact, architecture is one of the first things I notice when I travel. The great part about photographing buildings is that they don't move. You can take your time with getting the composition you want without having to worry that your "model" will change positions. It is possible to move around and check out the different compositions from different angles.

When you look at and photograph buildings, you tend to aim the camera upward when shooting tall buildings. This is usually the only way to get the whole building into a single image, but it can also cause problems. Shooting this way will cause a phenomenon in which the building will appear to be tilting backward. This distortion is known as converging verticals, or keystoning. There are only two ways to fix this type of distortion: Move farther back from the building so that the angle you are shooting at is even with the horizon, or use software to correct for the distortion in post-processing.

6.5 The unique architecture of this building located in Youghal, Ireland, shows a combination of form and function. Shot at ISO 200, 30mm, f/5.6, 1/250 second.

6.6 This skyscraper in New York City seems to be tilting backward as it towers overhead. Shot at ISO 100, 18mm, f/8, 1/125 second.

Inspiration

A great deal of time and energy is spent to produce good-looking buildings and other structures. Look to see what draws your ey

to certain aspects of a building or structure, not only in the overall look but also in the details that have been added to improve the appearance.

Improving your architectural photography will also improve your travel and vacation images. Nothing says travel more than the differences in architecture between different cultures and geographic areas.

6.7 Details on the exterior of the Great North Door of the Collegiate Church of St Peter, Westminster, showing a sculpture of the Virgin and Child. Shot at ISO 400, 200mm, f/6.3, 1/200 second.

Architectural photography practice

6.8 The architecture of Balboa Park

Table 6.2
Taking Architectural Photographs

Setup	**Practice Picture:** Balboa Park was created back in 1868 but was only named Balboa Park, after the explorer Vasco Nunez de Balboa, in 1910. In 1915, the Panama–California Exposition to commemorate the opening of the Panama Canal was held in Balboa Park. Many of the buildings that stand today were created for this event, including the Prado pedestrian walkway, which was built in the Spanish–Renaissance style. I photographed the image in figure 6.8 in the early evening using a tripod from the far side of the lily pond to get the reflection of the buildings in the water. **On Your Own:** There is no need to travel far to get interesting architectural photographs. Look to the history of where you live and try to capture the unique style of your area. Try to find the best angle to show off the features of the building you are photographing.
Lighting	**Practice Picture:** The late afternoon sun cast a golden glow on the sides of the building, accenting the lights strung up in the walkway. **On Your Own:** While buildings don't move during the day, the sun does, and the light changes from minute to minute. Look to see how the building's look changes as the light moves across it. It is usually best to photograph buildings in the early morning and late afternoon when the light hits the architecture at a low angle, producing pleasing shadow detail.
Lens	**Practice Picture:** I used the 18-200mm lens for this photo. Because I was restricted in my location due to a large lily pond, I needed a lens that would be able to zoom in on the building. **On Your Own:** Wide-angle lenses are great for architectural photography. Try to keep the lens level with the building because if the lens is tilted either up or down, the building can seem distorted. The wide range of focal lengths available by using a zoom lens lets you recompose the scene without having to change your location.
Camera Settings	**Practice Picture:** The photo was taken using the Program Auto mode on the camera and using the Center-weighted metering mode because I was less concerned about the sunlight on the top of the frame. The A200 was able to give me a proper exposure without any problems. I was using a tripod, so I was not worried that the slower shutter speed combined with the longer focal length would cause any camera shake. **On Your Own:** Program Auto mode is a good place to start with your exposure. If the shutter speed is too long, the image will be blurry and you will have to adjust by increasing the ISO or using a wider aperture.

Exposure	**Practice Picture:** ISO 800, 200mm, f/8, 1/30 second
	On Your Own: When you shoot large buildings that take up most of the frame, start by using the Multi-segment metering mode. If the building is farther away or there is a bright light source in the scene, the Center-weighted or Spot metering mode works better in making sure that the building is correctly exposed.
Accessories	A tripod is a very useful tool for shooting architecture.

Architectural photography tips

✦ **Be careful where you photograph.** Some buildings and areas are off limits to photographers, and shooting in these areas can even result in your arrest. Airports and government-owned buildings are usually off limits, and the best policy is to ask permission before shooting. When in doubt, ask first.

✦ **Try to get to a higher vantage point.** Sometimes getting a whole building into a single frame is difficult. One way around this is to shoot from a higher vantage point.

✦ **Use the widest-angle lens you have.** Because most buildings are big, a wide-angle lens is necessary. If possible, use the 11-18mm super wide-angle lens.

✦ **Check the reflections.** Modern glass and steel buildings tend to be very reflective, so it is important to pay attention to the reflections in the windows and other reflective surfaces. Clouds, people, cars, and other buildings can all be reflected in your composition; make sure that they add to the image and don't distract the viewer.

✦ **Watch the light.** Observe how light moves across the building during the day. Usually, the best time to photograph a building or structure is in the early morning or late afternoon; bright midday sun can wash the colors out of a building and produce flat, boring photos.

Candid Photography

Photographing people when they are not posing for the camera can produce great images. The subjects of candid photographs don't know or care if they are the subjects of your image, and capturing a candid moment can produce images that show the true nature and personality of your subject.

People tend to tense when they are posed in front of a camera, and this can lead to images that are stiff and unnatural.

The key to candid photography is to be able to take advantage of those relaxed, natural photographic opportunities when they happen.

6.9 This young Hispanic performer was getting ready to do a lariat demonstration at a Cinco de Mayo event. Shot at ISO 100, 200mm, f/8, 1/400 second.

Inspiration

Wherever there are people around, there are candid photographic opportunities. Recognizing and being ready to take advantage of these opportunities takes practice. Look for opportunities at parades, festivals, weddings, and any family gathering. Candid

6.10 Nothing says New York as much as the yellow taxi cabs and the Statue of Liberty. This street performer dressed as the Statue of Liberty enabled me to get both icons in the same photograph. I waited until the cab was behind the performer before taking the photograph. Shot at ISO 100, 200mm, f/8, 1/125 second with Super SteadyShot turned on to reduce camera shake.

photographs of family members can hold a special place in your heart. Catching a child with a favorite toy or a parent engrossed in the Sunday crossword puzzle will always mean more than a posed portrait of the same people just sitting and staring straight ahead.

6.11 A father and son caught during a waterpark ride. Shot at ISO 100, 200mm, f/8, 1/250 second.

Candid photography practice

6.12 The interaction between the child and adult make for an interesting candid image.

Table 6.3
Taking Candid Photographs

Setup	**Practice Picture:** During a trip to New York City, I spent the day walking around the city with the A200 looking for new and interesting subjects to photograph. I came across thetwo people in figure 6.12 while touring some of the skyscrapers. They were sitting looking out at the Empire State Building, and I photographed the scene from behind them. **On Your Own:** Look for interesting situations and scenes; you never know when they will happen. The best advice for getting a candid photograph is to be prepared.
Lighting	**Practice Picture:** This shot was taken during the middle of the day with the light coming in from the big windows around the room. **On Your Own:** The light for a candid photograph can range from the bright sunlight to the light from the built-in flash. The way to get the best images is to practice in all kinds of lighting situations. Being comfortable shooting in the shadows as well as in the bright daylight will let you be ready for any candid lighting situation.
Lens	**Practice Picture:** This image was shot using the 18-200mm lens with the focal length at 18mm. **On Your Own:** You can use any lens for candid photography, and usually the situation and surroundings determine what lens works best. A zoom lens like the 18-250mm is perfect for this type of photography, letting you frame the image in a variety of ways without disturbing the subject, and letting you shoot at a huge range of focal lengths.
Camera Settings	**Practice Picture:** I shot this using Program Auto mode. The A200's autofocus and multi-metering can correctly focus and set the exposure in most situations. The minute after the photograph was taken, the pair got up and walked away. When there might not be a chance for a second or third exposure, the Program Auto mode is a great place to start. **On Your Own:** Use the Program Auto mode and trust the camera to get the exposure correct. After getting the shot, check the LCD screen on the back of the camera and change the metering mode if the exposure is too dark or too light. Using spot metering will use the light in the middle of the scene to calculate the exposure.
Exposure	**Practice Picture:** ISO 100, f/8, 1/320 second **On Your Own:** Use the Multi-segment metering mode and the Program Auto mode in most candid situations. Let the camera do the work while you concentrate on the composition.
Accessories	Carry extra memory cards when out shooting. You never know when you will run into a situation you want to shoot and you are out of memory.

Candid photography tips

✦ **Carry a camera at all times.** This one is self-explanatory. If you have a camera with you, you can try to get the shot. If the camera is at home, there is no chance of ever getting the shot. I always have a camera with me, and my friends and family are so used to it that they don't notice when I start to shoot.

✦ **Shoot a lot.** With the high capacity of CompactFlash cards combined with their low price, it pays to shoot as much as possible. Don't wait for the shot to be perfect; shoot anyway. I usually have the camera on Burst mode and take three to four photos at a time, which increases my chances of getting the perfect shot.

✦ **Shoot without a flash.** The first time that your flash goes off, your subject knows that you are photographing him or her, killing any chance of future spontaneity. Using a higher ISO or a wider aperture is better than using the flash.

✦ **Use a longer lens.** Being farther away from your subjects increases the chances that they will not notice you photographing them. Give your subjects a little space. This helps them act naturally and not feel like you are invading their personal space.

✦ **Shoot from the hip.** Sometimes bringing your camera up to your face draws attention to you and ruins any chance of capturing the candid moment. I usually zoom out to the widest focal length and shoot from the hip.

✦ **Respect other people and their privacy.** Ask permission when shooting strangers, especially children. Get permission before you take the photograph if you are not sure your subject is willing.

✦ **Carry business cards and model releases.** I always carry business cards and a small pad of model releases. Although capturing a great candid image is fantastic, getting a signed model release helps protect you if you ever want to sell or use the image for publication.

Child Photography

Photographing children can be a real challenge, because they rarely stop moving, and they certainly don't like to spend a lot of time standing still. Successful child photography is part candid photography, part portrait photography, part action photography, part luck, and part perseverance. And while child photography can be a challenge, it is the one type of photography that can bring more joy to family and friends than any other type of image.

The one time that photographing children is easier is when they are really young and can't move around on their own. They also tend to spend a lot of the first year sleeping, and this is a great time to get a photo. Just about everyone thinks that babies are cute, and if the baby is related to you, then it must be the cutest baby ever. Once children start to crawl and move about, all bets are off. Some children like to sit quietly and play in one spot, and others tear around the house, only stopping when they finally run out of energy. So, when photographing children, you need to be prepared for nearly anything!

6.13 A sleeping newborn photographed to show the peaceful look and the details in the small hands. Shot at ISO 200, 50mm, f/5.6, 1/60 second with the built-in flash firing.

6.14 Sierra photographed dressed as a pirate. Shot at ISO 100, 35mm, f/5.6, 1/60 second with a dedicated flash unit.

Inspiration

Capturing children in their natural environments doing what they want to do will produce photographs showing children at their happiest. The best bet for photographs that leave a lasting impression is to let the personality of the child come through in the picture. Don't try to pose the children, but instead look to see what it is they are doing and are interested in. Some children are quiet and serious and enjoy playing alone while others are outgoing and gregarious.

6.15 This young drummer was enjoying the sound of his new drum. Shot at ISO 100, 60mm, f/9, 1/160 second.

Having your own children or grandchildren is usually inspiration enough. Children grow up very fast, and one of the best reasons to take their photograph is to document a time in their life. If you have no children of your own, look at your nephews, nieces, or children of friends who don't mind being the subject of your photography. You will grow as a photographer and they will appreciate the images you produce.

6.16 Brandon collecting stones. Shot at ISO 100, 60mm, f/8, 1/200 second.

Child photography practice

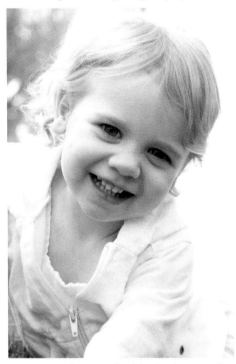

6.17 Anna photographed in the front yard of her house.

Table 6.4
Taking Child Photographs

Setup	**Practice Picture:** I was photographing this young girl when she got tired and just laid down on the grass and stared at me. I quickly lay down on the grass, and started photographing her from her height to create the image in figure 6.17.
	On Your Own: Look for the photo opportunities that capture a moment in the child's life. The lives of children are full of milestones, from taking their first steps to going to the park with friends. All of these situations offer you opportunities for great images and treasured memories.
Lighting	**Practice Picture:** This shot was taken during the midmorning hours with light coming down behind the young girl. There was a low, thin cloud cover that diffused the light nicely.
	On Your Own: Shooting children in direct sunlight results in the children squinting or looking away from the light. Cloud cover or shade from trees will help you create better images.

Lens	**Practice Picture:** I used the 18-70mm lens that comes with the A200. This let me start out wide and zoom in until the composition was what I wanted. I ended up using the 70mm focal length.
	On Your Own: A zoom lens covering a wider focal range gives you more options to recompose the scene without having to move. Using a prime lens like the 50mm f/1.4 will allow you to use a very shallow depth of field that blurs the background, allowing the subject to stand out.
Camera Settings	**Practice Picture:** I shot this using the Program Auto mode and used the Spot metering mode so that the exposure would be correct even with the bright background and the very light color of the subject's shirt. The first shot that I took with the camera set to Multi-segment metering mode caused the image to look too dark, so I switched to the Spot metering mode and focused on the girl's face to get an accurate reading.
	On Your Own: Make sure you set a shutter speed that is fast enough to capture a moving subject. As I mentioned earlier, children tend to move around a lot, so a fast shutter is needed to capture them when moving. When the subject of the photograph is in different lighting than the background, metering correctly is important. I start with Multi-segment metering mode, which works well for most situations, but review the image on the LCD screen and adjust the metering mode accordingly.
Exposure	**Practice Picture:** ISO 200, f/5.6, 1/125 second
	On Your Own: In bright light, using the Program Auto mode or Full Auto mode works well, but when the light starts to be a little lower, switch to Shutter Priority mode so that the shutter speed is fast enough to freeze the action of a moving child.
Accessories	I recommend an external flash to help with fill light even when shooting outdoors. The High Speed Sync mode available with the Sony brand dedicated flash units lets me use a very high shutter speed.

Child photography tips

✦ **Look to change your angle.** Get down to the level of the child. Taking all the photos looking down doesn't show the child in the best way. Being at your subject's eye level adds a real look of intimacy.

✦ **Wait until they are used to you.** To capture children in an unposed, natural manner, wait until they are used to you and your camera.

✦ **Be patient.** It may take a lot of photos to get the one that you want. Just stay calm and be patient.

✦ **Be natural.** Try to stay away from unnatural settings or trying to force a smile. It will look fake and the image will not be as good as a natural look.

✦ **Keep them busy.** When shooting children in a studio setting, have plenty of toys and games around to distract them from what you are doing. This helps in getting a natural look in an unnatural situation.

✦ **Shoot in Continuous drive mode.** Children move pretty fast and I usually have the camera set to shoot in Burst mode, giving me more than one chance at getting the shot I want.

Concert Photography

Concert photography can be one of the most rewarding and frustrating experiences you can have as a photographer. These days it is very difficult to even get a camera into a concert venue. Most venues now do not allow photography during any live performances, and the only people who are allowed to bring cameras are those working and photographing for the venue, the band, or a promoter. Getting permission to photograph usually requires you to contact the band's publicity company and request a photo pass. Another method is to contact the venue and inquire if it allows photography for the show you are interested in photographing. If you do have permission to photograph, it is usually only for a very short time — perhaps one minute or three songs.

There are exceptions to this rule, but it is better to plan for the worst. Knowing that there is a limited time to shoot, don't waste time by changing lenses or memory cards during the shoot; have your camera set up the way you need it to be before the show starts.

Most concerts take place in the evening and at night, and these are harder to photograph due to the constantly changing lights. It is difficult to get an accurate reading for exposure settings when the intensity, direction, and color of the light keep changing. Combining the difficult lighting with a limited amount of space to shoot and the constantly moving musicians makes taking concert photos a real challenge. One way to start out and get practice is to photograph at free daytime music events like the Green Apple Festival, which was held in eight U.S. cities in 2008.

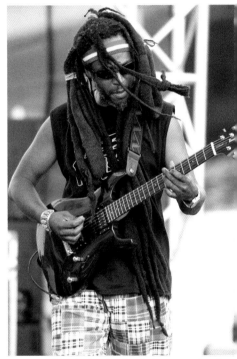

6.18 David Hinds, the lead singer and guitar player for the Reggae band Steel Pulse, performing at the San Diego Fair in 2008. Shot at ISO 200, 200mm, f5.6, 1/250 second.

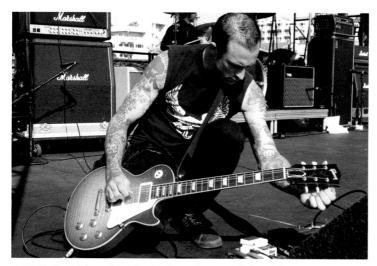

6.19 Craig Fairbaugh, guitarist for Juliette and the Licks, tunes up between songs while performing at the Green Apple Festival on the Santa Monica Pier. Shot at ISO 100, 24mm, f/5.6, 1/250 second.

Inspiration

Music has been an inspiration to many people in many different ways, and when shooting music events, let the music be your inspiration. Live music has a real energy about it, and the musicians put their heart and soul into producing their music. Capturing the energy of the music is the essence of concert photography.

The best way to practice is at small local venues that cater to local bands. Local bands are more willing to allow audience members to photograph the show and are easier to contact than major label acts. Another benefit to shooting in local clubs is that, because the lights in these clubs are usually worse than those in bigger stadiums, shooting concerts will actually seem to get easier when you progress to bigger shows. Other venues to practice your concert photography skills include outdoor venues and afternoon concerts. These images will not have

the same lighting as an indoor show, but that will help you work on composition and timing. Images 6.18, 6.19, and 6.20 were all taken outdoors allowing low ISO and short shutter speeds.

Shooting concerts works best if it is something you really love. Unlike other photography, there are some real downsides to shooting concerts. I have been shoved, pulled, bumped, nudged, had drinks spilled on me, and had camera gear broken by a rowdy fan. Even after all the damaged gear and bruises, I would not pass up the opportunity to shoot a concert.

Tip *Having a portfolio of concert images helps when trying to convince bigger acts that you should be allowed to shoot them. Some of the biggest names in photography have spent many hours shooting live music.*

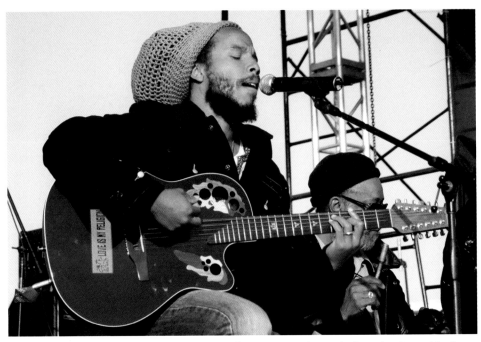

6.20 Ziggy Marley playing an acoustic set at the Green Apple Festival on the Santa Monica Pier. Shot at ISO 200, 60mm, f/5.6, 1/400 second.

Concert photography practice

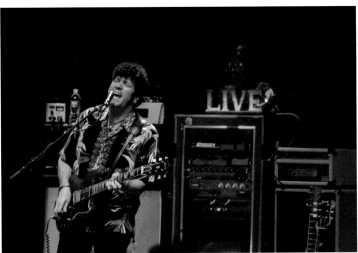

6.21 Mark Karan, lead guitarist for Bob Weir & RatDog.

Table 6.5
Taking Concert Photographs

Setup	**Practice Picture:** Mark Karan, lead guitar player for RatDog, performing during a three-night run at New York's Beacon Theater. This image in figure 6.21 holds a special place for me because of the light hitting the word LIVE on top of his guitar rig. Mark recently was treated for throat cancer, and after a year off the road, he has healed and is back out on the road. **On Your Own:** Find a good angle for photographing the performance. Try to avoid getting directly in front of the performers as microphones and microphone stands can cast unwanted shadows. When shooting from the crowd, protect you camera by keeping it close to your body. No one else will care that you are carrying expensive camera equipment. Make sure that you don't obstruct anyone else's view with your camera. Everyone paid to enjoy the show, not watch you be a photographer.
Lighting	**Practice Picture:** I had a good position to get Mark and his gear all in the frame and took a burst of three images when he started to sing. The second image of the three was the one where the blue light reflected off the metal LIVE sign. **On Your Own:** Concert lighting can be one of the most difficult types of lighting a photographer has to deal with. The constant changing color and intensity make getting good concert shots a real challenge. Shooting in bursts of three photos at a time lets you capture a variety of lighting effects and increases your chances for correct exposure.
Lens	**Practice Picture:** I used a 70-200mm f/2.8 lens zoomed out to the 200mm focal length. This lens is the lens needed for shooting concerts in low light, but be aware that this lens costs more than the A200. **On Your Own:** The 70-200mm f/2.8 lens is an absolute necessity when shooting concerts seriously. The low light capability along with the telephoto zoom capabilities make this lens the best in filling the frame with the musicians. For shooting concerts in low light, a maximum aperture of f/2.8 is a must.
Camera Settings	**Practice Picture:** I shot on Manual mode, giving me complete control over the exposure of the scene without having to worry that the constantly changing lights would cause the metering of the A200 to under- or overexpose the musician. **On Your Own:** When starting out I recommend setting the camera to Shutter priority and picking a shutter speed just low enough to freeze the action. This lets the A200 pick the aperture for you. Looking at the results will give you an idea of what shutter speed and aperture combinations work best for various types of lighting situations. Set the ISO at 100 for outdoor bright light situations and to 400 for indoor or low light shooting. To shoot in Manual mode, set the camera to the widest aperture possible on your lens and use a shutter speed that stops the action, 1/60 second or higher.

continued

Table 6.5 (continued)

Exposure	**Practice Picture:** ISO 400, f/2.8, 1/80 second
	On Your Own: If you are going to use Aperture or Shutter Priority mode, then set the metering mode to Spot metering and focus on the main subject. This will give you the best results other than setting the exposure manually.
Accessories	A small flashlight comes in handy in dark concert venues.

Concert photography tips

✦ **Practice without a flash.** Most bands, venues, and promoters do not allow flash photography to be used, even if you have credentials to shoot the show. It is better to learn how to get the correct exposure without relying on a flash.

✦ **Know your gear and where it is packed.** When shooting in a dark club or arena, it is important to be able to change settings, lenses, and memory cards without fumbling around. Knowing where you put the extra batteries and memory cards in your bag can save you a couple precious minutes.

✦ **Protect your health and hearing.** Shooting loud music close to the stage can result in hearing loss. I keep a set of earplugs in my camera bag for the times when I am close to the stage.

✦ **Pay attention to your surroundings.** If you are lucky enough to photograph from the front of the stage or the stage itself, make sure you stay out of the way of the working crew. There is no quicker way to get your credentials removed than by getting in the way of the folks putting on the show.

✦ **Go to the venue early.** It is best to get to the venue early enough to secure your credentials if you have any; and if you don't, the earlier you get there, the closer you can get to the stage.

✦ **It pays to be polite.** It is important to remember that people are there to hear the band and enjoy themselves, not watch a photographer. Try not to cause other concertgoers any problems, because security will have no problem asking you to leave.

Event Photography

Event photography can cover a huge range of subjects and photographic opportunities. Birthday parties, street fairs, parades, and graduations can all fall under event photography.

There are other types of events, such as weddings and concerts, which are covered separately in this book, but the basics of event photography can be used for all events.

Photos from the event need to tell a story or have a unifying theme. Each photo should be able to stand on its own merits and tell a story or evoke a feeling relating to that type of event.

6.22 A member of the Shamrock & Thistle Pipes & Drums during New York's National Tartan Day parade. Shot at ISO 200, 200mm, f/6.3, 1/40 second using Super SteadyShot to compensate for the slower shutter speed. A dedicated flash unit was also used for fill light.

When shooting events, planning is the key to a successful shoot. Knowing what you are going to photograph lets you pack the right gear. Knowing if the subjects you want to shoot are close up or far away lets you know what lenses to bring. Knowing if the event takes place inside or in low light helps you plan whether to bring fast prime lenses or an extra flash to help with shooting in low light situations. Knowing how long the event lasts and how many images you think you will be taking lets you make sure you have enough memory cards for the whole event.

Inspiration

There are events held every weekend in just about every city; it's just a matter of looking for them. Look in the local newspaper or community Web sites to see what is going on in your area or any area that you are going to visit. Most organizations have a Web site to advertise their events, and this is a great place to look for info on the event. Sometimes the Web sites will even have images from past events.

6.23 Local dancers at a Cinco de Mayo celebration in Old Town San Diego. After shooting the event the previous year, I knew I was going to need a long lens to fill the frame with the dancers. Shot at ISO 200, 200mm, f/6.3, 1/100 second.

If the event is based on a person or persons, like a graduation or birthday, make sure you capture them in some of the photos. Look at the decorations, food, and other surroundings that can add to the feel of the whole event.

Event photography practice

6.24 The Blues Brothers meet Bishop

Table 6.6
Taking Event Photographs

Setup	**Practice Picture:** The San Diego Comic Convention is the biggest event of its kind in the world. The great thing about it is the fantastic photo opportunities. You never know whom you might run into. For figure 6.24, I came across Jake and Elwood Blues hanging out with Bishop, one of the X-Men. They posed in the middle of the concourse for a quick photograph, and I was ready to capture this special moment in time.
	On Your Own: Look for special moments in any event that you are photographing. Try to keep the background as clutter free as possible and keep the focus on what you are photographing.
Lighting	**Practice Picture:** I used a dedicated flash unit on top of the camera with a diffuser dome attached. The flash was angled at 45 degrees so that the light was aimed over the heads of my subjects. The light from the windows behind my subjects would have caused the image to be underexposed; the flash added enough light to make the light seem natural.
	On Your Own: Plan for the lighting of the event. A parade happening in the middle of the day will have strong light, while a birthday party held inside will require you to supply light with a flash. Planning ahead will let you bring the right accessories.

Lens	**Practice Picture:** I used a zoom lens that allows me to pick between a wide range of focal lengths. In this case it was set at 50mm, but I also moved in a little closer so that the flash would light up my subjects correctly.
	On Your Own: Lenses with focal lengths of 18-200mm make great event lenses, letting you go from a wide-angle view to a close-up without having to move. If you are shooting indoors, pack a prime lens that has good low-light performance — one with a wide maximum aperture of f/2.8 or better.
Camera Settings	**Practice Picture:** I shot this using the Program Auto mode with the metering set on Center-weighted metering. I used the Center-weighted metering mode because of the bright sunlight behind the trio. I wanted to make sure that the subjects were the main focus of the metering system.
	On Your Own: The Full Auto mode or the Program Auto mode is a great place to start, but if shooting moving subjects, consider switching to Shutter Priority mode and make sure you are using a shutter speed fast enough to freeze the action.
Exposure	**Practice Picture:** ISO 100, f/5.6, 1/125 second
	On Your Own: In bright scenes, use the lowest possible ISO that will give you the least amount of digital noise. For indoor events, or those in the evening, a higher ISO is usually necessary to get a proper exposure. Digital photography lets you change the ISO without changing the film, which means you can adjust the ISO between each shot if needed, but that also means that you can use the Auto ISO to automatically adjust the ISO as needed.
Accessories	Extra memory cards and batteries are useful when shooting for full-day events, and a dedicated flash is very useful when shooting in low light.

Event photography tips

✦ **Arrive early and do your homework.** Find out if there are going to be any special displays or presentations at the event. If you are shooting a parade, find out where the judges, if any, are going to be and try to set up close to that point. Each float tries to impress the crowd at that location.

✦ **Ask permission.** I carry business cards and photo releases with me when shooting any event. Most people don't mind having their photo taken, but it is best to ask either before or right after taking the photograph if possible. There are times I will shoot first and ask later, but I always ask, and if the answer is no, the image gets deleted immediately. When shooting children, make sure you get the parents' permission before photographing them.

✦ **Plan for the changing light.** Outdoor events take place under the changing sunlight. Be aware of the movement of the sun. A place that's great for morning photos can change drastically in the afternoon. Be prepared to move around to make the most of the changing light.

✦ **Change angles.** Try to move around and shoot from a variety of positions and angles. Shooting from low angles is great for parades: It makes the whole event seem larger than life.

Flower and Plant Photography

Every flower and plant offers up distinct details to capture. Their bright colors, interesting shapes, and unique textures make them natural photographic subjects. Flowers and plants can be photographed in their natural surroundings, but they can also be used as a subject for still-life photography.

Flowers and plants can be posed in any manner; they can be cut, bent, and twisted, and will never complain about the treatment. This makes them great to work with in the studio. Just be careful abut leaving them under hot lights for too long; they can, and will, wither and die.

6.25 The patterns of this succulent makes for an interesting image. Shot at ISO 200, f/2.8, 1/60 second.

6.26 A single flower surrounded by a sea of Baby's breath. Shot at ISO 400, 55mm, f/5.0, 1/20 second with Super SteadyShot turned on to help with the slow shutter speed.

Inspiration

Flowers are available everywhere. They grow wild and can be bought at the local supermarket. This easy availability makes them fantastic as available subjects for your photography.

At times I just walk into my backyard to see what flowers are in bloom, or I take a quick trip to a local botanical or public garden in town. Look for the local plants and flowers in your neighborhood. But great flowers and plants can be found everywhere, even in the local supermarket. Just a quick look at the flower section after doing some grocery shopping can lead to some great flower photos.

Combine different flowers and plants. The combination of colors and textures can lead to pleasing images.

6.27 A white orchid purchased at a local supermarket and photographed with a piece of black foam board as the background. The light was provided by using a Sony external flash fired through an umbrella to provide a soft, even light. Shot at ISO 100, 50mm, f/5.6, 1/60 second with a dedicated Sony flash unit in wireless mode.

Flower and plant photography practice

6.28 A daisy photographed at a different angle.

Table 6.7

Taking Flower and Plant Photographs

Setup	**Practice Picture:** This Gerbera daisy plant in figure 6.28 was purchased at a local discount store. The multiple flowers offered a wide range of colors and shapes all on the same plant. This image was shot at a low angle in the late afternoon using the sky as the background.
	On Your Own: When shooting flowers at a low level, sometimes you will need a solid-color background, and although a professional backdrop is useful, a piece of white or black foam board works just as well. Look for compositions that let your subject stand out and not end up hidden against the background.
Lighting	**Practice Picture:** This photograph was taken outside against the late-afternoon sky. The light was coming from behind me and gave an even, bright light over the flower.
	On Your Own: The best lighting for shooting flowers and plants outside is early-morning or late-afternoon lighting. Cloudy and overcast days result in great diffused light and are the perfect time to photograph plants and flowers outdoors. When the sky is gray, use the opportunity to go out and photograph local flowers.
Lens	**Practice Picture:** I used a 50mm macro lens for this image. This let me get close to the flower and fill the frame with the flower. I like using the 50mm or the 100mm macro lens for these types of images.
	On Your Own: Any lens can be used to take flower and plant photographs. Each situation can require a different lens depending on how you want the image to be framed. If you want to fill the frame with your flower or plant and you don't have a macro lens, try to zoom in using a longer focal length.
Camera Settings	**Practice Picture:** I set the camera to Shutter Priority mode. Because I was shooting outdoors, I wanted to make sure that I froze the flower if there was any movement caused by a breeze. With the shutter speed of 1/250 and an ISO of 200, there was enough light for an f-stop of f/8, creating a nice, deep depth of field across the whole top of the flower.
	On Your Own: The Auto mode on the A200 is a good starting point for these types of photos. After you get more comfortable with the setup and composition, you can work on getting the depth of field you desire. Keep in mind that the depth of field on macro lenses is very narrow, so the petals in the front of the flower will be in focus, but the petals at the back of the flower will be blurred.
Exposure	**Practice Picture:** ISO 200, f/8, 1/250 of a second
	On Your Own: When shooting large areas with many plants and flowers, use a deeper depth of field to keep all the flowers and plants in sharp focus. To make a single flower stand out against a background, use a shallow depth of field.
Accessories	A tripod is the most useful piece of equipment for this type of photography. Being able to set the camera in one position and fine-tune exposure and focus is key to getting great flower and plant photographs.

Flower and plant photography tips

✦ **Change your point of view.** Shoot from a low angle across the flower instead of down at it. This results in flower photographs that stand out from the crowd.

✦ **Fill the frame with the subject.** Using a macro lens helps in this, but even if you don't have a macro lens, try to either move closer to the flower or plant or zoom in as tight as possible. Filling the frame with the subject and keeping the background simple make the flower or plant the center of attention.

✦ **Use colors to your advantage.** A single white rose in a bunch of red roses makes for a striking

photograph. The contrast between the colors makes the single white rose stand out.

✦ **Block the wind.** When shooting outdoors, placing yourself between the flower and the breeze can block a slight breeze. This will cut down on any movement caused by the wind.

✦ **Look for patterns.** There are great patterns in nature, from the structure of the leaves and petals to the way the flowers follow the sun. These patterns make for interesting elements in your images.

✦ **Bring your own rain.** Having a small spray bottle of water lets you create fake rain or dewdrops on your flowers and plants. A little bit of water goes a long way, so be careful not to drench the flower, and remember to keep your camera dry.

Group Portrait Photography

Group portraits can have a couple of people or a couple hundred, but the basics remain the same. As the photographer, you need to keep the attention of the group focused on you. The more people involved, the harder this can be. Getting a single person to smile naturally is difficult; getting a group of 30 to do it at the same time is incredibly difficult. This section can't cover every group situation, but it will cover some of the basics. Getting a good group portrait involves the same basics as an individual portrait: great use of light and well-posed subjects.

Considering lighting and location

Good group portrait photography is dependant on the same things as all photography; if there is good light, you can make a good image. Light is used to illuminate the scene, and getting the right amount of light onto all of the people in a group portrait can be a daunting task. Make sure that all the people in your photo are evenly lit. Make sure that the people in front don't cast shadows on the people behind them.

If you know that you are going to be taking a group portrait and you have the time, scout out locations that will give you the

6.29 This is a photograph of musician Pato Banton and his backup singers moments before they took the stage. Shot at ISO 100, 50mm, f/5.6, 1/250 second.

best chance of success. The location needs to be big enough to hold the whole group, and if possible have even lighting and no overhanging items that can cause strange shadows to fall over the group. Keeping the background as neutral as possible insures that the focus is on the people and not the surroundings. In figure 6.29, I had no control over the background. The photograph was taken backstage at a festival and the only area available had a chain-link fence as the backdrop.

Working with people

Posing a group of people is more difficult than posing just one person. Some basic guidelines when posing a group:

✦ **Stagger the heads.** When setting people up, do not put the heads of the people in the second row directly above the heads of the people in the first row.

✦ **Light the whole group as evenly as possible.** If one part of the group is in deep shadow and the other is in bright sunlight, achieving proper exposure is very difficult.

✦ **Group people around a center point.** Instead of putting the group in a straight line, have them gather around something or someone. For example, if you are shooting a family portrait, have the mother sit in the middle and then have the rest of the family gather around her to add a feeling of togetherness that a family standing in a straight line doesn't.

✦ **Keep the main subjects the center of attention.** When shooting a group photo at a wedding, birthday, or a special event for one or two people, make sure that the main subjects are the center of attention. Place the very important person(s) in the middle of the group and build the group around them.

Tip *When arranging people in a group setting, try to keep the rows close together so that a very deep depth of field is not needed.*

Inspiration

A group portrait can be anything from a group of friends gathering for a party to a band doing a promotional photograph. The range of subjects that can be considered group photos is very wide. There is something very special about a group portrait as opposed to an individual portrait, and that is that the people who make up the group might never be together in this setting again. This is especially true for family events like weddings and birthdays when people travel to be together. These images will be treasured now and for generations to come. When you look at a group portrait, it can instantly transport you back to that time and place, and more importantly, it can bring back treasured memories of family and friends. Never hesitate to gather a group together for a quick portrait. You will not regret it later.

The team in figure 6.30 will never forget the feeling of winning the relay race. Chances are they will not always be together, but the photo will always remind them of that time together.

6.30 A women's relay team photographed after winning a track-and-field event. Shot at ISO 100, 35mm, f/8, 1/250 second.

Group portrait photography practice

6.31 The Hollywood School of Rock All-stars

Table 6.8
Taking Group Portraits

Setup	**Practice Picture:** The photo in figure 6.31 was taken backstage at the Green Apple Festival where the School of Rock was getting ready to play. This photograph was the fifth shot, and I had the kids relax and strike a rock-and-roll pose. The attitude of the kids shined through, and this was the best shot of the group. These kids might grow up to be rock stars, but they could also end up being doctors or accountants. This image will always recapture that day in the sun when they played at the festival.
	On Your Own: Anytime there are two or more people gathering together, it's a good time to take a group portrait. Small groups can be gathered and posed just about anywhere, while larger groups will need a little more planning. Trying to put a large group into a small area will cause your image to look cramped and uncomfortable, so try to find an area that is big enough to comfortably fit your group.

continued

Table 6.8 *(continued)*

Lighting	**Practice Picture:** I posed the kids in the shade created by the stage. This created an even light over all of them, and I didn't have to worry about very bright highlights.
	On Your Own: When shooting outdoors, try to have the light fall evenly over all the people in your group. Having part of the group in shadow and part in direct sunlight can cause problems with exposure, and you may end up with some people overexposed and others underexposed.
Lens	**Practice Picture:** I used the 18-70mm kit lens set at the 24mm focal length and had the kids lean in toward the lens.
	On Your Own: A zoom lens lets you adjust the focal length between shots quickly and easily. If you use a wider angle, be aware that you can cause some distortion if the lens is not even with the people. Try not to tip the lens too far up or down; this will help avoid any problems.
Camera Settings	**Practice Picture:** I shot this using the Program Auto mode on the A200. The Multi-segment metering accurately determined the settings needed for proper exposure, letting me concentrate on the composition.
	On Your Own: For group portraits that have more than one row of people, it is important to make sure that you are using a deep enough depth of field to make sure that all the people are in focus. Setting the camera to Aperture Priority mode will make sure that the aperture does not change as the light does. It is also important to remember that the shutter speed needs to be fast enough to keep things from being blurry.
Exposure	**Practice Picture:** ISO 100, f/8, 1/125 second
	On Your Own: The Multi-segment metering mode on the A200 works well for most situations and would be the place to start. Use the LCD screen to preview whether the image looks correctly exposed. The A200 was able to correctly handle the exposure in figure 6.29 even with the wide difference in clothing and skin tones.
Accessories	A tripod is useful for group shots, not only for keeping the camera steady but also for keeping the camera in one place, freeing up the photographer to direct the group.

Group portrait photography tips

✦ **Shoot multiple shots.** Take as many shots as possible in as short amount of time as possible. People seem to relax right after the first shot is taken, resulting in the second or third photo being better.

✦ **Have a posing plan.** Look at magazines, books, and the Internet, and see what group poses appeal to you. Keep these in mind the next time you need to pose a group.

✦ **If they can't see you, you can't see them.** Ask the folks if they can see you before you take the photo. If they have a problem seeing you, then chances are their faces will not be in the image.

✦ **Get in close.** Unless the background is an important part of the photograph, fill the frame with your subjects.

✦ **Try a different angle.** A great way to photograph a very large group is to shoot from a higher vantage point down at the group. A small ladder comes in very handy for this type of photograph.

Indoor Portrait Photography

Good portraits depend on two things: good lighting and a good pose. Shooting indoors will give you more control over the light, but with that comes another set of problems. Triggering studio lights from the A200 requires extra equipment, and because of this, your light choices for indoor portraits are limited. The three images in this section were all taken indoors, using different light sources available for the A200.

Knowing that you can control the light lets you concentrate on composing the photo and posing the model. Getting the most out of your subject requires him or her to relax in front of the camera and look natural and not stiff and uncomfortable. Many people become tense when they are asked to pose for an individual portrait, which translates to your photo. The best portrait photographers have the ability to relax their models quickly, which results in better shots. I find that explaining what I am doing lets the model become part of the process and removes the barrier between photographer and model. Here are some general tips to help solve some common problems when posing your subjects.

✦ **Bald is beautiful, but it can cause problems.** Bald heads can cause unwanted reflections. Make sure that no lights are aimed directly at a bald head. Use a softbox to soften the light hitting the problem area.

✦ **Glasses are not bad, but reflections are.** Glass reflects light, and eyeglasses can cause lots of problems in portraits. Moving the temples of eyeglasses up slightly higher than normal can change the angle of the glasses and reduce reflections. Try to reposition the main light a little higher than normal to minimize the reflections even more.

✦ **A little weight reduction.** To reduce a double chin, have the subject look slightly up and shoot down from a higher angle. Place the main light slightly higher than the camera and aim the light slightly downward, creating more of a shadow under the chin. Turning slightly toward the camera and having one side closer to the camera than the other is another great way for a subject to look slimmer. Profile poses are not a good idea because they tend to exaggerate body size.

✦ **A little more weight reduction.** Using a low-key lighting style with lots of shadow area helps hide problem areas. Move the light in a little closer to the subject and change the angle to create more shadows on problem areas.

✦ **Working with hands.** Hands can be very expressive and add character to a portrait, but a badly placed hand can just as easily ruin an otherwise great portrait. Don't let the hand appear to be too large. This is more important when the hands are close to the subject's face. To reduce the size of the hands, turn them so that the side of the hand is facing the camera and not the back or palm.

6.32 Mia was posed against a solid white background and lit with one dedicated Sony flash that was fired through an umbrella to the right of the camera. The flash was fired in wireless mode, and because the white paper backdrop was behind the model, it was lit with less light, becoming gray in the image. Shot at ISO 100, 50mm, f/5.6, 1/60 second.

Inspiration

Look to capture the character and personality of your model. The lighting, background, and even props will not matter if the model's personality doesn't come through in the portrait. Creating a rapport with your model will result in a better experience for both your model and you.

6.33 Danyelle Wolf, an up-and-coming boxer photographed using a continuous studio light against a black background. The light was placed to the left of the camera, enabling me to concentrate on getting the right look on her face and the best placement of the gloves. Shot at ISO 100, 35mm, f/5.6, 1/100 second.

For the boxer in figure 6.33, I wanted to bring out the fighter in her, so posing with the gloves on and forward and with a serious look in her eyes were important in getting this shot to look just right.

Indoor portrait photography practice

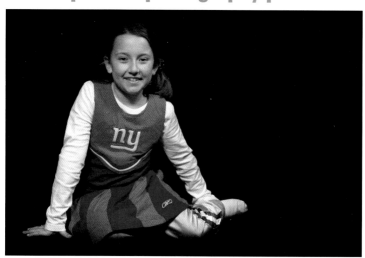

6.34 Sierra posing in the studio

Table 6.9
Taking Indoor Portraits

Setup	**Practice Picture:** This photo was part of a series done with a family of Giants fans shot in my photo studio. After doing a series of group portraits, I had Sierra sit on the black seamless paper backdrop and used the A200 with a dedicated flash to take the image in figure 6.34.
	On Your Own: Seamless paper backgrounds are great for portraits, and they come in a wide variety of colors and sizes. The drawback to using paper is that it is easily damaged and can't be used more than a few times. Viable alternatives are cloth backdrops; they are available in a huge variety of colors and patterns and are easy to transport and store. The downside to the cloth backdrops is that they are more expensive and any wrinkles might show up in the final image.
Lighting	**Practice Picture:** The lighting was one Sony dedicated flash unit fired wirelessly through an umbrella that was behind and above the camera.
	On Your Own: Studio lighting can be very expensive and bulky. The modern flash units available from Sony can help produce great images, and the new Sony F58AM flash can even be angled on the camera to match the orientation of the camera.

continued

Table 6.9 *(continued)*

Lens	**Practice Picture:** I used a 35mm fixed-focal-length lens for this shot.
	On Your Own: Most lenses can be used to create great portraits. I find it best to start in the 35-85mm range and work from there. The 35mm f/1.4 and the 50mm f/1.4 are both great lenses for portrait work. Both these lenses also work really well in low light with their maximum aperture of f/1.4
Camera Settings	**Practice Picture:** I shot this in Program Auto mode with the flash compensation set to –1. I started with the flash at normal output, but the image seemed too bright so I dialed the flash compensation down to –1.
	On Your Own: When using continuous lighting, it is easy to see where the lights will fall and to use the camera's built-in light meter to get an accurate reading for setting the proper exposure.
Exposure	**Practice Picture:** ISO 100, f/5.6, 1/60 second
	On Your Own: Focus on the eyes and make sure the aperture is set so that the whole face is in focus. This will change with the focal length and the distance between the camera and the model. A good rule of thumb is f/5.6.
Accessories	An umbrella and a flash bracket that allowed me to attach the flash to a light stand and use a shoot-through umbrella. These adapters are available at any large camera store.

Indoor portrait photography tips

✦ **Meet beforehand if possible.** Although it isn't always possible, meeting with the subjects before a portrait session lets you know what they expect to get from you and, just as importantly, what you will receive from them.

✦ **Be prepared.** Nothing can make a portrait shoot go bad faster than a bored subject. Don't make him or her wait for you to get ready or set up your equipment. Have a game plan ready before you start. This makes the whole process go by faster and creates a positive experience for both you and the subject.

✦ **Talk to your subjects.** Talking to your subjects not only keeps them at ease and makes for a more relaxed atmosphere, but also lets you direct the poses without sounding like you are ordering them around.

✦ **It's all in the eyes.** Focus on the eyes. If the eyes are out of focus, the rest of the portrait won't matter. If one eye is closer to the camera, focus on that eye.

✦ **Shoot multiple photographs.** In this digital age, there is no reason not to take multiple frames of the same pose. Sometimes a slight difference in expression is the difference between a good portrait and a great portrait.

✦ **Follow simple clothing rules.** Vertical stripes add length, giving the subject the illusion of being taller and therefore slimmer. Horizontal stripes have the opposite effect and should be avoided.

Logos on clothing should be avoided unless they are needed as part of the portrait. Dark clothes can cause the A200's metering system to underexpose the skin tones, while light clothes can cause the metering system to overexpose the skin tones.

✦ **Makeup is key.** Do not underestimate the usefulness of a professional makeup artist. The portrait photograph is capturing a moment in time, and looking your best is important. A good makeup artist can do wonders, and proper use of makeup can accentuate the positive and hide the negative.

Landscape and Nature Photography

Landscape photography has long been a favorite of photographers. Landscape can be taken in any environment, from the mountains to the deserts, forests, lakes, beaches, and any place in between. Where other types of photography are all about being quick enough to capture a moment (think sports, children playing, concerts, even weddings), landscape photography is about

waiting until the light is just right to get the shot you want. If you plan it right, there is no hurry in taking landscape photography; you can wait until the right moment to press that Shutter button.

Shooting a landscape in the horizontal or "landscape" orientation gives the images an expansive feeling, conveying the feeling of wide-open spaces. Shooting with a vertical or "portrait" orientation emphasizes the height of your subjects.

6.35 The Irish countryside shot at ISO 100, f/8, 1/250 second.

Inspiration

Taking great landscape and nature photographs requires you to slow down and really look at and appreciate the natural beauty all around. The wide-open spaces and ever-changing light offer the photographer many opportunities for great images. Look to the sky and decide if including more or less of the sky will enhance or detract from your image. A clear sky will usually detract from an image, if there is nothing in the sky, there is nothing for the viewer to look at. Clouds, on the other hand, can add much-needed texture and color.

The sweeping vistas and mountain ranges make for breathtaking images. From before the sun rises, to after the sun sets, landscapes off an ever-changing view. Take a landscape image one day, and the next day the landscape will be different. The light is never exactly the same twice.

6.36 Tall trees framing the Southern Oregon landscape. Shot at ISO 100, f/8, 1/125 second.

6.37 Colorado in the summer still has snow on the high mountain peaks. Shot at ISO 100, f/9, 1/160 second.

Landscape and nature photography practice

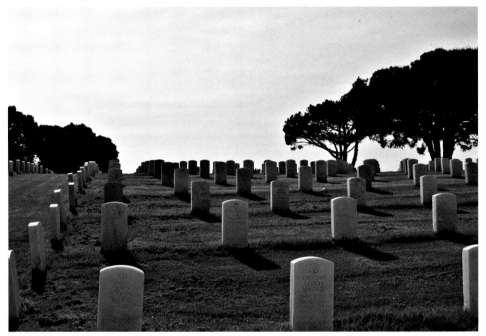

6.38 Fort Rosecrans National Cemetery

Table 6.10
Taking Landscape and Nature Photographs

Setup	**Practice Picture:** The image in figure 6.38 was taken at the National Cemetery at Fort Rosecrans in Point Loma, California. I spent an afternoon walking around the cemetery, and at times the sheer amount of gravestones was overwhelming. I took this image facing west toward the Pacific Ocean. I wanted a bleak look to match the somber mood of the cemetery.
	On Your Own: Explore your surroundings by walking around and looking at the different views. One way to change the view is to change the angle of the image. Shoot from a low perspective and the landscape will seem to tower over you majestically. Work on putting the horizon a third of the way from the top or bottom of your image using the Rule of Thirds, as described in Chapter 3.

continued

Table 6.10 *(continued)*

Lighting	**Practice Picture:** This was taken in the early afternoon; I would have liked to have stayed until sunset. The area is part of a military base and access is limited to certain times of the day. There was very little cloud cover and the light was hard and direct. The direction of the shadows indicates the direction of the light.
	On Your Own: Be patient and watch the light as it moves over your scene. Landscape photography uses available light, which changes constantly. Traditionally the best light for landscape photography is in the early morning or late afternoon when the shadows are at their longest and the color of the light is warmer.
Lens	**Practice Picture:** I was using the 18-70mm lens set at the 35mm focal length, which did a great job in getting the whole scene in the frame. It also let me take a couple of photos with different views of the same scene.
	On Your Own: Landscape photographs can be taken with any lens, depending on the scene. Having a wide range of focal lengths in a single lens is useful in letting you change composition without having to move.
Camera Settings	**Practice Picture:** I used the Aperture Priority mode to make sure that the depth of field was deep enough to get the whole scene in focus.
	On Your Own: Aperture Priority mode lets you set the depth of field and make sure that the whole scene is in sharp focus. If this causes the shutter speed to be too slow for you to hand hold the camera, then use a tripod. In landscape photography, it is important to get the image as sharp as possible, and this means using a tripod to hold the camera rock steady.
Exposure	**Practice Picture:** ISO 200, f/11, 1/30 of a second
	On Your Own: Start with the A200's Multi-segment metering mode. This usually gives you the best results for landscape photography. If after reviewing the image on the camera's LCD screen you see that the exposure is too dark or too light, then switch to Center-weighted metering, or change the exposure either by shooting in manual mode or using exposure compensation. This will use the value determined by the center of the scene with less emphasis on the edges.
Accessories	A tripod is a must for shooting during the morning or evening light when longer shutter speeds are needed to achieve proper exposure. When shooting in rainy weather, there is some great all-weather gear to help keep you and your camera dry. One product is the Op/Tech Rainsleeve which offers an inexpensive way to keep your camera dry while letting you access the camera controls.

Landscape and nature photography tips

✦ **Identify your subject.** Find the most interesting feature in the landscape and make sure that it does not have to compete for the viewer's attention.

✦ **Use different focal lengths.** This is easy to do with lenses like the 18-200mm f/3.5-6.3. Just zoom in a little closer to see what happens. The telephoto focal lengths will cause elements in the background to appear to be closer than elements in the foreground, while the wide-angle focal length will cause elements in the background to appear to be much farther away than elements in the foreground.

 Cross-Reference *For more on focal length distortions, see Chapter 5.*

✦ **Add a person.** Including a person in the image adds a sense of scale and perspective. It is sometime hard to determine the true size of a landscape without an easily recognizable object to give a scale of reference.

✦ **Protect yourself and your gear in bad weather.** When shooting outdoors, be sure to protect yourself and your gear from the elements.

✦ **Adjust your exposure when shooting snow.** Huge areas of bright white can cause the metering system in the camera to underexpose the rest of the scene, so it is important to adjust accordingly.

✦ **Watch the light.** The light changes constantly as the sun moves across the sky. Watch where the shadows fall and how different areas are lit over time. The same landscape photographed at dawn will look very different even one hour later.

Light Trail Photography

Light is essential to creating a photograph, but with light trail photography, the subject of the photograph is the light. If your subject or your camera moves during an exposure, the photo looks blurry or streaky. This effect can be used to your advantage, and with some creative vision and control, the results can be stunning.

There are three ways to get good light trail photographs. You can keep the camera steady as the light moves, or move the camera as the light stays steady. The key to these two techniques is longer-than-usual shutter speeds. The third method is to just zoom in or out when the shutter is open. Having the camera on a tripod helps during the long shutter speeds.

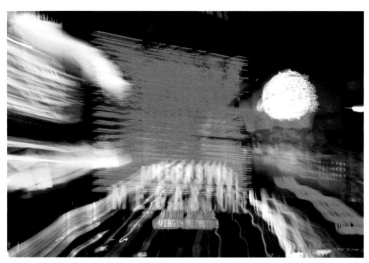

6.39 The bright explosion of color was created by slowly zooming out while taking the photograph. Shot at ISO 100, f/5.6, 1 second.

Inspiration

Photographing with light as the subject requires the rest of the scene to be rather dark. The best time to look for light trail subjects is after the sun has set. Look for viewpoints where you can see movement:

For example, the headlights and taillights on a busy road at night create great streaks of red and white. Light trail photography can add a sense of movement to a static image. Use the light trails to draw your viewer's eye into the image.

6.40 This image combines two techniques. The long exposure lets the light trails from the car lead the eye toward the middle of the image; at the same time, I rotated the zoom during the exposure, causing the straight-line light trails. Shot at ISO 100, f/9, 15 seconds.

Light trail photography practice

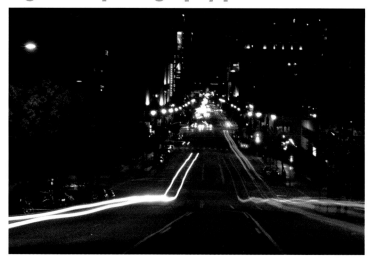

6.41 The car lights going up and down Vine Street

Table 6.11
Taking Light Trail Photographs

Setup	**Practice Picture:** Los Angeles at night, even late night in the middle of the week, has traffic. The image in figure 6.41 was taken at the top of Vine Street looking down toward Hollywood. I was set up in the center median and had traffic going around me in both directions.
	On Your Own: Photographing traffic at night is a great way to get light trail photographs, and the best thing about shooting traffic is that it is never the same twice. Traffic patterns change, and the light trails will change as well.
Lighting	**Practice Picture:** The lighting was mainly from the car lights going around me. It was important to keep the tripod steady even with the cars rushing by.
	On Your Own: To get the light trails to stand out, the photograph needs to be taken after dark.
Lens	**Practice Picture:** I used a wide-angle lens to shoot the cars going past me, creating the white and red lights coming in from each corner.
	On Your Own: Any lens will work for this. A zoom lens is needed to make certain types of light trails like those in figure 6.39 and figure 6.40.

continued

Table 6.11 *(continued)*

Camera Settings	**Practice Picture:** I set the camera to Manual mode and the shutter speed to 10 seconds, then set the aperture to f/20 and took the first exposure. After checking the exposure on the LCD screen, and seeing that the scene still looked a little too dark, I increased the shutter speed to 15 seconds and then 20 seconds. This kept the sky dark and made nice light trails.
	On Your Own: The most important part is to shoot multiple exposures of the scene. It is better to shoot first and study later. Use the LCD screen to make quick adjustments to the exposure and keep shooting.
Exposure	**Practice Picture:** ISO 100, f/20, 20 seconds
	On Your Own: To get the whole scene in sharp focus, an aperture of f/9 or higher is needed. If the background doesn't need to be in focus, a wider aperture can be used, but that could cause a shorter shutter speed, which might not let enough light into the scene to get the trail effect.
Accessories	A tripod is great for holding the camera steady during the long exposures necessary for getting good light trail exposures. The Sony remote is useful for this type of photography because it lets you trigger the Shutter button without touching the camera.

Light trail photography tips

✦ **Use a tripod.** Light trail exposures need long shutter speeds, and the best way to keep the camera steady is by using a tripod.

✦ **Use the 2-second self-timer.** Pressing the Shutter button can cause the camera to shake, which can cause the image to be slightly blurry. Using the 2-second self-timer accessed in the Drive mode can help to reduce this.

✦ **Use the review on the camera to adjust the exposure.** One of the biggest advantages of digital photography is the ability to review the photograph that you just took to make adjustments before the next photograph.

Fireworks

The most important advice for shooting fireworks is to use a tripod. Setting the camera on a tripod keeps the camera steady during the long exposure needed to capture the falling light trails. Use manual focus to preset the focus to infinity, so that the camera doesn't have to try to focus on distant bright lights that might give the camera problems. Set the camera to Manual mode, the ISO to 100, and the aperture to f/11. The only setting to change at this point is the shutter speed. I start at 2 seconds and work up or down from there. For photos of just the fireworks, use as long a lens as possible to fill the frame with the fireworks. If the photo you want to capture is a fireworks display over a city skyline, a wider-angle lens is necessary. A fireworks display gives you multiple chances to shoot the fireworks; use these chances to correct the exposure and framing between photos. The optional Sony cable release is useful in this situation because it reduces camera movement and lets you watch the fireworks so that you can trigger the shutter release when the rocket is at its apex. This lets the shutter stay open while the light trails are visible and helps in getting a bright, sharp photo.

After the first photo, check the exposure by looking at the picture on the LCD screen. If it looks underexposed, increase the shutter speed to 3 seconds and try again. If the scene looks overexposed, decrease the shutter speed to 1 second. Because the A200 has a Bulb setting, you can also manually keep the shutter open while the fireworks are visible. Just set the shutter speed to Bulb, hold the shutter down when the rocket bursts, and release the shutter when the light trails start to fade. There is usually a grand finale, which will have multiple color bursts all at the same time. This will be brighter than the single explosions, so adjust the shutter speed accordingly.

Macro Photography

A macro lens lets you get really close to your subject. The specialized macro lenses give you a 1:1 view of your subject, allowing you to see the world in a different way. It is possible to get really close to your subject without using a specialized and expensive macro lens by using a special close-up filter that will turn any zoom lens into a macro lens. Sony makes two true macro lenses, and there are third-party lens manufacturers that also produce macro lenses that can be used on the A200.

/Note *A 1:1 view means that the image being captured on the sensor is the same size as the area being photographed.*

Macro lenses are usually used very close to their subjects, and because of this they have a very shallow depth of field. It is not unheard of to use an aperture of f/8 or higher in macro photography. The small distance between the lens and the subject also makes it critical that you not move the camera once you've set up a macro photograph. The smallest movement can cause the image to be out of focus or it can cause the focus to shift from one area to another.

 Cross-Reference *For more information on specialized lenses, see Chapter 5.*

6.42 The bees in my yard were out pollinating the flowers. I used a 100mm macro lens to get as close as I dared and kept the camera focused on one flower and then waited for a bee. Shot at ISO 400, f/8.0, 1/400 second.

6.43 The edge of this flower was photographed with a macro lens.

Inspiration

Great subjects for macro photography can be found in nature and around the house. Almost any item can be used in macro photography, and photography close-ups of these items can reveal textures and shapes that you wouldn't normally notice. Look to nature for other great macro photography opportunities. Leaves, flowers, and insects can all make great subjects for close-up photography. A trip to a local park will yield a great many macro photo opportunities.

6.44 This little fishbone carving was photographed on a white board with a yellow board behind it. This was taken at ISO 100, 100mm, f/13, 1 second exposure on a tripod.

Macro photography practice

6.45 A lone ladybug crawling along a leaf

Table 6.12
Taking Macro Photographs

Setup	**Practice Picture:** I wanted to shoot a photograph of a ladybug, so I bought a container of ladybugs and let them loose onto the plants in the backyard. I had set the camera on a tripod aimed at the main flower and managed to get some great ladybug photos when I noticed a lone bug on an adjacent leaf as shown in figure 6.45. So I moved the camera over to the left and photographed the ladybug as it traveled across the leaf.
	On Your Own: Examine the world around you and look for patterns in your subject, like the leaf veins in figure 6.45. Experiment with different angles.
Lighting	**Practice Picture:** This photo was taken with natural light in the late afternoon. The sunlight was strong enough to light the scene through the leaf, which allowed me to use a fast enough shutter speed to freeze the walking lady bug and use an aperture that let the whole ladybug be in focus.
	On Your Own: Watch the angle of the light play across the subject. Because the area being photographed is very small, it doesn't take a big change in the light source to make a big difference in the composition of your photograph.

Lens	**Practice Picture:** I used a 100mm macro lens.
	On Your Own: Sony makes two dedicated Sony-branded macro lenses. The 100mm f/2.8 macro lens that has a 1:1 magnification and a minimum focusing distance of 14.4 inches, and the 50mm f/2.8 macro lens with a 1:1 magnification and a 7.8-inch minimum focusing distance. Both of these lenses do a great job of getting you in real close to your subject.
Camera Settings	**Practice Picture:** I set the camera to Shutter Priority mode and the shutter speed to 1/100 of a second so that the ladybug would be frozen as it moved across the leaf.
	On Your Own: When the subject of your macro photograph is moving, a shutter speed that freezes the motion is required. If the subject of your photograph is motionless and you use a tripod, set the camera to Aperture Priority mode and don't worry about the shutter speed.
Exposure	**Practice Picture:** ISO 100, f8, 1/100 second
	On Your Own: Make sure that you use an aperture that is deep enough to get the whole area you want in focus. To get really great macro photographs, a tripod is necessary, but if one is not handy then make sure that the Super SteadyShot is turned on to help with camera shake.
Accessories	A tripod is a necessity when shooting very close to your subjects. A Sony Remote control can be used to trigger the shutter release without touching the camera to make sure there is no camera shake at all.

Macro photography tips

✦ **Use a tripod and cable release.** I know I have mentioned this, but using a tripod is a must to getting the sharpest macro photographs possible; and using the Sony Remote control, a wired cable release, will let you take the picture without having to push the Shutter button on the camera.

✦ **Super SteadyShot.** If you can't use a tripod, turn the Super SteadyShot on and use the vibration reduction that is built into the A200.

✦ **Change your viewpoint.** Try different angles and distances. After you set up the camera and tripod for the shot, it isn't hard to experiment a little. Move the camera to the right or left and shoot a different angle of the same subject.

✦ **Change the light.** If it is possible, try moving the item in relation to the light, or try moving the light. A small change in the angle or direction of the light can make a big difference to the final image.

✦ **Move the camera to focus.** Switch from autofocus to manual focus and set the lens for the closest focus point. Then move the camera and lens forward or backward until the focus is sharp. You basically move the camera as close as possible until your subject is in sharp focus. This results in getting the maximum magnification of that lens.

Night and Low-Light Photography

Shooting photographs in low light can be difficult, but when it is done right, the images can look great. After the sun goes down, a great deal of light remains, especially in cities. Buildings that are lit up at night, streetlights that cast their glow, and even neon signs are all great light sources for night and low-light photography.

The same city street shot during the day has a completely different look to it when shot at night. Under the bright direct sunlight of midday, a street might look washed out and dull. That same street lit by the glow of streetlights can look warm and inviting. As the sun sets, watch how the city lights up, from streetlights coming on to the lights from restaurants and bars spilling out into the streets along with the headlights and taillights of cars.

As discussed in Chapter 3, getting the correct exposure means adjusting the shutter speed, aperture, and ISO. Low-light situations can be especially tricky. Because low-light photography by definition has very little light, the shutter needs to stay open longer so that more light can reach the sensor. The ISO might have to be raised to make the sensor more sensitive to the light and the aperture will most likely need to be set as wide open as possible.

6.46 The neon signs and brightly lit marquee provide enough light to hand hold the camera at ISO 200, f/3.5, 1/40 second.

Inspiration

Right after the sun has set and before the sky turns completely dark is one of the best times to photograph. The sky takes on a pleasing deep blue hue and is not completely black during this twilight time. Because this is a relatively short period of time, you need to be prepared to get the most out of it.

6.47 The wide stairs outside the San Diego Convention Center are lit at night. Shot at ISO 200, f/5.6, 1/3 second.

Night and low-light photography practice

6.48 The San Diego skyline after dark

Table 6.13

Taking Night and Low-Light Photographs

Setup	**Practice Picture:** The San Diego city skyline as seen from Coronado Island. This is a great spot to take photos, especially right after the sun sets. In figure 6.48, the lights from the city were reflected in the water, making for a great nighttime city skyline.
	On Your Own: Bodies of water reflect light and increase the amount of light in the scene. Static subjects make good subjects for night and low-light photography. Buildings and other structures usually have their own light source.
Lighting	**Practice Picture:** The lights from the city were reflected into the water and there was still a small bit of blue left in the sky.
	On Your Own: When shooting at night, there are usually a variety of light sources and you should take them all into consideration. One method of dealing with the different types of light is to decide which light source is the one lighting up most of the scene, and then set the white balance to accurately deal with that light source. It is also possible to deal with the white balance in post-processing. One thing to keep in mind is that the color of the lights can add to the feeling in the photo.
Lens	**Practice Picture:** I used a wide-angle lens for this shot of the city. The lens was set to 18mm, which was wide enough to get the whole skyline in the scene.
	On Your Own: Any lens can be used for night and low-light photography. Many zoom lenses change the maximum aperture as the lens changes focal lengths. When using these lenses, be aware that the aperture setting might change when changing the focal length.
Camera Settings	**Practice Picture:** I shot with the A200 on Manual mode, and after a test shot at 6 seconds, I set the shutter speed to 8 seconds and then to 15. I previewed the image on the LCD and liked what I saw. I then set the Drive mode to Bracketing mode and started taking photographs.
	On Your Own: Preview your images to check the first exposure as a basis for the following exposures. I recommend bracketing the exposures and shooting as many shots as possible when the twilight is just right.
Exposure	**Practice Picture:** ISO 100, f/9, 15 seconds
	On Your Own: Using a tripod lets you get sharp images using long shutter speeds, and this is especially important when shooting in low light. Using the lowest ISO possible will result in photos that have lower digital noise and will look better when enlarged, especially for printing.
Accessories	A tripod is needed when shooting long exposures.

Night and low-light photography tips

✦ **Bracket your shots.** The time period between sunset and complete darkness doesn't last very long. Bracketing your shots is a good way to make sure you get the exposure you want.

> **Cross-Reference** *Bracketing is covered in more detail in Chapter 2.*

✦ **Use a remote or the 2-second self-timer mode.** Pressing the Shutter button with your finger, even when the camera is on a tripod, can cause a small amount of movement, resulting in a blurred image. Using the Sony Remote control is great if you have one, but it is also possible to use the 2-second self-timer. This will mean that you will not be able to bracket, as the Drive menu controls both the bracketing and the self-timer modes.

✦ **Use a tripod.** Many night and evening photos require longer shutter speeds that need a tripod to keep the camera steady.

✦ **Be aware.** When shooting at night, be aware of your surroundings. Places that seem safe during the day can change at night, so you should always be on the cautious side, especially when you are setting up camera gear. The best bet is to have a friend or two with you, and leave if you don't feel safe.

✦ **Use the full moon.** To make the most of shooting at night without having to use any extra lights, try to use the light of a full moon. On a clear night, the light of the moon can be very bright and useful in getting a good image.

Online Auction Photography

There are people who have turned online auctions into full-time businesses, but the great thing about the Internet and online auctions is that anyone can do it. Web sites such as eBay, uBid, and Yahoo! Auctions let you sell a wide variety of items, from concert tickets to cars, but you should always check the rules before posting on any auction site. Having images of what you are selling is very important, and having good, sharp images can make you stand out from your competition. Good photographs of your items can help in getting more bids, and, in the end, a higher price.

Photographs for online auctions need very little in the way of extra equipment. The shot of the drill set took no extra gear because of the nature of the item being sold; the brick and concrete background did not detract from the drill at all. There is no reason to spend a lot of time on each photograph that will be used for online auctions, as they only have one purpose, and that's to accurately represent the item that you are selling.

6.49 This cordless electric drill set is shown with all the parts and manual, sitting together without any distracting background. This photograph was taken outside using direct sunlight, making for a hard, bright light. Shot at ISO 100, 50mm, f6.3, 1/640 second.

Inspiration

Photographing your items for online auctions against a clean uncluttered background is very important. This lets your item really stand out and be seen, and nothing in the background distracts your potential buyers. Keeping the background simple can be nothing more than keeping the area clear of any other items as in image 6.49 or it can be done using some inexpensive equipment.

6.50 A signed and numbered, framed poster was set on a white board with another board behind it. I then zoomed in tight using the 18-70mm lens and using the light coming into the room from a nearby window. Shot at ISO 400, 35mm, f/5.6, 1/15 second using the Super SteadyShot to avoid camera shake.

6.51 A concert ticket photographed against the same white board used in images 6.50 and 6.52. When shooting the ticket, I overexposed the scene by 2 stops to make the ticket white. Shot at ISO 800, 70mm, f/5.6, 1/40 second with Super SteadyShot turned on, exposure compensation set to +2.

While there are many products available that let prospective sellers photograph their goods with a nice clean background, you can do the same with two pieces of white foam board available in any art store for a lot less. By placing one foam board on the ground and one behind it, you can make a nice white area to shoot your items for sale. The size of the boards is determined by the size of the largest objects you want to sell.

Online auction photography practice

6.52 A limited first edition of Stephen King's *Desperation* photographed next to its clamshell case

<div align="center">

Table 6.14
Taking Online Auction Photographs

</div>

Setup	**Practice Picture:** The book and the case in figure 6.52 were set up on the white board with a second white board set behind them. If you look closely, you can see where the two boards meet to the right of the book. I made sure that this image showed both the book and the inside of the book case. If I were to sell this online, I would add images of the side and back along with a photo of the signature page. **On Your Own:** Keep the setup simple and ask yourself what you think a buyer wants to see. Because these photos will only be used on computer monitors, they do not have to be extra big, and it is important that the item that you are selling fills the frame.
Lighting	**Practice Picture:** The lighting I used here is very plain. There was no extra light other than the natural light coming through a nearby window. I used a higher ISO and slower shutter speed to achieve proper exposure. **On Your Own:** Keep the lighting simple and clean. Keep the item evenly lit and try to avoid harsh shadows on the items you are selling. The buyer is probably more concerned that you show the item in the truest form and don't try to hide any scratches, dents, or cracks with creative lighting.
Lens	**Practice Picture:** I used the 18-70mm lens that comes with the A200 kit from Sony. This lens, while not the fastest or most expensive, does a great job for photos like these. I zoomed in close enough to fill the viewfinder with the book and the cover while making sure that the viewer could see both clearly. **On Your Own:** Any lens that lets you get close enough to fill the frame will work. When in doubt, use the lens that came with the A200.
Camera Settings	**Practice Picture:** ISO 400, 55mm, f/5.6, 1/15 second with the Super SteadyShot turned on **On Your Own:** Because I was using the natural light in the room, I adjusted the ISO so that I could get a proper exposure and was still able to hold the camera steady enough to get a sharp exposure. Turn Super SteadyShot on to help with getting a good exposure in the available light.
Exposure	**Practice Picture:** I used Multi-segment metering, and because the book was very dark and the backdrop was very light, the camera took these values and came up with the exposure automatically. **On Your Own:** The metering system in the A200 is good and works for most items. If you need to, use exposure compensation to make the image lighter or darker as needed. If the metering is constantly getting the image too light or too dark, then switch to Center-weighted metering.
Accessories	Using a tripod is good for this type of photography because you can just leave the camera set up and keep moving new items to be photographed onto the white board. Two pieces of white board make it easy to get these types of images.

Online auction photography tips

✦ **Honesty is the best policy.** It is easy to remove dents, scratches, or other imperfections using today's photo-editing software. This is one time that I recommend not correcting the imperfections. You should be honest about what you are selling instead of making the object flawless.

✦ **Zoom in close.** You only have a second or two to make an impact when your potential buyer is look-ing through the auction listings. Use all the space in the photo for the item. Because the A200 does not have any crop functions, it is important to fill the frame when photographing the object.

✦ **Shoot all the items at the same time.** If you have multiple items to sell, gather them all together and shoot them at the same time. Setting the backdrop up once and shooting all the items at the same time will save you a lot of time and energy.

✦ **Keep the background simple.** Having a cluttered background filled with items that are not for sale or that have nothing to do with your item for sale is distracting to the prospective buyer. Keep the background plain and simple.

✦ **Take multiple photos from vari-ous angles.** Buyers like to see mul-tiple angles of whatever they are buying. It pays to have multiple shots of the same product, and using the method outlined earlier makes taking multiple shots a snap.

Outdoor Portrait Photography

Taking pictures of people, or portrait pho-tography, is one of the most common forms of photography and the reason a lot of peo-ple buy cameras in the first place. Portraits can include only the head of the subject, the shoulders and head, the upper torso, or the entire figure. Portraits can either be posed or candid, and although portraits can be shot anywhere, this section deals with shooting outdoors. Indoor portraits are dis-cussed earlier.

Shooting outdoors usually means that you will be using natural light, and will most likely be incorporating elements from the scene into the photograph. The natural wood fence background in figure 6.53 is very different from the plain black background used in indoor portrait photography.

6.53 Anna was photographed in her own backyard. She was standing on a bench while her mom held a diffuser overhead to create even lighting. Shot at ISO 100, 35mm, f/8, 1/250 second.

6.54 The couple posed on the beach are lit by the setting sun and fill light from a flash on the camera. Shot at ISO 100, 50mm, f/5.6, 1/60 second.

Inspiration

As with indoor portraits and group portraits, the key to getting a great outdoor portrait is to let the character of the subject shine through. The greatest background combined with the greatest model will not make the greatest photo if the two don't seem to go together.

I have found that the best outdoor portraits happen when the subject is comfortable in his or her surroundings. However, be careful not to let the surroundings overpower the subject.

Outdoor portrait photography practice

6.55 Dave, photographed before a morning surf

Table 6.15
Taking Outdoor Portraits

Setup	**Practice Picture:** The image in figure 6.55 was taken in the midmorning before Dave went out to hit the surf. I posed him on the top of the cliff overlooking the Pacific with the other surfers in the background.
	On Your Own: When shooting outdoors, it is important to pay attention to not only your subject but also the background. One method of making your subject stand out while lessening the background is to use a shallow depth of field. This keeps the subject in sharp focus while blurring the background.
Lighting	**Practice Picture:** This was shot in the midmorning light. I angled Dave slightly so that the light played across his face and not directly on it.
	On Your Own: The best times to shoot are early in the morning or late in the afternoon. The light is not quite as harsh during these times, and the shadows are not so hard. If the shadows are too severe, you can use a fill flash to bring out details in the shadow areas or adjust your model if possible to change the angle of the shadows.

continued

Table 6.15 *(continued)*

Lens	**Practice Picture:** I used the 18-70mm kit lens set to the 35mm focal length to take this photo. I was not able to back up any farther away from Dave due to the heavy traffic on the road behind me, and Dave couldn't back up any farther due to the cliff behind him. **On Your Own:** If everything was perfect in the world, I would use a 50mm or higher focal length for these portraits; the 85mm f/1.4 makes a fantastic portrait lens. But because the world is not perfect and there isn't always enough room to use that focal length, any lens can be used to create a good outdoor portrait.
Camera Settings	**Practice Picture:** I shot this on Aperture Priority mode to try to keep the background and foreground in as much focus as possible. Because of the bright sunlight available, there was no need to use a slow shutter speed or a high ISO. **On Your Own:** Shooting in Aperture Priority mode gives you a greater amount of control over the background. Shooting outdoors means that the light can change from minute to minute. Having the subjects hold their position while you shoot lets you not worry as much about shutter speed. Start with an aperture that gives you the look you want for the portrait, and then increase the ISO if needed.
Exposure	**Practice Picture:** ISO 100, f/13, 1/125 second **On Your Own:** Set the camera to Multi-segment metering mode as a good starting place to keep all the elements in your image in good exposure. If the scene has a very light or dark area, use Center-weighted metering or Spot metering to get an accurate exposure reading for your subject's face.
Accessories	A tripod is useful for holding the camera steady while adjusting the model. An assistant can be a great help in posing people and holding a reflector or diffuser if necessary.

Outdoor portrait photography tips

✦ **Watch the light.** Sunlight constantly changes as the sun moves through the sky. A stray cloud can change the lighting dramatically, and it is up to you to adjust accordingly.

✦ **An assistant is useful.** At times, shooting outdoors requires the use of reflectors and diffusers, and using these correctly while taking the photograph can be nearly impossible.

 Cross-Reference *For more on diffusers and reflectors, see Chapter 4*

✦ **Pay attention to the background.** The background can change during a shoot, and it is easy to forget to continuously check to make sure the background is clear of distractions. After completing a recent on-location shoot, I found that during the shoot a stranger had wandered into the frame and was in the background of a handful of shots, effectively ruining the photographs.

Panoramic Photography

Panoramic photographs convey a sense of space that makes them a great choice for sweeping landscapes. Panoramic photography used to take specialized pieces of equipment or cameras. With digital photography and advances in software, panoramic photography has become much easier for everyone. Stitching three, four, or more photos together has become much easier. You can shoot panoramic photos in two ways: The first is to shoot multiple exposures, panning the camera to capture a large area and then merging the photos together into a single image using third-party software, like Adobe Photoshop CS3. The second method is to crop a single photo to create a panoramic effect. Cropping one image actually removes information, making a smaller file with fewer pixels, while combining two or more images creates a much larger image.

The key to shooting good panoramic photos is to set up the shot correctly before making a single exposure. Although you can shoot a series of photos to create a panoramic print without a tripod, I always recommend using a tripod. This keeps the camera on the same level throughout the process.

Sports Photography

Sports photography is all about capturing a moment in time. To freeze fast-moving action, a shutter speed of 1/250 second is the absolute minimum that should be used, and I recommend a shutter speed of 1/500 second or faster. What this means in practical terms, is that either there needs to be a lot of light or you need to use a fast lens, one with a maximum aperture of f/2.8 or faster.

Shooting kids' sports can be a challenge because games like baseball take place behind a protective fence. The same techniques that are used to shoot animals in a zoo can be used to get good photos of the children that are playing behind a protective barrier: getting as close as possible to the barrier and using a 100mm focal length or more to focus on the action. Use the narrowest depth of field possible on the lens (smallest number) and the fence will seem to disappear as it did in figure 6.57.

Note *Professional sports photography requires super-fast, super-long telephoto lenses, which makes shooting pro sports events a very expensive pastime that is not for everyone. For example, the Sony 300mm f/2.8 lens costs more than $5,000.*

6.56 I wanted to freeze the runners in motion so I used a very fast shutter speed of 1/2500 second, freezing the runners in midstride, two of them in the air. Shot at ISO 400, f/6.3, 1/2500 second.

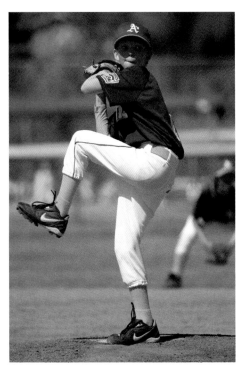

6.57 Lyle gets ready to pitch in a local Little League game. The photograph was taken through the protective fence at the Little League field. Shot at ISO 200, 200mm, f/2.8, 1/200 second.

The timing needed to get a good sports photo takes practice and knowledge of the sport. Every sport has predictable moments and movements, and knowing these helps you get the best shot. With fast-moving sports, it is important to anticipate the action; if you see the action you wanted to capture through the viewfinder, it is too late to capture it. Pressing the Shutter button right before the action occurs will help in capturing that defining moment.

Inspiration

There are a great many sporting events happening all the time, some big and some small, but they all give you the opportunity to practice your sports photography. Sporting events in their very nature are exciting; that's what keeps people watching. Consider photographing events that are not part of the traditional sporting events — like the paintball player in figure 6.58.

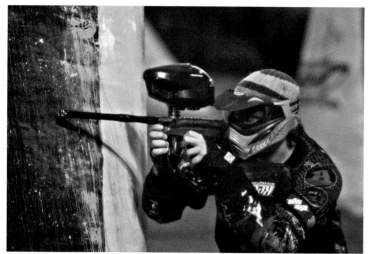

6.58 A paintball player gets ready to make a final charge for the flag. Shot at ISO 800, 160mm f/2.8, 1/125 second.

Sports photography practice

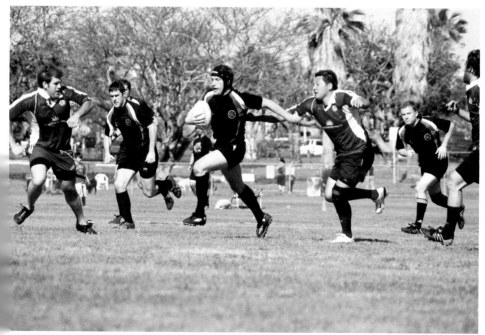

6.59 A rugby game played at the local park

Table 6.16
Taking Sports Photographs

Setup	**Practice Picture:** The local park down the road from my house is host to many different sporting events during the year, and I enjoy stopping and watching some of the different games. I particularly like to watch the rugby games, and because I played a little in college, I understand the game well and can follow the action with my camera. The action moves fast and furious and can change direction very quickly. In figure 6.59, the ball carrier was making a break for it and I was tracking along with my camera.
	On Your Own: Successful sports photography takes planning. Make sure you have the right gear and, more importantly, the right positioning to capture the action. Knowing where the action takes place will help you get set up to capture the shot. Watch the sport for a while to see how the play is moving and look for the best angles to capture the excitement.
Lighting	**Practice Picture:** This photo was taken in the midafternoon and the sun was high and bright. This helped by making it easy for me to use a fast shutter speed so as to freeze the action.
	On Your Own: The more light present when you shoot, the easier it is to use a higher shutter speed to freeze the action and a low ISO to avoid digital noise. Pay attention to any hats or headgear worn by the players that can cause shadows to fall across the players' faces. Be aware of how the shadows can move during the game as the sun moves across the sky. Areas that were in bright sunlight at the start of the game could be in heavy shadows toward the end, requiring a higher ISO, slower shutter speed, or a wider aperture.
Lens	**Practice Picture:** I was using the 18-250mm lens so that I could zoom in across the field and still fill the frame with the action. The zoom lens also let me go with a wider-angle shot when the action got close to me.
	On Your Own: Most sporting events happen pretty far away, so a lens with a long focal length in usually necessary to capture good sports photographs. A quick look at the sidelines of any pro sporting event and you will see photographers with really big lenses; this lets them get up close while not interfering with the game. Even capturing the action at a child's soccer game requires at least a 100mm lens.
Camera Settings	**Practice Picture:** I set the camera on Shutter Priority mode because I wanted to make sure that I froze the fast-moving action.
	On Your Own: Set the camera to Shutter Priority mode and set the shutter speed fast enough to freeze the action, at least 1/500 second (1/250 if the action is a little slower). Use the LCD review to see if the shutter speed really is getting you the sharpness you want, and adjust the shutter speed if necessary.

Exposure	**Practice Picture:** ISO 200, f/6.3, 1/1250 second
	On Your Own: Shooting using the Shutter Priority mode with a shutter speed fast enough to freeze the action may require you to increase the ISO to get a properly exposed image. If possible, use a wider aperture (smaller f-number) to get the most light through the lens as possible before raising the ISO. This keeps the digital noise to a minimum and helps isolate the action by blurring the background.
Accessories	Take plenty of memory cards; shooting in Continuous Advance mode can really use up the memory. When shooting in the sun, wear a hat to avoid sunburn.

Sports photography tips

✦ **Shoot in Continuous Advance mode.** By shooting multiple exposures during the action, you are more likely to capture the best action shot.

✦ **Carry a lot of memory cards.** Shooting in Burst mode results in a great many photos, and because there is not enough time to edit them during the event, make sure you have enough memory cards to last.

✦ **Shoot using the widest aperture possible.** Shooting with the widest possible aperture lets you use the highest possible shutter speed, which helps freeze the action. It also blurs the background, which helps keep the focus on the main subject.

✦ **Look to use different angles.** At times it is better to kneel down and shoot from a lower angle, especially when shooting a field game like kids' soccer. Other times it pays to go a little higher in the bleachers and shoot down.

✦ **Ask permission when shooting kids.** This is a good basic tip for any event. Parents are highly protective of their children, and asking them before aiming your long lens at their children helps avoid any misunderstandings. If the parents are not present, talk to a coach or game official.

Still-Life Photography

There is no better way to practice your lighting and composition than with still-life photography. Having a subject that is small enough to move and position so you can see the way light strikes it is a great learning tool. Shooting still life gives you control over the lighting and viewpoint, and setting up a small still-life area is easy. All you need is a table to hold your subject or subjects, your

A200, a tripod, and a light source. The light source could be a continuous studio light or a dedicated flash unit, or it can be the sun coming through a window. When shooting still life outdoors, the best light is in the early morning or late afternoon when the sun isn't directly overhead. The problem with this light is that it changes very fast, which doesn't give you much time to photograph.

It is important to take the background into consideration when shooting still-life photographs. The right background makes your

6.60 The chess pieces are set up on the board. The focus and depth of field really make the knight stand out. The background was a piece of white foam board and the light was a simple table lamp. The white balance was corrected using software after the image was taken. Shot at ISO 100, f/2.8, 2 seconds.

photos stand out. Keep the background clean and uncluttered. I use different colored pieces of foam board as backgrounds. They come in a wide variety of colors and can be easily found at any good art store.

Using a tripod lets you set the camera up and make minute adjustments without having to deal with holding the camera. Keeping the camera rock steady also lets you use a lower shutter speed without having to worry about blur.

Inspiration

The subject matter for still-life photography can encompass a great many things, which makes practicing easy, as any item can be used. Try to avoid the temptation of cluttering the scene; start with a single item and

build the scene carefully. Only add items that enhance your composition and watch how each item changes the light and shadows falling onto the other items.

Any item can be made the subject of a still-life photograph: flowers, jewelry, a favorite vase, or a piece of clothing. It is up to you to arrange and stage the items so they are shown in the best light.

Food makes a great subject for still-life photography, and there are a great many places that use food photographs. Look in any cookbook or food magazine and you will see numerous great-looking food images. When shooting food, make sure that it is fresh, as nothing is as unappetizing as stale-looking food.

6.61 These peppers were placed on a black piece of foamboard with a second piece as a back drop, and light with a single wireless flash was held over the peppers. I underexposed the image by a full stop to get the look I wanted. Shot at ISO 200, f/5.6, 1/60 second with the exposure compensation set to −1.

Still-life photography practice

6.62 Tahitian mask

Table 6.17
Taking Still-Life Photographs

Setup	**Practice Picture:** This Tahitian mask in figure 6.62 was placed alone on a piece of black paper, and a sarong was hung behind it. I wanted the rich color of the wood to stand out alone.
	On Your Own: Anything can be a subject for a still-life photograph. Look at the scene from different angles and watch how light plays across your subject. Don't be afraid to experiment with the arrangement of the items, the light, or even the background in your composition. You might come across a more pleasing image than the one originally envisioned.
Lighting	**Practice Picture:** I used a dedicated flash fired off-camera in wireless mode to the left of the camera to get the side lighting, and to keep the background relatively dark.
	On Your Own: An external light source is a big plus when shooting still-life photos. Positioning the light source at a different angle than the camera helps create scenes that don't look flat.
Lens	**Practice Picture:** I used the 18-70mm kit lens at the 50mm focal length.
	On Your Own: Any lens can be used for still-life photography. Use a lens that allows you to get the compositions you want. A zoom lens will allow you to adjust the focal length without moving the camera and can help with creating unique still-life images.
Camera Settings	**Practice Picture:** I shot this scene in Manual mode. I wanted to control the depth of field so the mask in the front would be in sharp focus while the background is pleasantly blurred.
	On Your Own: Because your still life by definition is not moving, the shutter speed is not as important. Use the aperture to set the depth of field you want. Apertures of f/5.6 or wider cause the backgrounds to blur, making your subject really stand out. A slower shutter speed requires a tripod to keep the camera from moving.
Exposure	**Practice Picture:** ISO 100, f/6.3, 1/250 second
	On Your Own: Because you have control over the light and the items in your still life, the Multi-segment metering mode works really well for this type of image. If you want to slightly over- or underexpose the image, use the exposure compensation to make the adjustments.
Accessories	A tripod is helpful so that the camera can be held still and in the same place while the scene is built and lit.

Still-life photography tips

✦ **Use a tripod.** Using a tripod keeps the camera steady, and more importantly, in the same exact position so that you can arrange and rearrange the subject of your photograph. Keeping the camera steady on a tripod also produces the sharpest photographs possible by eliminating any movement even during long exposures.

✦ **Use the best-looking items.** This is especially true when shooting food. Use the freshest, most appealing food. Clean off any dirt and grime to get the item as clean as possible.

✦ **Watch for dust.** When shooting anything that has a reflective surface, dust carefully. I use a can of compressed air to blow the dust of any reflective surface between shots. Just remember not to aim the compressed air back toward the camera.

✦ **Change the background.** Shooting in front of a different background can change the entire tone of the photograph. If you were shooting against a light color, try using a darker background.

Sunrise and Sunset Photography

The light during sunrise and sunset is special to photographers, as I talked about in Chapter 4. The light available during this time of the day is so good that it is nearly impossible to not get a good sunset photo. Everybody loves to take sunrise and especially sunset photographs, and even though they are very common, a great sunset photograph can still elicit wonder from the viewer.

6.63 The moments after the sun set photographed from under the pier in Ocean Beach, California. ISO 100, f/13, 2 seconds.

The light changes very rapidly during sunrises and sunsets, and to make the most of it you need to be prepared. Knowing what time the sun rises or sets will help you be in place and ready to shoot before the light starts to get that great golden glow.

Inspiration

There is a new sunrise and sunset every day; it is just a matter of going out and photographing it. It doesn't matter if the sun is setting over the ocean, a city skyline, or a far-off mountain range, the warm colors during the sunrise and sunset make for great photographs.

To make your sunrise and sunset images stand out from the pack, look for natural or manmade formations. Use these formations to add depth and interest to your images, as I did with the pier in figure 6.64.

6.64 The beautiful deep reds and oranges created by the setting sun and the moving storm clouds. ISO 100, f/5.6, 1 second.

Sunrise and sunset photography practice

6.65 The gate on the Ocean Beach pier at sunset

Table 6.18
Taking Sunrise and Sunset Photographs

Setup	**Practice Picture:** The Ocean Beach pier is one of my favorite photo subjects and I shoot it often, especially at sunset. For figure 6.65, I went looking for a different angle on the same old sunset photos, and instead of shooting below the pier I shot on the pier. The gates that close the pier at night and during high surf have the words OCEAN BEACH in them and I shot through the gate, so that the reds and oranges of the sunset were seen through the cutout words.
	On Your Own: Sunrises and sunsets change every day, and because of this, when you find a great sunrise or sunset view, revisit the area if possible. The difference in the various sunrises and sunsets will amaze you.
Lighting	**Practice Picture:** Shooting a sunset is all about shooting the light. The colors are at their most vibrant when the sun has just set.
	On Your Own: Sunrise and sunset photographs are all about the light, so check the image on the LCD in the Histogram mode to see if there are any areas that have gone completely to white. There will be a line all the way to the right on the histogram that lets you know that there are areas of complete white. Areas of complete black in the image are shown by a line on the far left of the histogram.

continued

Table 6.18 *(continued)*

Lens	**Practice Picture:** I switched from the wide angle to a longer focal length to fill the frame with the gate. This needed a longer focal length than I normally use for sunset images, but it worked in this situation.
	On Your Own: Using a zoom lens is helpful in recomposing your scene without having to move. The ability to go from super wide to telephoto lets you produce multiple images of the same sunset. One thing to keep in mind is that many lenses change the maximum aperture as they zoom out. When changing the focal length, make sure the other settings have not changed without your knowledge.
Camera Settings	**Practice Picture:** This was shot using Manual mode. I set the ISO to 100 to get the least amount of digital noise possible. I then set the aperture to f/9 to get a deep depth of field, and finally I set the shutter speed. Because the camera was mounted on a tripod, I was able to experiment using a longer shutter speed without worrying about camera shake.
	On Your Own: I will always recommend using a tripod for these types of photographs, but at times it isn't possible. When that happens, start by opening up the aperture and increasing the ISO. Make sure that the Super SteadyShot is turned on. This lets you raise the shutter speed enough to hand hold the camera and still get a good exposure without camera shake.
Exposure	**Practice Picture:** ISO 100, f/9, 2 seconds
	On Your Own: The light changes very rapidly when the sun is rising or setting. A quick look at the LCD screen will let you make adjustments to your settings and try again. I adjust the shutter speed, leaving the aperture and ISO alone. The hardest part of shooting a sunrise or sunset is the actual sun. It is so bright that it can cause the camera to underexpose the rest of the image. To get the correct exposure, use the Spot metering mode to meter on the sky above the sun. Make sure that none of the actual sun is in the metering spot.
Accessories	A tripod is really important in getting decent sunset photos. Being able to hold the camera steady for long periods of time lets you get very sharp photos long after the sun has dropped below the horizon.

Sunrise and sunset photography tips

✦ **Use the Internet to find out sunrise and sunset times.** You can use Internet search engines like www.google.com or sites like www.sunrisesunset.com and www.timeanddate.com to find sunrise and sunset times for most areas around the world.

✦ **Use the Rule of Thirds.** Try to keep the horizon one third of the way down from the top or a third of the way up from the bottom of the image.

 Cross-Reference *For more on the Rule of Thirds, see Chapter 3.*

✦ **Arrive early.** To shoot a sunrise, arrive before the sun has started to rise and get set up. Once the sun starts to light the sky, there is not much time to get the shot.

✦ **Bracket your exposures.** The light at these two times of the day changes very quickly. Bracketing your exposures helps you get the exposure you want.

Travel Photography

Everybody loves to take vacations, and nothing helps to re-create those times than good travel photographs. It is one of the main reasons that people buy cameras — to get better photographs when on vacation. The A200 is perfect for this. Its small size and light weight make it easy to take with you, and combined with a telephoto lens that covers a wide range of focal lengths, it makes a great travel camera. I recently put this to the test by spending the day in New York City with the A200 and the 18-200mm lens. The camera was great in taking photos ranging from the Brooklyn Bridge to the views of New York from the top of Rockefeller Center.

Photographing identifiable landmarks is a must when traveling. When going to New York, make sure you get a photo of the Empire State Building, or when in San Francisco try to get a shot of the Golden Gate Bridge. Look for landmarks that identify your travels, but try to find a different perspective than the standard postcards. Make the image your own by using your viewpoint. This will not only make for a more personal image, but one that you will have an emotional tie to as well. The story on how you got the image will be part of the memory always associated with that trip.

Inspiration

Travel photography is a great way to share your adventures with others. Great travel photography will have your friends and family looking forward to seeing the latest photos of your trip. Look for unique clothes,

6.66 The Golden Gate Bridge. Shot at ISO 200, 28mm, f/5.6, 1/180 second.

6.67 A diner sign in Manhattan. Shot at ISO 100, f/5.6, 1/125 second.

people, architecture, events, and any other scenes that will transport you back when you see the images. Street posters, soft drink cans, even street signs that, while familiar in form and use, are unique to your location all make great travel images.

When shooting travel photos, especially at the popular areas or attractions, there will be many other people trying to get the same shot. Try to shoot from a different perspective or try to arrive early to get a good vantage point.

Respect the culture of the country you are visiting. There are places where photography is frowned upon. There are cultures that frown upon taking photographs of people, and some that dress the women in clothes that hide their appearance. Be polite and ask permission before photographing people so as not to disrespect the people who live there.

Travel photography practice

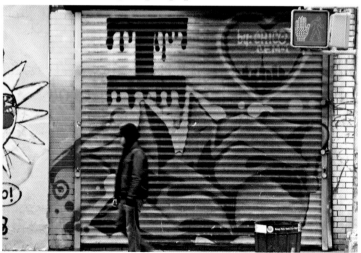

6.68 A street scene in New York

<div align="center">

Table 6.19

Taking Travel Photographs

</div>

Setup	**Practice Picture:** After eating a great sandwich at Katz Deli in the Lower East Side of Manhattan, I walked through the neighborhood armed with the A200 with the 18-200mm lens attached. The image in figure 6.68 was taken from across the street, and I waited until there was a break in the traffic. The pedestrian walking in front of the street art gives the image some motion.

On Your Own: Most vacations are not based on photography, and unless you are on a specific photo vacation, there are times that you need to make the most of a situation. It would be great to be able to come back in good light or on a sunny day, but that is not always possible. Try to change your viewpoint or angle to change the way the light hits your subject. Preplanning comes in handy: Do some research on your travel location, and make a list of places you want to see and photograph. |
| **Lighting** | **Practice Picture:** I was walking on the sunny side of the street and was looking across to the shady side. The tall building blocked out a lot of the direct light and made for nice even lighting on the building.

On Your Own: The best lighting is just after sunrise and just before sunset, but it is not always possible to be out photographing during these times. If there is a special landmark or area that is important for you to photograph, try to plan on being there either first thing in the morning or last thing in the afternoon. |
| **Lens** | **Practice Picture:** I used the 18-200mm lens zoomed out to 180mm to fill the frame with the street art across the street.

On Your Own: Travel photography can encompass a wide range of subjects at a wide range of distances. A compact zoom like the 18-200mm provides a wide range of focal lengths. Having a zoom lens on your camera means that you can recompose the photo without having to move. This makes it easier to get the shot you want. |
| **Camera Settings** | **Practice Picture:** I used a slower shutter speed to make up for the lower light in the shade. The Super SteadyShot helped to get the wall sharp while the shutter speed was still slow enough to show the motion in the pedestrian.

On Your Own: Shooting in Program Auto mode yields the best results in most situations with ample light. For shooting indoors, use Aperture Priority mode to use all the possible light. If the shutter speed is still too slow to get a sharp image, increase the ISO and make sure the Super SteadyShot is turned on. For situations where the exposure of a certain element of your scene is critical, switch to the Spot metering mode and take a second or third photograph. |

continued

Table 6.19 *(continued)*

Exposure	**Practice Picture:** ISO 100, f/9, 1/60 second
	On Your Own: When shooting people, use a wide aperture, such as f/4.5 or f/5.6, to slightly blur the backgrounds, making the people stand out. If the background is important to the image, then use apertures that will keep the whole scene in focus, such as f/9 or f/10. These apertures work well for shooting buildings and other large scenes as well.
Accessories	I recommend using a tripod most of the time; however, keep in mind that many places do not allow tripods to be used. The Web site www.photopermit.org/ has a lot of useful information on shooting in public places. Getting the permits needed before shooting is important. Plan ahead.

Travel photography tips

✦ **Practice at home.** It is easy to forget that the place where you live has attractions that visiting photographers would love to shoot. Think about the unique places close to home and practice your travel photography in your hometown or nearby countryside.

✦ **Protect your gear and yourself.** As a photographer, you can be an easy target for thieves because you carry your expensive camera gear around in the open all day. Use some common sense and keep your gear close to you at all times. Pay attention to your surroundings; exploring new places is great, but don't put your safety in jeopardy. Don't take more than you need when traveling.

✦ **Plan your day.** Shooting landmarks and other scenic areas on your travels is best done in the early morning or late afternoon; use the midday to shoot interiors and for planning the afternoon shoots. Keep shooting after the sun goes down because many cities take on a whole new life at night.

✦ **Take one more shot.** It is not often that you get to travel to the same places over and over again, so chances are that whatever photographic opportunity you have while traveling will be a once-in-a-lifetime chance. If you have taken your photographs and are ready to move on, take one more look and one more photo. Change the orientation from portrait to landscape or vice versa.

✦ **Shooting through a window.** At times you will be traveling by car or train and will see a scene you want to capture. When shooting through the window, place the camera as close to the window and at a slight angle to cut down on reflections. Make sure you focus on something in the distance and that the shutter speed is high enough to avoid the image being blurry.

✦ **Ask permission.** Always ask permission to photograph people, especially children. Even if the people don't speak your language, try to communicate your intentions and get a confirmation that photographing them is allowed.

✦ **Take a tour.** No matter how well you think you know a place, a trained guide can show you the best places to photograph and the best times to do it. Many specialized photography-based vacations and travel workshops are available for the novice and the professional photographer.

Wedding Photography

Weddings are a time of great joy and happiness, and can be a time of great stress and anxiety for a photographer. There are lots of professional photographers who spend their entire careers shooting weddings, and it can be a very lucrative business. The reason I included this section is because now that you own a dSLR, chances are that at some point friends or family members will want you to take some photos at their weddings. This seems to be one of the laws of digital photography, so it is better to go along with it.

Weddings are very special days, and the most daunting task facing a wedding photographer is that there are no second chances. There will only be one ceremony and one first dance, and those photos will mean the world to the bride and groom, so it's best to get it right the first time.

Inspiration

Weddings, by their very nature, take place at sites chosen for their beauty, and the people involved are dressed to impress. As the wedding photographer, it is your job to capture this in your images. The bride has spent a long time picking out the perfect dress for the perfect day; make sure that you capture her in the dress.

6.69 The wedding is based around the bride, so getting a nice shot of her before the ceremony is important. Shot at ISO 200, f/3.2, 1/60 second.

6.70 The bride, groom, and the minister photographed during the ceremony. A long lens was used so as not to intrude on the moment. Shot at ISO 200, f/2.8 1/200 of a second.

Tip
The A200 lets you push the ISO up to 3200, but setting the ISO at 400 or 800 will let you shoot in lower light and still be able to use a fast-enough shutter speed to avoid camera shake and freeze the action and will help to keep the digital noise to a minimum.

Look for the moments between the bride and groom during the ceremony when small gestures and glances convey their love. After the ceremony is a great time to gather the family and wedding party together to do some more formal-type photographs.

Wedding photography practice

6.71 The wedding party photographed right after the ceremony

Table 6.20
Taking Wedding Photographs

Setup	**Practice Picture:** The wedding party in figure 6.71 was gathered together right after the ceremony and quickly posed around the bride and groom. I started with the bride and groom in the middle and built the group by adding the groomsmen on the right and the bridesmaids (which included a man) on the left.
	On Your Own: Getting shots of the wedding party is important when photographing a wedding. These are the people who are closest to the happy couple and need to be captured for posterity. It is easier to shoot the bride and her entourage before the ceremony, but because traditionally the bride and groom do not see each other before the wedding, right after the ceremony is the first time that they can all be together.

Lighting

Practice Picture: The wedding was in the early evening and the sun was about to set, but there was still enough light to not have to use the flash as a main light source but instead as a fill light. I used a Sony dedicated flash with a sto-fen diffuser dome over the top of the flash to soften the fill light.

On Your Own: Soft light without harsh shadows makes the wedding couple look the best. Try to keep the couple out of direct, harsh light, and use the shadows if possible. Because the wedding is not under the control of the photographer, you will have to work with what you get. A dedicated flash will give you more power and control than the built-in flash. The new F56-AM with its ability to rotate the flash head is perfect for the lighting at a wedding.

Lens

Practice Picture: I used a wide to medium zoom lens to get wide enough to get everyone in the photo. Shot at 22mm.

On Your Own: Shooting a wedding can require a number of different lenses. Wide-angle lenses are great for interior and exterior location shots and for activities like the garter and bouquet toss. A telephoto lens is great for capturing close-ups in the ceremony without intruding. Primes with maximum apertures work best in low light and should be part of your wedding photography gear. A wedding photographer needs to have a full arsenal of lenses to be able to handle any situation.

Camera Settings

Practice Picture: The camera was set to Aperture Priority mode with the aperture set to f/5.6 to keep the group in sharp focus but not the background. I had the camera in the Multi-segment metering mode so that it would meter the full scene and I added the flash for some fill light.

On Your Own: When shooting a bride alone in her wedding dress, it is important to remember that the camera tends to underexpose to compensate for the large area of bright white. When shooting a groom in a dark tuxedo, the camera tends to overexpose the scene. Each of these situations can be handled by dialing in the correct exposure compensation. Overexpose slightly for the bride in the white and underexpose for the groom in the dark tux.

Exposure

Practice Picture: ISO 200, f/5.6, 1/60 second

On Your Own: Each part of the wedding can, and usually does, have different lighting from late-afternoon sunlight to the dark insides of a church. The good part is that the light won't change much inside, so you can get a good reading and set the camera correctly beforehand. Make sure you get the right white balance dialed in for the inside lighting, or shoot using the RAW file format so that you can correct the colors later. Make sure you reset the white balance and the other settings when changing locations.

Accessories

Plenty of memory cards and a good flash are absolute necessities when shooting a wedding. You never want to run out of space when shooting a wedding, as there are no second chances.

Wedding photography tips

✦ **Follow the bride.** Nothing at a wedding happens without the bride — no toasts, no cake cutting, no first dance. To make sure you get the important moments of the wedding, follow the bride.

✦ **Shoot in RAW.** With the sheer amount of photos taken in different light, shooting in RAW is easier than having to set the white balance for each JPEG shot. The ability to set the white balance during post-processing leaves you with more time to shoot.

✦ **Carry lots of memory cards.** Shoot as much as possible. Don't take the time to edit on the camera. Weddings move much faster than you realize, so shoot everything and carry as much memory as you can. I have shot over 1,000 images at a single wedding before!

✦ **Plan ahead.** Knowing the order of the events in the wedding will allow you to plan ahead and make sure you are in position for the important moments, like the first dance and bouquet toss.

✦ **Build the group portraits.** Put the bride and groom in the center, and then add people around them. This keeps the couple as the center of attention for all the portraits.

✦ **Shoot the guests.** Nothing is worse than going through the photos after the wedding and realizing that you missed getting a shot with some of the guests. One quick tip to get around this takes a little help from the bride and groom: A great time for the newlywed couple to make the rounds is during the meal. After they have had a bite to eat, going from table to table to greet all the guests is a great time to get photos.

✦ **Use your flash outside for fill light.** Using the flash outdoors helps reduce harsh shadows and creates a more even, pleasing light. I usually set the flash exposure compensation to −1 or −2 so that the light from the flash isn't very bright and does not overpower the natural light.

Wildlife Photography

Photographing animals can produce great images because people have an emotional bond with animals. Shooting animals in the wild is fantastic, but most people don't get to go on a photo safari, so they are left with the wildlife that is in close proximity to where they live. This could be the birds and animals that live in the wild, or the more accessible ones that live at the local zoo.

6.72 There was no glass or fence barrier between the grizzly bear and zoo patrons, so it was just a matter of time until the bear looked up at us. Shot at ISO 200, 105mm, f/5.6, 1/320 second.

Modern zoos offer great access to animals that most of us will never see in the wild. While it can take weeks of tracking down animals in the wild, the same animals can been see and photographed at the local zoo. Because some of the animals are dangerous to people, shooting them in a controlled environment is a whole lot safer.

Shooting animals both in the wild and at zoos and animal parks require that you use a telephoto lens so that you can get close and fill the frame with your subject. While zoos allow you to get close to the animals, they still make it difficult to get great shots because of the barriers that are there to protect people from the animals and the animals from the people. One solution when shooting through bars and fencing is to use a lens with a focal length of at least 100mm and shoot with the aperture wide open as close to the barrier as possible. When you focus on the animal, the shallow depth of field usually makes the barrier disappear.

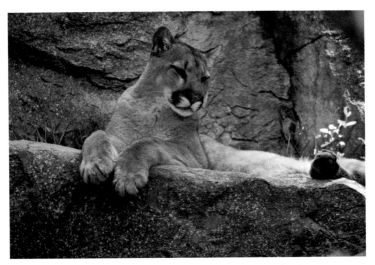

6.73 The mountain lion was photographed through the fence surrounding its enclosure. I was able to make the fence disappear by using a wide aperture and shooting as close to the fence as possible while focusing on the lion. Shot at ISO 200, 200mm, f/2.8, 1/160 second with Super SteadyShot turned on.

Inspiration

Today's zoos and wildlife reserves let you travel the world in a single day, or even a single morning. It is possible to travel from the plains of Africa, where you can see majestic elephants and giraffes, to the jungles of India where tigers roam. There is a wide variety of photographic subjects in a relatively small area.

6.74 The elephant was walking toward the fence and I was able to focus in on the eye and fill the frame with the elephant and no distracting zoo backgrounds. The image then becomes all about the elephant and not the location where the image was taken. Shot at ISO 200, 160mm, f/5.6, 1/150 second.

For those wanting to experience the thrill of actually going out into the wild to photograph animals in their natural habitat, there are numerous photo safari trips where professional photographers and wildlife guides take you out and let you photograph animals in their natural habitat. Programs like Moose Peterson's Wildlife Base Camp take photographers to locations around the United States shooting a variety of wildlife.

Wildlife photography practice

6.75 A green tree snake

Table 6.21
Taking Wildlife Photographs

Setup	**Practice Picture:** The green tree snake in figure 6.75 was photographed at a local zoo. I went with the express purpose of photographing snakes and lizards in the reptile house. This is one of the harder areas to photograph due to the lack of light and the thick glass in front of every enclosure. I had seen a photograph of a green tree snake and thought that it would make a great subject.
	On Your Own: Look at other photos from the zoo or animal park before you go by checking out the zoo's Web site if possible. It will give you a good idea of the animals that are there to photograph. If you have the time, revisit each area throughout the day. The photo of the tree snake was taken on the second trip to the reptile house that day. In the first images, the snake's head was in a different position.

continued

Table 6.21 *(continued)*

Lighting

Practice Picture: The lighting for the green tree snake came from a bright bulb inside the glass enclosure. The light was above and a little behind the snake, making it brighter toward the top left of the image. I also made sure that the lens was as close to the glass as possible, and in this case I pressed the lens hood against the glass for stability and to cut out the ambient light reflecting off the glass. I also made sure the flash was turned off; it would just reflect back from the glass.

On Your Own: You have no control over the lighting at the zoo or animal park, but you can come early or stay late to get a different angle with the sunlight. Overcast days are great for shooting animals, even though you will need a higher ISO or slower shutter speed or wider aperture than you would to get the same exposure on a bright sunny day. The diffused light is better for getting the details and an even exposure.

Lens

Practice Picture: I used a 50mm f/1.4 lens to capture the snake. The combination of low light and having to shoot through thick glass made the f/1.4 a necessity. It also helped to blur the background enough that you could not tell that the snake was in a small enclosure. I needed to use a lens with a very wide aperture, so I chose the one in my bag that had the widest aperture, which was the 50mm f/1.4 lens. This worked well, letting the snake fill the frame. There were actually two snakes in the enclosure but the lens could only capture one at a time.

On Your Own: When shooting other animals at the zoo, a longer lens will be necessary to get that close. A zoom lens with a wide range of focal lengths, like an 18-250mm lens, will let you shoot both wide angle and zoom in close to those animals farther away. When shooting in low light, a lens that has a maximum aperture of f/2.8 or faster is very useful to have.

Camera Settings

Practice Picture: I used the Aperture Priority setting on the A200 and set it for f/1.4, the widest opening the lens would allow. I then checked the exposure using the histogram view on the LCD screen on the A200. I could see that there was no white in the image, so I needed to make sure that the histogram was more to the dark side of the image. If necessary, I would have changed the exposure compensation to slightly underexpose the image, but the metering on the A200 was accurate enough for me to use the camera-selected shutter speed of 1/25 second. The slow shutter speed was due to the low light and my choice to use a low ISO. I kept the camera was very steady by actually pressing the lens hood right up against the glass. I was able to use a slow shutter speed because the snake was not moving.

On Your Own: You will need to set your shutter speed fast enough to freeze the action. Some animals sit still for minutes at a time, but others more around quite a lot, so to get crisp sharp images, you will need to make sure you are using a fast enough shutter speed.

Exposure	**Practice Picture:** ISO 200, 50mm, f/1.4, 1/25 second
	On Your Own: The Multi-segment metering on the A200 is great for this type of shooting, but check the LCD to see if the subject looks too light or too dark. If that is happening, try to switch to Center-weighted or Spot-metering modes or adjust the exposure compensation like I did when shooting this snake.
Accessories	I carry plenty of memory cards and a comfortable pair of shoes. There can be a lot of walking from area to area and standing waiting for the perfect shot.

Wildlife photography tips

✦ **Leave some space in front of the subject.** When framing an image, leave some space in front of the subject so that it looks like there is space for the animal to go. If the photo is cropped too close, the animal will seem to be trapped in the photograph, making for an awkward composition.

✦ **Use a large aperture to create a small depth of field.** The subject of your photograph needs to stand out from the background, and using a shallow depth of field helps with this.

✦ **Go early or late to the zoo.** Animals are more active in the early morning or late afternoon, and the crowds are usually smaller than during the middle of the day.

✦ **Check for special events or feeding times.** Check the schedule at the zoo for any special events and feeding times; these times make great photo opportunities.

✦ **Don't harass, tease, or torment the animals.** This holds true for pets, animals in the zoo, or any other animal at any other time.

✦ **Check the Internet for information on the zoo before leaving home.** Modern zoos take advantage of the World Wide Web by posting their hours and exhibit details on the Internet. Use this information to help plan a successful trip to the zoo.

Pet Photography

People love their pets, and pet photography is a huge business. Photographers everywhere are realizing that more and more people are treating their pets as members of the family, and photographing pets in the studio and on location is a money-making prospect. Even if you don't plan on being a professional pet photographer, chances are you either have a pet or know someone who does. Photographing pets is very similar to photographing children, and some of the same techniques apply. The following list of helpful hints will make pet photography a little easier.

Continued

Continued

✦ **Think about personality.** Every pet, like every person, has a unique personality. A pet's personality is reflected in the behaviors and expressions of that animal. If the pet is yours, you already know the behaviors to watch for; but if you are photographing someone else's pet, ask that person what separates the pet from all others.

✦ **Location, location, location.** At times it is easier to shoot a pet at its location. Pets are more likely to act in a natural way if in familiar surroundings.

✦ **Use a long lens.** Pets, just like people, can react if their space is intruded upon. Using a longer lens helps you fill the frame with the pet, as it did when shooting my father-in-law's dog, Lady Jane.

✦ **Try a wide angle.** Shooting close with a wide-angle lens can add a slight amount of distortion to the photograph, and although this is not a good thing to try with people, it can add to a pet photograph.

✦ **Get down to the pet's level.** Shooting at the pet's eye level lets you see the world from its perspective and produces better photographs.

✦ **Capture the action.** Using a fast shutter speed helps freeze the action of a dog or cat running or playing.

✦ **Shoot one shot with the owners.** Because pets are considered part of the family for most people, I usually try to get the owners to pose with the pet for a couple of photographs. Try to get the owners to get down to the pet's level; this is a good time to shoot in Burst mode. The expressions on both the owner and the pet can change very quickly, and because there is no way to ask a dog or cat to smile for the camera, shooting four or five shots in a row is a good idea.

Viewing, Downloading, and Printing Your Photos

Taking photographs can be a whole lot of fun. Spending the day photographing an event or capturing that perfect sunset, or maybe a day spent taking photos on your vacation, can leave you with a memory card full of great images. You have viewed the images on the LCD on the back of the camera, but now what? It is now time to do something with the images.

When I shot photographs using film, I would drop the film off to be developed and rush back after they were developed to see my prints or slides. I would put slides into a slide tray and use a slide projector to see the images on a screen. Then I could share the images with friends and family as a slide show. Or, I could have my images developed as prints, and send copies of the prints to family members or friends in other cities.

The A200 now allows you to view an instant slide show on any television with a video input jack. You can also attach the camera to a computer and download the images from the camera's memory card to a computer hard drive, and share the images by e-mail or load them onto an online photo-sharing site. It is also possible to connect the A200 directly to a PictBridge-enabled printer and print the images directly from the camera.

Viewing Your Images on a Television

It's no surprise that Sony, a leader in home electronics and televisions, makes it easy to connect your A200 directly to a television. When you connect the A200 to a television, the LCD on the back of the camera no longer functions. Instead, the display switches from the camera LCD to the television screen.

The A200 connects to a television through the supplied mini-USB-to-video out cable. Follow these steps:

1. **Make sure the camera is turned off.**

2. **Open the memory card cover on the right side of the camera.**

3. **Insert the mini-USB-to-video cable into the mini-USB plug.**

4. **Plug the yellow video RCA plug into a video-in plug on your television.**

5. **Turn the camera on.**

6. **Turn the television on and select the video input that matches the location where you plugged in the camera cable.** If needed, refer to your television manual on how to do this.

 Note *The camera cannot be plugged into a computer or printer and a regular television at the same time.*

When the camera is connected to a television, all the images on the camera's memory card can be displayed on the television. The controls on the camera that are used to review images on the LCD are the same controls that are used to review the images when connected to a television.

 Cross-Reference *For more on the display modes, see Chapter 1.*

A great way to show your images on a television is to use the slide show feature. This automatically plays back all the images on the memory card with a limited amount of information across the bottom of each image. The date and time the image was taken along with the sequence number and total number of images on the memory card appears.

To run the slide show, follow these steps:

1. **Turn on the camera.**

2. **Press the Menu button to open the A200 Menu screen.**

3. **Use the Multi-selector to navigate to the Playback Menu 2.**

4. **If you want to, adjust the interval between photos from the default 3 seconds by selecting the Interval menu choice before starting the slide show.** Choices include 1, 3, 5, 10, and 30 seconds.

5. **Navigate to the Slide Show selection and press the Multi-selector center button to start the slide show.**

Downloading Images to a Computer

You can get your images from the camera to the computer using two methods. The first is to connect the camera directly to the computer with the supplied USB cable. The second is to remove the memory card from the computer and use a separate card reader

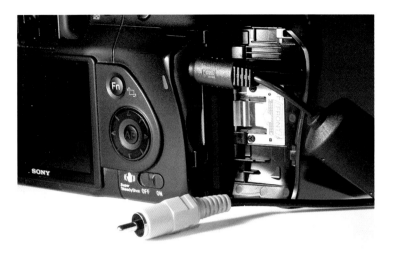

7.1 The USB-to-video out cable connected to the camera

to transfer the images to the computer. Both methods allow you to copy the images stored on the CompactFlash card to the computer, and each has its own pros and cons.

USB cable

Attaching the A200 to a computer is as easy as plugging one end of the supplied USB cable into the camera and the other into the computer. Follow these steps:

1. **Turn the camera on.**

2. **Press the Menu button. Use the Multi-selector to navigate to Setup Menu 2.**

3. **Select USB connection and press the Multi-selector center button, and make sure that the USB connection is set to Mass Storage.**

4. **Turn the camera off.**

5. **Open the memory card cover that covers the mini-USB port on the right side of the camera and plug one end of the supplied USB cable into the camera.**

6. **Plug the standard USB plug into your computer.**

7. **If your computer is not on, turn it on, and then turn the camera on.** The camera is now connected to the computer and will be recognized as an external device.

You can use the computer's operating system to copy the image files from the camera to the computer. When you are done transferring the images from the camera to the computer, eject the camera as you would any computer peripheral.

 Caution *When using this method, make sure the camera's battery has a full charge. If the battery runs out of power during the transfer, the photographs could be corrupted.*

The main advantage to using the supplied USB cable is the ease of use and the simple fact that you need no extra components. The downside is that the camera battery is used when the camera is connected to the computer using up the charge that could be

7.2 The USB cable being used to connect the A200 to a computer

better spent taking photos. This might not be very important when you are shooting close to home, but if on vacation or shooting out of town, this could be the difference between getting all the images you want or running out of battery power while shooting.

Card reader

Dedicated card readers come in many different styles, but they all do the same thing. They let you transfer your files from the CompactFlash card to a computer without having to use the camera. Using a card reader is easy. Follow these steps:

1. **Turn off the camera.**

2. **Open the memory card cover by sliding it straight back toward the back of the camera.**

3. **Remove the CompactFlash card by pressing the CompactFlash card eject lever.**

4. **Plug the card reader into the computer using the directions that came with the card reader.**

5. **Insert the memory card into the reader until it is firmly seated.**

With the card reader connected to the computer, the memory card is recognized by the computer as an external device. Use the computer's operating system to copy the image files from the camera to the computer.

 For more on importing images using different software, see Appendix B.

When you finish transferring the files, eject the CompactFlash card as you would any computer peripheral. The card reader has some distinct advantages of transferring the images using the camera, and the biggest is that the card reader doesn't use any of the camera's power. This frees the camera up while the images are being downloaded. I use this time to clean the camera, but more about that in Appendix A.

7.3 An eFilm multi-card reader connected to a laptop

Connecting to a Printer

It is possible to print directly from the A200 without using a computer at all. This is done by using printers that support the PictBridge technology. The A200 supports the PictBridge technology to enable printing directly from the camera. PictBridge is a standard technology that is used by many of today's printer and camera companies.

To print directly from the camera, follow these steps:

1. **Turn the camera on.**

2. **Press the Menu button.** Use the Multi-selector to navigate to Setup Menu 2.

3. **Select USB connection and press the Multi-selector center button.** Make sure that the USB connection is set to PTP mode.

4. **Turn the camera off.**

5. **Open the memory card cover on the right side of the camera and plug one end of the supplied USB cable into the mini-USB port on the camera.**

6. **Plug the standard USB plug into your PictBridge-enabled printer.**

7. **If your printer is not on, turn it on, and then turn the camera on.** The LCD shows the last photo taken.

8. **Use the Multi-selector to navigate through the images stored on the memory card.** Pressing the Multi-selector center button marks an image for printing. Pressing the Menu button opens the Print menu.

Remember that RAW images cannot be printed using PictBridge printing. If you plan on printing directly from the A200, make sure you are shooting in JPEG or in RAW & JPEG mode. When shooting in the RAW & JPEG mode, the printer only prints the JPEG copy of the image.

Print Menu 1

Pressing the Menu button when the camera is connected to a printer displays Print Menu 1. This menu is only available at this time and cannot be accessed if the camera is not connected to a printer.

The menu options are as follows:

✦ **Print.** This prints the selected images.

✦ **Set Print Quantity.** You can print up to 20 copies of each image.

✦ **Paper size.** This is dependant on the printer connected. The A200 can print images from 3.5 × 5 inches up to 11.7 × 16.5 inches as long as the printer supports the paper size.

✦ **Layout.** The layout default is Auto, but it can be set for any of the following:

 • **Auto.** This uses the printer setup to determine the layout.

 • **1-up/Borderless.** Borderless, 1 image per sheet.

 • **1-up.** 1 image per sheet.

 • **2-up.** 2 images per sheet.

 • **3-up.** 3 images per sheet.

 • **4-up.** 4 images per sheet.

 • **8-up.** 8 images per sheet.

 • **Index.** This prints all the selected images and an index print using the setup from the printer.

✦ **Date Imprint.** The date and time of the photo can be attached to the image. Make sure to turn this off if you don't want the date and time printed.

Print Menu 2

Pressing the Menu button when the camera is connected to a printer displays Print Menu 1. Use the Multi-selector to navigate to Print Menu 2.

The menu options are as follows:

✦ **Unmark All.** This menu choice clears all selected images.

✦ **Print All.** This prints all the images on the memory card.

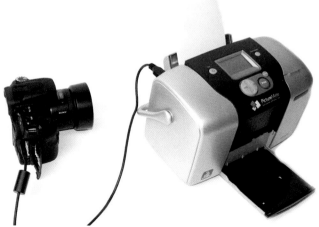

7.4 The A200 connected to a home inkjet printer

Appendixes

◆ ◆ ◆ ◆

◆ ◆ ◆ ◆

Camera Care

T he only way your camera is not going to get dirty is if you keep it in the box. Regular use results in dust and dirt settling on the lenses and the camera body. Dust and dirt can also get into the camera body, and this can cause problems with your images. The good news is that regular camera care and cleaning can extend the life of your camera and lenses. Good cleaning habits can keep your gear in good working order so that it will be ready when you need it.

The designers at Sony have added features to the A200 to reduce the effects of dust and dirt that might make their way into the camera body. The A200 has both a static-free, anti-dust coating on the sensor, and an anti-dust vibration system that automatically vibrates the sensor to dislodge any dust every time the camera is turned off. These features help to keep any dust or dirt from settling on the camera sensor, but there are steps you can take to reduce the chances of dust and dirt entering the camera body in the first place.

The two areas that dust and dirt will cause you the most problems are on the lens and on the sensor. When using a point-and-shoot camera, the lens is permanently attached to the camera body and is sealed from dust and dirt. The lens on the A200 can be removed, which can let dust and dirt into the camera. When dust and dirt are present on the camera's sensor or on the back element of the lens, it can cause marks and smudges to appear in your images.

Preventing Dust from Entering the Camera Body

The most common time that dust can enter the camera body is when you are changing lenses. During this critical time, the camera body is open to the elements allowing dust and dirt to enter the camera. The most important thing you can do to reduce the amount of dust that can enter the camera body is to be careful when changing lenses.

AA.1 The red circles mark where dust and dirt in the camera have made their way onto the final image.

Camera manufacturers recommend never changing the lenses when dust is present. This is rarely possible, so there are a few techniques that can help reduce the amount of dust and dirt that enters the camera body.

✦ **Minimize lens changes.** You can reduce the amount of time the camera body is open to the elements by only changing the lens when you absolutely need to, and have the new lens ready to go so that changing the lens can be done as fast as possible.

✦ **Point the camera down.** When changing the lens, hold the camera pointed toward the ground to cut down on the amount of dust that can enter the camera body.

✦ **Use your body as a shield.** Keep the camera close to your body when changing lenses to help block any wind that could blow dust and dirt into the camera body.

✦ **Check the lens.** Make sure that there is no dirt, dust, or anything else on the lens, especially on the rear part that attaches to the camera.

✦ **Use your car or an inside location.** When shooting in a dusty or sandy location, make a trip back to a car or inside a building before changing lenses. It is still important to point the camera body down to keep it as dust free as possible. A quick inspection of the rear of the lens each time you change it is a good idea. Just make sure there's no obvious dust or lint, or any other debris before you mount it.

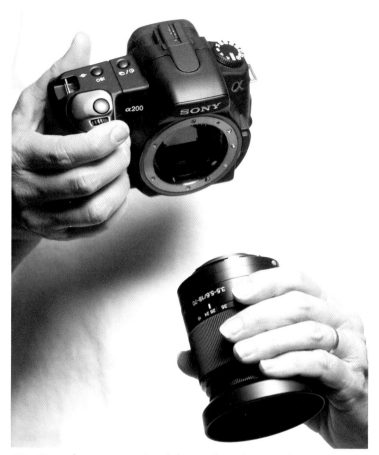

AA.2 Keep the camera pointed down when changing lenses.

AA.3 The rear element of a lens, clear of dirt and dust

Cleaning Your Gear after Shooting

An important part of my post-shooting work-flow is to clean my camera gear that I just used so that it is clean and ready to go the next time I want to use it. I use the time it takes to transfer the images from the CompactFlash cards to the computer to wipe off the camera and any lenses that I have used. I use a soft, lint-free cloth to wipe off any dirt and grime so that over time it doesn't build up and end up in the camera body.

I also carry microfiber cloth that has its own carrying case and attaches with a clip to my camera bag. This lets me wipe off the camera or lens if needed when I am out shooting. This is especially helpful in areas when there is a lot of dust and dirt, like the beach or desert.

> Tip *Do not use a t-shirt or dust cloth to wipe off the camera. Use a cloth that is made to clean camera gear. A microfiber cleaning cloth works great for this.*

Cleaning the Lenses

Protecting my lenses starts when I purchase the lens. Because accidents happen, I purchase a protective filter for the front element that protects the front of the lens from dust and dirt, and can save a lens if it is dropped. For example, I have dropped lenses or had them bump into things and, in most instances, the only damage that was done was to the protective filter, and not to the actual lens.

Sony sells the Multicoat Protector series line of filters, made especially for this protective purpose. Your local camera store should also carry a full line of protective filters.

The basic lens-cleaning tools are a hand blower, lens cleaning solution, a microfiber cloth, and canned air, if necessary. It is also possible to buy a whole cleaning kit that packages the essential cleaning supplies into an inexpensive package. For example, you can purchase a Giottos cleaning kit that comes with a Rocket Air blower, a microfiber cleaning cloth, a retractable brush, a multioptical cleaning solution, and cotton swabs for less that $20.00.

When cleaning your lenses, the first step is to remove any surface dust and dirt. The best tool for this job is a hand blower, which I use on both the front and back elements of the lens. This should dislodge dust and dirt that is on the lens, but if the hand blower

AA.4 The Sony Multicoat (MC) Protector line of filters is manufactured by Carl Zeiss for optimum image quality while protecting the front of the lens. This one is attached to the Sony 50mm f/1.4 lens. The MC Protector is clearly visible on the filter.

AA.5 A camera-cleaning kit from Giottos

doesn't seem to have enough power, I use canned air very carefully.

 Caution *When using the canned air to blow dust from a lens, never blow directly at the glass elements, but instead blow across the glass. The high pressure of the compressed air can damage the glass. It is also important to keep the can upright so that the propellant used does not get expelled as a liquid, which can damage the lens coatings.*

If there are any fingerprints or smudges on the lens, use the microfiber cloth to wipe the dirt away in a circular motion.

If after all that cleaning, the lens is still dirty, special lens-cleaning solutions can help get rid of the stubborn dirt. I use a Zeiss Lens Cleaner solution, but there are plenty of good products available in any good camera store. Spray the solution onto a clean cloth, and then use the cloth to wipe the lens element clean.

 Caution *Never apply any liquid cleaners directly to your lenses or camera.*

Cleaning the Mirror

Everyone wants to clean the mirror, but usually for the wrong reasons. Any dust and dirt that you see on the mirror does not affect the image because the mirror moves out of the way when the Shutter button is pressed to allow light to reach the sensor.

The best reason to clean the mirror is to stop dust on the mirror from moving and ending up on the sensor. Keep in mind that it is not vitally important to clean the mirror, and much more importantly, the mirror is a very delicate part of the camera that can be

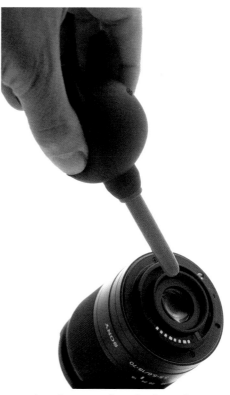

AA.6 The Giottos Rocket Air Blaster is a great tool for removing dust and dirt from a lens. Here one is being used to gently blow the dust and dirt from the rear element of the 18-105mm lens.

damaged if it is treated too roughly. The only tool I ever use to clean the mirror is a hand blower to gently blow the dust and dirt off of it.

Hold the camera upside down and look up into the body, being careful not to touch the mirror with the end of the blower. Gently blow the dust off the mirror. By holding the camera upside down, the dust that is blown loose falls out of the camera and does not end up back in the camera on the sensor.

Cleaning the Sensor

A static-free, anti-dust filter that is made to repel dust and keep the sensor clean covers the sensor of your A200. Sony also equipped the A200 with an anti-dust mechanism that vibrates the sensor to dislodge dust every time the camera is turned off. These two safeguards help to keep the sensor in the A200 relatively dust free, but no system is absolutely perfect, and there may come a time when you need to clean the A200 sensor.

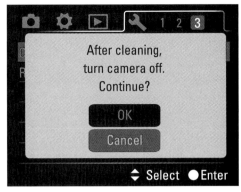

AA.7 The A200's Cleaning mode menu

Cleaning the sensor can be done easily by following these steps:

1. **Make sure the battery is fully charged.** It is important that the camera does not lose power during the cleaning. Make sure that the battery shows at least three stripes on the battery display. If the battery does not have enough power, the camera will not go into the cleaning mode. If you have the optional AC adaptor, use that instead.

2. **Select the cleaning mode.** Press the menu button to open the A200 menus and use the Multi-selector to navigate to Setup Menu 3. The first choice is the Cleaning mode; press the Multi-selector center button to start the cleaning process.

3. **Start the cleaning mode.** The camera displays the following message when the cleaning mode is activated: "After cleaning, turn camera off. Continue?" Use the Multi-selector to navigate to OK and press the Multi-selector center button. The Image sensor vibrates for a short time to help dislodge the dust and dirt on the sensor and then moves the mirror up and out of the way, giving you access to the sensor itself.

4. **Carefully remove the lens or body cap.** Keep the camera body pointed toward the ground.

5. **Clean the sensor and the surrounding areas using a hand blower.** Make sure not to touch the sensor with the tip of the blower. This part needs to be done as quickly and carefully as possible.

Caution *Do not use compressed air or a spray blower when cleaning the inside of the camera because both of these can introduce vapor into the camera body. Do not insert a hand blower (or any blower) into the camera body past the lens mount. There is no reason to get that close to the sensor.*

6. **Reattach the lens or body cap and turn the camera off.** This is all there is to cleaning the A200.

If after doing all the cleanings there is still dirt and dust in the camera, your best option is to send the camera to Sony to have it professionally cleaned and serviced.

Editing Software Options

Digital photography has made it easier to get instant feedback on the photos you have just taken. This has simplified the reviewing process and lets you as a photographer see what you have just done by just pressing the Playback button and looking at the LCD on the back of the camera. What has become more difficult is getting the images out of the camera. With film, all you did was rewind the film, open the back, take the canister of film out of the camera, replace it with a new roll, and take the exposed film to a developer. In as little as an hour, your photos were printed and you could then take them home to put into frames or albums.

Digital photography has made that process very different. The images need to be transferred from the digital film to a computer, and the old-style photo album is being replaced with digital versions, like iPhoto or with online versions like Flickr and Photoshop Express. So deciding what to do with your images after they have been taken plays a big role in what happens after you are done photographing. While it is possible to print directly from the camera, most of the time you will want to transfer the images from the camera to the computer and then use software to review, sort, edit, and output your images.

Sony Software

The A200 comes with two software programs for both Apple and Windows-based computers. The two programs are Image Data Lightbox SR and Image Data Converter SR ver2. Sony also supplies a Windows-only program called Picture Motion Browser. The following sections briefly look at each of these and their uses.

Image Data Lightbox SR

The Sony Image Data Lightbox SR software can be used to view, compare, sort, label, and rate images on your computer. The Lightbox software allows you to load a single image or a folder of both RAW and JPEG images. Lightbox allows you to view each image at 100 percent to check out the critical focus. You can compare images to each other and rank each photo with a 5-star rating system. If you need or want to edit the individual files, you can open the RAW files using the Sony Image Data Converter SR, which is launched from inside the Lightbox software. Any changes made to the RAW file are automatically updated in Lightbox.

Although this program is not as complete or as powerful as Adobe Photoshop Lightroom or Apple Aperture, it is free, and you can use it to launch the Image Data Converter SR. What the Image Data Lightbox SR software does not do is supply an easy way to transfer the image files from the camera or memory card reader to the computer.

Sony Image Data Lightbox SR can also display the shooting data for any image. This quickly gives you all the image data in an easy-to-read location. One advantage to digital photography is the ability to see the settings used when you have created great photographs, making it easier to re-create the image.

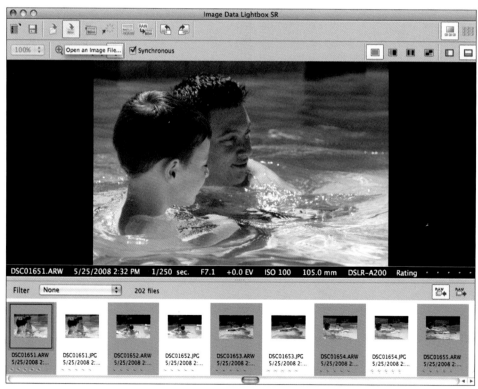

AB.1 The screen layout of the Image Data Lightbox SR software program

Item	Value
File name	DSC01651.ARW
File type	ARW 2.0 Format
Date taken	5/25/2008 2:32 PM
Created	5/25/2008 2:32 PM
Image width	3872
Image height	2592
Orientation	Standard
Manufacturer name	SONY
Model name	DSLR-A200
Max aperture	F5.6
Lens focal length	105.0 mm
Shutter speed	1/250 sec.
F number	F7.1
Exposure correction	+0.0 EV
Exposure program	Shutter speed priority
Metering mode	Multi pattern
ISO	100
White balance settinç	Auto
White balance mode	Auto
Flash	Not used
Flash mode	No flash
Red–eye reduction	Off
Saturation	Standard
Contrast	Standard
Sharpness	Standard
Color space	sRGB
Scene capture type	Standard
Creative Style	Standard
Scene selection	
Zone matching	Off
Color temperature	––––
Magenta/Green comį	0
Lens	DT 18–200mm F3.5–6.3
STEADY SHOT	Off
D–Range Optimizer	Standard

Image Properties

AB.2 The data screen of the Image Lightbox SR software

Image Data Converter SR

Photographing using the RAW file quality means that you will have to use a special software program to translate these image types into a form that printers, e-mail, digital picture frames, and the Internet all use. Sony developed the Image Data Converter SR software for photographers who shoot and save their images using the Sony RAW format. The Image Data Converter SR, or IDC SR, software has some advantages over any other RAW conversion software because it

gives the photographer complete control over the RAW file.

The real power comes from the three adjustment palettes.

Adjustment 1

The first adjustment palette, labeled Adjustment 1, enables you to make the following adjustments to your RAW images:

✦ **White Balance.** Here you can choose to use the white balance values that the camera recorded or choose from several presets. The options are:

 • **Color temperature.** You can set the white balance by setting a specific color temperature by either using a slider or by typing a value directly.

> **Cross-Reference** *Color temperature is covered in Chapter 4.*

 • **Specify gray point.** You can set the white balance by specifying a gray point in the image and having the software calculate the white balance for you. The gray point can either be selected with an eyedropper tool to choose a specific point or with a selection box that uses a user-defined area.

 • **Color correction.** Once you set the white balance, you can shift the overall color using this slider. Moving the slider to the left adds green and to the right adds magenta.

> **Tip** *If the Camera Settings button is available for the option you are working with, click it to return the values to those set in the camera when the image was taken.*

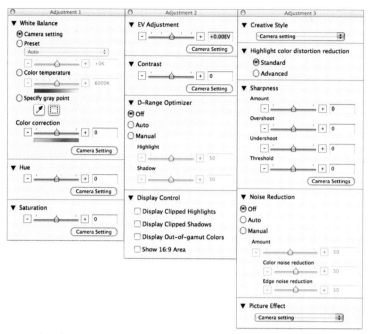

AB.3 The three adjustment palettes in Image Data Converter SR

✦ **Hue.** The hue of the image can be adjusted using the slider or by typing a value between −100 and +100 directly. Moving the slider to the left shifts the colors in the image toward red and toward green when moved to the right.

✦ **Saturation.** The saturation of the image can be adjusted by typing a value between −100 and +100 or by moving the sliders. Moving the slider all the way to the left, or typing −100, removes all the color from an image, creating a black-and-white image. Moving the slider to the right adds saturation and causes the image to appear more vivid.

Adjustment 2

The second adjustment palette (Adjustment 2) enables you to control the following settings:

✦ **EV Adjustment.** This controls the Exposure Value; moving the slider to the right will increase the exposure, lightening the image, while moving it to the left will decrease the exposure, darkening the image.

✦ **Contrast.** The contrast of the image can be adjusted here by moving the slider to the right for more contrast or to the left for less contrast.

✦ **D-Range Optimizer.** The Dynamic Range optimizer can be set to Off, Auto, or Manual. The Manual option then allows you to individually adjust the highlights and shadows.

✦ **Display Control.** Use this setting to control aspects of what is displayed. These display settings let you adjust the other sliders and see what effect they have on the lightest and darkest parts of your image. You have four options:

- **Display Clipped Highlights.** Areas in your photo that are pure white appear magenta. This is helpful when trying to avoid bright spots in your photo.

- **Display Clipped Shadows.** Areas in your photo that are pure black appear yellow. This helps when trying to find areas that are too dark.

- **Display Out-of-gamut Colors.** Areas in your photo that have colors that cannot be displayed correctly appear gray.

- **Show 16:9 Area.** When selected, the display superimposes bars on the top and bottom of the image to display the image as if it had been taken using the 16:9 aspect ratio.

Adjustment 3

The third adjustment palette (Adjustment 3) has several different settings you can make adjustments to, including:

- ✦ **Creative Style.** From this menu, you can assign any of the Creative Styles to the image after it has been shot. These are the same Creative Styles that are available in the camera. Use this setting with caution. If you change the Creative Style, nearly all other settings you may have adjusted are reset back to the way they were when the image was captured.

> **Cross-Reference** *The Creative Styles are covered in Chapter 2.*

- ✦ **Highlight color distortion reduction.** This setting can either be set for Standard or Advanced. It is used to help adjust the very brightest parts of your image, reducing any color distortion and producing a more natural looking image.

- ✦ **Sharpness.** While sharpening an image can't make an unfocused image any clearer, when used sparingly it can help to improve your images by making the subjects stand out by increasing the contrast slightly at the edges where two different colors meet. Adjusting the sharpness is done with four separate sliders.

 - **Amount.** Dragging the slider to the right increases the overall sharpness of the image, while dragging to the left reduces the sharpening.

 - **Overshoot.** Adjusts the amount of sharpening in the overshoot direction.

 - **Undershoot.** Adjusts the amount of sharpening in the undershoot direction.

 - **Threshold.** Sets the amount of difference that needs to occur between two colors before the sharpening amount is applied.

- ✦ **Noise reduction.** Apply noise reduction to the image automatically or by manually setting the amount, color noise reduction, and edge noise reduction. Noise reduction is more common in the higher ISO range (800 to 3200), and these settings can help to reduce this. Each image will require a different amount of noise reduction, and it is best to experiment until you get the results that look pleasing to your eye. I have found that the Auto setting is a good place to start. It shows what a little noise reduction can do to improve the overall quality of your image.

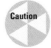 **Caution** *Applying noise reduction to an image can cause deterioration of the overall image quality.*

✦ **Picture Effect.** You can assign one of four different picture effects — Sepia, B&W, Solarize, or Negative — using this menu. Each of these settings changes the overall color of the image, and it is up to you to decide if it works for your image or not.

The great part about all these adjustments is that they do not damage or even change the image file. Each can be applied or removed and experimented with without damaging the original digital RAW file.

Other features

In addition to the three adjustment pallets, there are also palettes that show a navigator for help in navigating around the image, a Histogram palette that shows histogram data for an image, and a Tone Curve palette. The Tone Curve palette allows you to adjust the overall tone curve of the image. Changing the tone curve essentially increases or decreases the tone. The tone curve allows you to adjust both the color and tonal values in your image with a great degree of accuracy. The entire image's brightness or the individual Red, Green, and Blue color curves can be adjusted.

After the images have been edited, they can be saved in a variety of formats: JPEG, TIFF, or ARW (the Sony RAW file type) files. This is important because Web browsers, e-mail clients, and many print order companies need the photograph files to be in the JPEG file format to be used. When the file is saved as the ARW, the information in the actual photo information isn't being changed, but the adjustments are saved along with the image. If the image is opened again in the IDC, the settings can be removed or reset to the original camera settings.

Sony Picture Motion Browser

This Sony application can only be used by a personal computer running Windows XP with Service Pack 2, or Windows Vista. Picture Motion Browser is an application used for organizing and editing your images, and the one feature that it has that the other Sony software doesn't is the ability to import the images from the camera to the computer.

AB.4 The image along with the Tone Curve palette, the Histogram palette, and the Navigator palette

When a Sony A200 is attached to the computer or the memory card is attached via a memory card reader, the Import Media Files option copies the files to the computer. The Picture Motion Browser sorts the images by date, and the default view is a calendar. This is useful to keep track of images taken over the years, but not that useful for finding specific images when you don't remember when they were taken.

Picture Motion Browser allows you to e-mail photos, play a slide show, and do minor adjustments to JPEG images. The biggest advantage to the Picture Motion Browser is the ability to import the images and sort by date and to burn any selected images to a backup CD or DVD depending on the ability of your computer.

Other Software Options

There are a great many software programs available for sorting, editing, and viewing digital photographs other than those made by Sony. Adobe has long been considered the leader in photo-editing software, and its flagship photo-editing software, Adobe Photoshop, is the most widely used software for professional photo editing and correcting. Adobe also produces two other programs for photographers: Adobe Photoshop Lightroom and Adobe Photoshop Elements, along with the new free online service, Photoshop Express.

Adobe Photoshop

Adobe Photoshop is the leading image-editing software available today. The program was first released by Adobe in 1990 and has continued to grow ever since.

Because Abode Photoshop has been around for so long, there are hundreds of books, videos, and online training programs that explore every aspect of Adobe Photoshop.

Adobe Photoshop is actually made up of three parts: Bridge, Adobe Camera Raw, and Photoshop. These parts work together as a complete editing suite. The latest version of Adobe Photoshop is available as a free 30-day demo at www.adobe.com, but be warned, Adobe Photoshop retails for over $600.

Bridge

Bridge essentially works in the same way as the Sony Image Data Lightbox software, and acts as a great starting point for editing your photographs. One great feature in Bridge is the Get Photos from Camera import feature. You can set this photo importer to launch any time a camera is connected to the computer, making the transfer of your photos from the camera to the computer very easy.

After the images are imported from the camera to the computer, Bridge functions as a file browser that also lets you sort, rate, organize, and label your images. You can select and open images (even JPEG images) and open them in Adobe Camera Raw directly from Bridge.

Each image can be rated with a star system, color-coded, and sorted by a variety of criteria including image orientation, ISO, and more.

Adobe Camera Raw

Adobe Camera Raw, or ACR, is the software that converts RAW images into a format that Adobe Photoshop can use. It does the same thing that Sony IDC does, but instead of working only with Sony files, the ACR works with all camera files and formats. Support for the A200 was introduced in Adobe

AB.5 The Import window in Bridge

AB.6 The main Bridge display

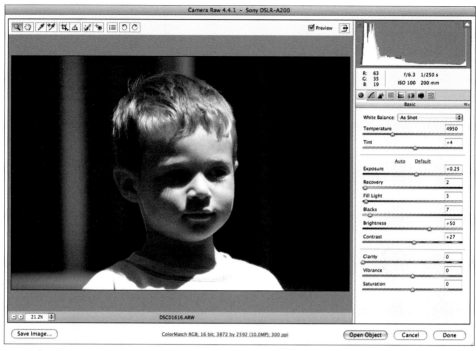

AB.7 The Adobe Camera Raw workspace

Camera Raw version 4.4. To use Adobe Camera Raw to translate the RAW files from your A200, you need Adobe Photoshop CS3 or later. Earlier versions cannot read the Sony RAW files. You are still able to edit JPEG and TIFF files that can be created from the Sony software, but you are not able to open or edit the Sony RAW files.

Because ACR works with all image files from all camera manufacturers, some of the features available in the Sony Image Data Converter SR are missing. ACR has no D-Range Optimizer and does not have the ability to change the aspect ratio after the image has been taken. A real bonus to using ACR, however, is the ability to adjust the white balance not only of RAW files but also of JPEG files. This makes it possible to repair images that previously would have taken hours to fix in Photoshop.

After any adjustments have been made to the photo in ACR, the file can then be opened in Adobe Photoshop.

Photoshop

For complete photo editing, Photoshop can do it all, and if you are planning on doing any serious photo editing, then Photoshop is something to seriously consider. Photoshop can make the smallest color adjustments or completely change the image. Due to the huge number of powerful tools and image processing power in Photoshop, the learning curve is quite steep; however, there are a great many books and tutorials available to help even true beginners find their way around.

Abode has also created a scaled-down and much less expensive version of Photoshop called Adobe Photoshop Elements and a new free online service called Photoshop Express.

Photoshop Elements

Photoshop Elements is Adobe's amateur version of Photoshop. The great part about Photoshop Elements is that it benefits from the same powerful editing features found in Adobe Photoshop. Photoshop Elements lets you download your images from the camera and view them in a media browser. The images can be tagged with custom keywords, ratings, and labels for easier searching and retrieval of your images.

Photoshop Elements has a new Stacks feature that lets you keep images of the same scene together, or you can reject images to hide them from view. Photoshop Elements has a set of one-click fixes that perform common image fixes quickly and easily: removing red eye, creating black and whites, and even creating the best group shot out of a series of multiple images. Photoshop Elements is also a good introduction to what Adobe Photoshop can do without having to spend the amount of money that Adobe Photoshop costs.

Photoshop Elements also lets you present your images in many ways. Producing photo books, scrapbook pages, online albums, cards, and CD/DVD labels is simple. Customized layouts and colors can be used along with text and text effects like drop shadows. It is also possible to order prints and other products with your images on them.

One advantage that Adobe Photoshop has over the Sony software is its ability to use third-party, plug-in applications. These plug-ins can do everything from adding artistic borders to selectively adjusting the colors of the image. This lets you customize Adobe Photoshop to your specific needs.

Photoshop Express

Adobe's new Photoshop Express is a new online photo-editing and -sharing software. As I am writing this, the service is a free public beta. Adobe Express allows you to upload 2GB of JPEG images to your own online Web gallery and sort them into albums. Each image can be edited by cropping, rotating, red-eye removal, touchup, changing the saturation, adjusting the white balance, and adding special effects like Black & White, sketch, distort, and Pop color.

Adobe Express also works with myriad other online services like Flickr, Photobucket, Facebook, and Picasa. Adobe Photoshop Express is a great free online program for those wanting to edit and share their images without having to purchase any software. Adobe Photoshop Express can be found at www.photoshop.com/express.

Adobe Photoshop Lightroom

Adobe Photoshop Lightroom, or just Lightroom for short, is a relatively new program. It was released as a free beta program for Apple Macintosh computers in January 2006. It was the first Adobe product released to the general public during development. The final product was released in February 2007. The feedback from actual working photographers during the development created a program that could be a complete digital darkroom solution. Lightroom is now in a second public beta for version 2, which should be available by the time this book is published.

The Library module is where the sorting and organizing of your photos takes place. You can associate keywords associated with images, add color labels, rate images with one to five stars, and flag an image as a keeper or reject it. Images can also be sorted into collections

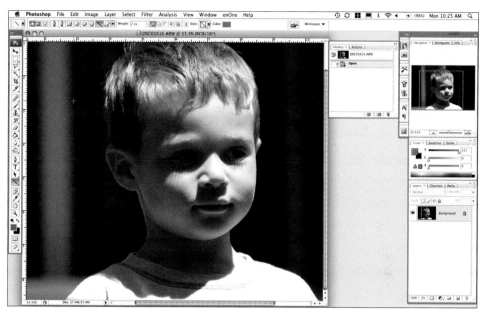

AB.8 Photoshop CS3 workspace

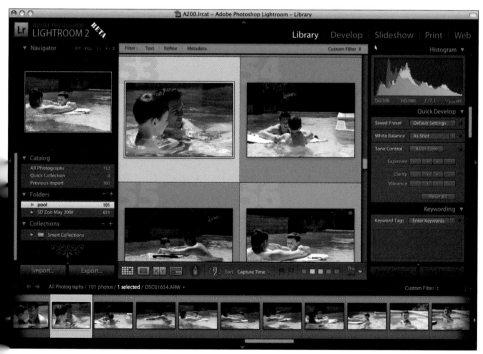

AB.9 Adobe Photoshop Lightroom's main workspace module

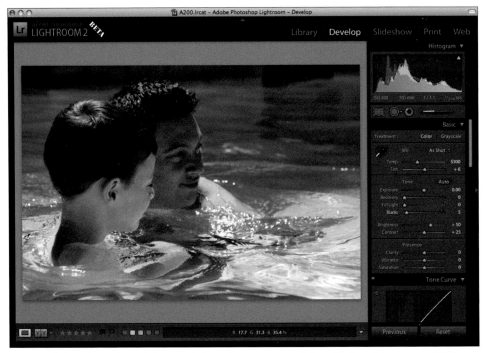

AB.10 Adobe Photoshop Lightroom's Develop space module with the side menus hidden

and the same image can actually be sorted into numerous collections. For example, an image of a tiger can be sorted into both a wildlife collection and a San Diego Zoo collection. This is a very powerful tool that makes finding photos later much easier than trying to remember when or where the image was taken.

Making adjustments to your photographs in Lightroom is similar to using Adobe Camera Raw because Lightroom uses the same Adobe Camera Raw processing engine that Photoshop has. This gives you consistent results using both of the Adobe professional editing software packages. The adjustments that are made in the Lightroom Develop module, as with the processing of any RAW image, are not made to the actual file, but are a set of instructions on how to develop the image. This means that the original file can be used to create numerous different images without changing the RAW file.

The Slideshow, Print, and Web modules all create different output from your images. The professional Web galleries, print packages, and slide shows are all customizable to a high degree, and there are a huge amount of free templates on the Internet. For more Lightroom resources, check out Appendix C.

Adobe Photoshop Lightroom was recently updated to version 2.0 with improved image-editing tools and built-in dual monitor support. It is available as a free 30-day demo at www.adobe.com.

Apple Aperture

Aperture 2.0 is the professional photography postproduction tool from Apple. Aperture lets you import, manage, edit, catalog, organize, publish, and save your images. Aperture works only on Apple computer systems, and Aperture 2.0 or higher along with Mac OS Tiger v10.4.1

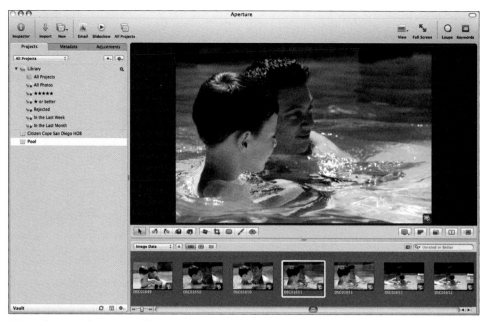

AB.11 Aperture's main workspace

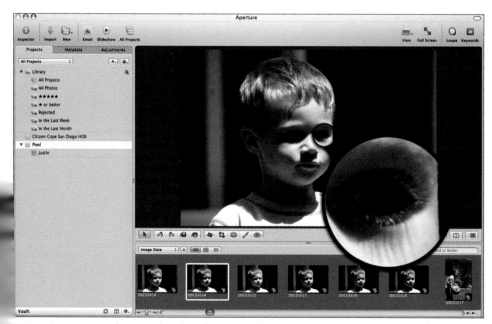

AB.12 Aperture workspace showing the Loupe feature to get a 100 percent preview to check the focus

or Mac OS Leopard v10.5.2 or later is needed to process A200 files. When your camera is attached to the computer or a memory card is inserted into a connected card reader, Aperture automatically displays an import window that lets you decide not only where to save the image files, but also lets you add copyright info, keywords, and other metadata.

Aperture 2.0 has an all-new image-processing engine that offers a complete set of RAW adjustments. You can recover details in both the shadows and highlights, remove small blemishes, and adjust the color, white balance, and exposure. As when working with any RAW file, the original image is not harmed by any of the adjustments.

Where Aperture really shines is in the features not found in other products. One of those features gives you the ability to sort your images like you would on an old-fashioned light table. The Light Table view lets you add, resize, and sort your images as if you were working on a light table, and no light table would be complete without a loupe. Aperture has a great loupe that can be used at any time to get a 100 percent view of any image on the screen. This lets you check the sharpness of the image at any time — a great feature for quickly deciding if the image is a keeper or not. Aperture also has the built-in ability to use two monitors, with the second monitor showing a 100 percent preview of any selected image.

Aperture 2.0 is available as a free demo from Apple at www.apple.com.

iPhoto

Apple's iPhoto is part of the iLife product line and is free on every new Apple computer. With iPhoto '08 and Mac OSX Leopard 10.5.2, iPhoto has the ability to process not only JPEG images, but Sony RAW images as well. iPhoto imports and sorts images automatically and enables you to sort photos into user-defined albums. Apple iPhoto has one feature that none of the other programs has: the ability to not only order prints directly from Apple, but to order a variety of products including calendars, cards, and photo books. iPhoto also makes it easy for users to select photos to be automatically attached to e-mails or uploaded to .mac galleries. Ordering products, printing, editing, attaching to an e-mail, and updating to a Web gallery are all easily done by clicking the dedicated button on the bottom of the user interface.

Images that are part of the iPhoto library can also be used systemwide on the Apple computer as screen savers, backgrounds, and slide shows. The new Apple TV product can also display images from the iPhoto library to any television that the Apple TV is connected to.

Photo Mechanic

Photo Mechanic software is produced by Camera Bits and is used to import images from a camera or memory card reader to the computer. Because the Sony software that comes with the camera does not have any way to automatically import photos, this program can be used instead.

The import function lets the user copy the images to two locations at the same time; rename the photos on import; and apply keywords, copyright, shooting data, and captions when the images are imported.

The Photo Mechanic software shows the images in a Contact Sheet view, which allows the images to be sorted, and if a RAW image needs to be edited, Photo Mechanic launches the Sony Image Data Converter SR automatically.

Photo Mechanic is available as a free demo that lets you try before you buy at www.camerabits.com.

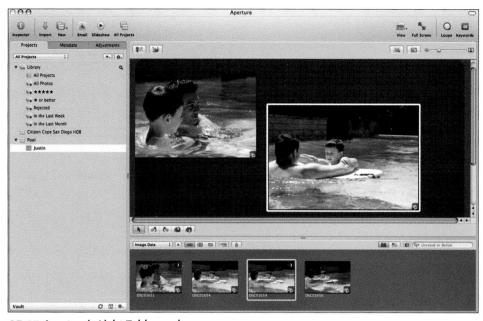

AB.13 Aperture's Light Table mode

AB.14 The iPhoto user interface

Photography Resources

All you need to take photos with the A200 is the camera, a lens, and a CompactFlash memory card. That doesn't mean that there is nothing else you can get that can help your photography or make it easier to get the types of photos you want. In Chapter 6, I mention a tripod and remote are especially useful for macro and low-light photography, but what's the best tripod to buy and how do you get a remote for the A200?

This appendix tries to answer some of those questions, as well as acting as a general resource guide to organizations and Web sites that can help your photography.

Photography Accessories

There are great many accessories out there for photographers, and it is easy to spend a small fortune on equipment you may not need. The following sections cover just a few that I believe are the more important accessories to consider.

CompactFlash memory cards

There are a great many CompactFlash card sizes and even manufacturers out there. When choosing a CompactFlash card, there are a couple of different things to take into consideration:

+ **Capacity.** The capacity of CompactFlash cards seems to get bigger every day, but the most commonly available cards are the 2GB, 4GB, and 8GB cards. The bigger the card, the more photos can be stored.

✦ **Speed.** The speed that the information can be written to the card is important. The longer it takes for the data to be written to the card, the longer it takes to clear out the buffer and let the camera be ready to take more images.

Picking the right card is a matter of personal experience and preference. The card that you pick needs to store the images you take, keep them safe, and then be able to be read by your computer so that the images can be retrieved. With CompactFlash cards, as with most things in life, I believe that you get what you pay for, and trusting a generic CompactFlash card with your once-in-a-lifetime trip photos doesn't seem like a good idea.

Lexar, SanDisk, Hoodman, and other CompactFlash manufacturers all have high-end cards that will work flawlessly in your A200. I use Lexar Professional series CompactFlash cards, and every image in this book was captured using one. One of the reasons I use the Professional series is because of the included image-recovery software and the limited lifetime warranty. I was photographing a model for a clothing company, and when I tried downloading the images, the card had an error. I used the included software to retrieve most of the images. When that failed to retrieve the last couple, I sent the card to Lexar, which managed to recover all the images and send them back to me on a CD along with a new card. This saved the job, and more importantly, my images. I am not saying that everyone needs to use Lexar cards, but carefully pick the cards you use. Sometimes a bargain ends up costing you more in the long run.

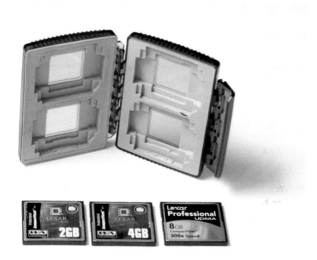

AC.1 Three different CompactFlash cards from Lexar along with a Gepe Card Safe (www.gepe.com). I use the Gepe card safe to keep my CompactFlash cards safe and secure when the cards are not in my camera.

Tripods

Tripods keep your camera steady and let you get the sharpest photos possible even at long shutter speeds. They are one of the most useful tools for a photographer, but picking the right one can be a bewildering exercise.

Tripod legs

Tripods are constructed out of a variety of materials, and each can influence the stability, weight, and cost of the tripod. Materials to consider include

✦ **Wood.** Wood is great for tripods due to wood's excellent ability to reduce vibration. It is still possible to purchase tripod legs made of wood, but they are not common anymore. Wood is very heavy and expensive compared to more modern materials such as aluminum.

✦ **Aluminum legs.** Aluminum is lighter than wood and creates a light, stable tripod that is inexpensive.

✦ **Carbon-fiber legs.** Created using layers of carbon fibers, these tripod legs are lighter than aluminum and are more stable than traditional wood tripods. The downside is that carbon fibers are more expensive than aluminum tripods.

✦ **Other materials.** Newer, more exotic materials such as basalt are now being used in tripod leg manufacture. These tripods are more expensive than the aluminum but not as costly as the carbon-fiber tripod legs.

AC.2 The lever lock on this tripod makes it easy to quickly adjust the height of the tripod.

Tripod legs are made to extend and collapse so that their height can be adjusted and so that they can be easily carried to the location they are needed. There are different methods of locking the legs into place. Two of the most common are locking levers and twist-lock collars. Both locking methods are easy to use and it is just a matter of personal preference on which you prefer.

The working height of a tripod is important. You want to be able to shoot from as high and as low as your style of photography calls for.

Tripod heads

The tripod head attaches to the center column of a tripod. The advantage to having a tripod that takes a separate tripod head is that you can change the head for different styles of photography. The two standard types of tripod heads are a ball head and a three-way pan head.

AC.3 This tabletop tripod is great for doing quick shots in the house and on vacation, but the working height is very low and isn't very practical for all photos.

AC.4 A medium-size ball head

✦ **Ball head.** A ball head is quicker to move and adjust than a traditional three-axis pan head. The ball head can swivel in all directions, letting the photographer adjust the exact angle of the camera with one locking knob. A good ball head can support heavy loads and can move smoothly and lock securely. A good ball head allows the photographer to control the amount of tension needed to move the camera around. Because there are no long handles jutting out at three different angles, they are easier to carry and pack.

✦ **Three-way pan head.** The more traditional tripod head lets the photographer adjust the camera by separately adjusting each angle. The three levers allow you to control how the camera moves left and right, to tilt the lens up or down, or

to adjust the camera from landscape to portrait orientation. The advantage of the three-way pan head is that after one of the settings is locked in, the others can be adjusted without changing the other settings.

Tripod manufacturers

Here is a list of some tripod manufacturers and their Web sites. There are many different brands and manufacturers including some that are manufactured for Adorama and Calumet, two of the bigger chain camera stores in the United States (www.adorama.com and www.calumetphoto.com).

✦ **Benbo.** www.patersonphotographic.com/benbo-tripods.htm

✦ **Berlebach.** www.berlebach.de

✦ **Bogen.** www.bogenimaging.com

✦ **Giottos.** www.giottos.com

✦ **Gitzo.** www.gitzo.com

✦ **Manfrotto.** www.manfrotto.com

✦ **Ries.** www.riestripod.com

Remote controls

A remote control is essential when you want to take photos without touching the camera to eliminate camera shake. Sony makes two remotes for the A200: the RM-L1AM with a 196-inch cord and the RM-S1AM with a 20-inch cord. Both remotes act as a Shutter button attached to the camera by a cord.

Camera bags

It's great having a camera and a couple of lenses, an external flash, and a couple of memory cards, but how do you carry all that stuff with you easily and comfortably? Getting a good camera bag is important to keep your gear close and to keep it safe.

There is no right bag for everyone, and there really isn't a single bag that works perfectly in every situation. I love camera bags, and have way too many. Here are some things to keep in mind when buying a camera bag:

✦ **Make sure everything fits.** If you are buying a bag for everyday walking around, it is different from a bag that will be going on safari and doesn't need to hold as much. Take your photo gear with you and see how it fits in the bag. Make sure the bag has enough space to keep everything you want to carry.

✦ **Make sure the bag has enough padding/protection.** Padding and protection help to keep your camera safe, but the more padding, the bigger and bulkier the bag will be. It is a trade-off between protection and size.

✦ **Make sure the camera is accessible.** Being able to get your camera out of the bag is important; there is no way to take a photo if the camera is in the bag. Having clasps and buckles that can't easily be undone will make it difficult to get the camera out of the bag. Make sure that you can get to the camera and open the bag easily.

✦ **Make sure the strap is comfortable.** Load the camera bag and put it over your shoulder; it should be comfortable and not too heavy or bulky for a long day carrying it around.

Camera bags come in a variety of sizes and designs, from the traditional shoulder bag to modular belt systems. The following is a partial list of some camera bag manufacturers:

✦ **Crumpler.** www.crumplerbags.com

✦ **Domke.** www.tiffen.com

✦ **Lowepro.** www.lowepro.com

✦ **Sony.** www.sonystyle.com

✦ **Tamrac.** www.tamrac.com

✦ **Thinktank.** www.thinktank.com

Photography Organizations

There are many photography organizations specializing in all aspects of photography. Joining one can provide extra benefits like specialized insurance, seminars, and other training opportunities.

✦ **Advertising Photographers of America.** Started in 1982, the APA has been working to help photographers in the advertising field. The APA offers a great deal of information even for nonmembers, along with resources on basic business forms, articles on copyright, and other online information.

www.apanational.com

✦ **American Society of Media Photographers.** ASMP calls itself the leading association of photographers helping photographers. The Society of Magazine Photographers started in 1944, then became the American Society of Magazine Photographers, and now is known as the American Society of Media Photographers. Currently the ASMP has over 5,000 members in 39 chapters nationwide.

www.asmp.org

✦ **National Press Photographers Association.** The NPPA was founded in 1946 as a voice for the working press photographer. The NPPA offers educational programs to promote freedom of the press and strive for high standards and ethics in news photojournalism.

www.nppa.org

✦ **Professional Photographers of America.** The PPA was founded in 1880 and has more than 18,000 members in more than 60 countries. The PPA is the world's largest not-for-profit association for professional photographers. Membership benefits include business discounts, legal advice, education programs, and insurance for both people and equipment.

www.ppa.com

✦ **National Association of Photoshop Professionals.** The NAPP was formed as an extension of Adobe Photoshop Seminar training tours to help with continuing education. NAPP was officially launched in 1998 and continues to grow every year. Membership in NAPP includes a subscription to the *Photoshop User* magazine and access to a member's-only Web site offering tips and tutorials. NAPP also offers a free member gallery and a great help desk.

www.photoshopuser.com

Photography Web Sites

The Internet is a great resource, and finding help or just wanting to share your images with others has become much easier. The following Web sites can help you get information on your A200 camera (or other Sony gear), get help with any general photography question, and share and edit your images online.

Sony-specific Web sites

The following Web sites are either run by Sony or deal specifically with Sony cameras. These are great places to start when looking for any specific information on your A200 or any other Sony cameras and lenses.

✦ **www.sonystyle.com.** The Sony home on the Web, and the place to purchase Sony equipment.

✦ **www.esupport.sony.com.** This is the support site for all Sony products: camera manuals, software updates, tutorials, and frequently asked questions.

- **www.sony.net/Products/dslr.** This is the home of the Sony dSLR on the Internet. This site is run by Sony and has the basic information on the full range of Sony Alpha cameras.

- **www.dyxum.com.** The home of the Minolta/Alpha-mount dSLR photography on the Internet. A great Web site devoted to cameras with the Minolta/Sony Alpha lens mount. The site includes lens and camera reviews, links to other resources, and a useful user forum.

- **www.alphamountworld.com.** A Web site dedicated to cameras with the Sony Alpha mount. It includes lens reviews, user forums, and news about Sony cameras in general.

- **www.alphalensrental.com.** A great way to try out a lens before buying it, or just using a specialized lens for the weekend without having to spend a large sum of money. Matt David is the owner/operator and a longtime Minolta/Sony photographer.

Photography and software Web sites

The following Web sites cover everything from camera reviews to online photo seminars. There are many sites not listed here. This listing is just a small sample of some of the sites I have used and find useful.

Digital Photography Review

www.dpreview.com

The DPR site is an independent review site that covers the photography industry. The main page not only has news and reviews, but links to the most active forum subjects.

The very active user forums cover a huge variety of subjects, and there are camera and topic-specific discussions. This is a great place to go for answers to any questions you might have about your camera or photography in general.

Kelby training

www.kelbytraining.com

Scott Kelby is the founder of the National Association of Photoshop Professionals and has recently started Kelby training. Kelby training is a Web site dedicated to bringing some of the biggest names in photography and Photoshop to online Web-based training. Kelby training also offers DVDs, books, and Photoshop training seminars. Along with Kelby, some of the trainers include Vincent Versace, Joe McNally, and Dan Margulis. One really nice part of the site is the free trial to see if you like it before you buy it.

Adobe Photoshop Lightroom Killer Tips

www.lightroomkillertips.com

This Web site/blog is run by Matt Kloskowski and is sponsored by the National Association of Photoshop Professionals and Adobe. Matt updates the site an a regular basis with video tutorial, presets, and general tips and news all for Adobe Photoshop Lightroom. The site is well laid out with the newest info on the top, a search function, and many examples.

Lightroom Galleries

www.lightroomgalleries.com

One of the great functions of Adobe Photoshop Lightroom is the ability to create Internet-ready photo galleries. These galleries

can be customized to create individual looks, and there is no better place to see what can be done than the Web site Lightroom Galleries. Downloadable templates and tips on creating the best looking photo galleries are all here.

Inside Lightroom

www.inside-lightroom.com

Inside Lightroom is another site that is dedicated to Adobe Photoshop Lightroom with news, presets, and other information. The site has current news and reviews along with presets and a great tutorial on how to load and use the presets.

Photography sharing sites

The following Web sites allow you to share your photos with others by posting them on the Internet. Each of these three sites offers something different to the user. While Photobucket is a great place to store your images, it doesn't have the editing capabilities of Photoshop Express, and neither Photoshop Express nor Photobucket can match the user groups in Flickr. So use one of them, none of them, or all three: It's just good to know that there is an inexpensive way to share your images using the Internet.

Flickr

www.flickr.com

Flickr is a photo-sharing Web site that offers users a free place on the Internet to share their photos with others. If that was all Flickr was, it would be a good place to go, but Flickr offers a lot more than that. There are groups dedicated to just about every type of photography subjects imaginable and there

are groups dedicated to Sony cameras. These groups are a great place to get information and feedback from other photographers who use the same cameras and gear as you. Users on Flickr can opt to upgrade to a pro account, which gives you more space for your images and bonuses like statistics for all your images. Some of the Flickr groups of interest to A200 photographers include Sony Alpha dSLR Cameras, Sony DSLR, and Sony DSLR-A200, and there are more groups being started every day.

Photobucket

www.photobucket.com

Photobucket is a free site on the Internet used for sharing your photos. Along with it being free, Photobucket offers free tools to create slide shows and allows you to share your photos with anyone. It is also possible to use Photobucket's online store to print your pictures and have them printed on a variety of products, from wall posters to coffee mugs.

Photoshop Express

www.photoshopexpress.com

While Adobe's Photoshop is known more for its image-editing capabilities, the new Photoshop Express online service allows users to upload images and share them with other users. While it is not yet as popular as Flickr or Photobucket, it offers a wider range of image editing than either of those.

Glossary

AE lock Pressing the camera's AE lock button locks the current exposure and lets you recompose the scene without changing the exposure.

AF (autofocus) lock The focus can be locked by pressing the Shutter button halfway down. When the focus is locked, the camera can be moved but the focus cannot. The focus stays locked until the shutter is released or the Shutter button is released. This allows the scene to be recomposed without changing the focus.

ambient light The natural light in the scene, also referred to as available light or existing light.

angle of view The amount of the scene in front of the camera that a specific lens sees.

aperture The size of the lens opening that the light passes through before reaching the sensor in the camera. The aperture is expressed as f/number — for example, f/5.6.

Aperture Priority mode In this mode, the photographer sets the aperture and the camera sets the shutter speed.

artificial light Any light that the photographer introduces into a scene.

aspect ratio The proportions of the image captured by the camera, calculated by dividing the width of the image by the image height. The A200 can save images in the standard 3:2 aspect ratio and in the HDTV aspect ratio of 16:9.

autofocus The camera automatically adjusts the focus depending on which focus sensor is selected. The autofocus on the A200 can be started by either the Eye-Start sensor or by pressing the Shutter button halfway down.

autofocus illuminator A built-in red light that illuminates the scene, helping the camera achieve focus when there is not enough ambient light present.

Auto mode In this mode, the camera sets the shutter speed, aperture, and ISO to achieve the correct exposure.

backlighting A method of lighting where the main light is placed behind the subject. See also *silhouette*.

barrel distortion An effect that causes straight lines to bow outward, especially at the outer edges of the frame. This effect is more pronounced when using wide-angle lenses.

bounce light Light that is bounced off a surface before hitting the subject to create a more flattering light source. This is used mainly with a dedicated flash unit that can be aimed at a wall or ceiling.

bracketing A method in which multiple exposures are taken, some below and some above the recommended exposure. The A200 can be set to bracket the exposure in 0.7 or 0.3 stops and can also bracket the white balance setting. Bracketing is controlled in the Drive menu.

buffer The camera's built-in memory that is used as a temporary storage before the image data is written to the memory card.

bulb A shutter speed setting that keeps the shutter open as long as the Shutter button is held down.

camera shake The small movements of the camera that can cause blurring, especially when the camera is being handheld. Slower shutter speeds and long focal lengths can contribute to the problem.

CCD Charged Coupled Device, the type of sensor that the A200 uses to capture the image.

Center-weighted metering Light from the entire scene is metered, but a greater emphasis is placed on the center area.

colorcast An overall look or predominant color that affects the whole image. Colorcasts are usually brought about by an incorrectly set white balance. See also *cool* and *warm*.

color temperature A description of color using the Kelvin scale. See also *Kelvin*.

compression Reducing image file size by either removing information (lossy compression) or writing the information in a form that can be re-created without any quality loss (lossless compression). See also *lossy* and *lossless*.

Continuous Autofocus mode A mode in which the camera continues to refocus while the Shutter button is held halfway down. This is the best focus mode for moving subjects.

contrast The difference between the highlights and the shadows of a scene.

Control dial The dial that allows the photographer to change settings depending on what mode the camera is in. For example, when the camera is in Shutter Priority mode, the Control dial changes the shutter speed, and when the camera is in Aperture Priority mode, the Control dial changes the aperture.

cool A descriptive term for an image or scene that has a bluish cast.

crop To cut off or trim one or more of an image's edges. When the A200 is set to the 16:9 aspect ratio, the image is being cropped by removing data from the top and bottom of the scene.

dedicated flash A flash unit designed to work with the A200.

depth of field (DOF) The area of acceptably sharp focus in front of and behind the focus point.

diaphragm An adjustable opening in the lens that controls the amount of light reaching the sensor. Opening and closing the diaphragm changes the aperture.

diffused lighting Light that has been scattered and spread out by being bounced off a wall or ceiling or shot through a semi-opaque material, creating a softer, more even light. Diffused lighting can also be sunlight shining through the clouds.

digital noise See *noise*.

diopter A unit of measurement used in the making of corrective lenses. The A200 has a diopter adjustment so that people who need corrective glasses can use the viewfinder without glasses.

exposure The amount of light that reaches the sensor.

exposure compensation A method of adjusting the exposure so that it differs with the metered reading.

exposure metering Using the light meter built into the camera to determine the proper exposure. See also *Metering modes*.

f-stop A measure of the opening in the diaphragm that controls the amount of light traveling through the lens. See also *aperture* and *diaphragm*.

fast A description referring to the maximum aperture of a lens. Lenses with apertures of f/2.8 and higher are considered fast lenses. See also *slow*.

fill flash A method where the flash is used to reveal details in shadow areas that would usually be lost.

filter A glass or plastic cover that goes in front of the lens. Filters can be used to alter the color and intensity of light, add special effects like soft focus, and protect the front elements of the lens.

flash A device that produces a short bright burst of artificial light. The word *flash* can be used to describe the unit producing the light or the light itself.

Flash Exposure Compensation An adjustment that changes the amount of light produced by a flash independently of the exposure settings.

flash sync The method by which the flash is fired at the moment the camera shutter opens.

flat A description of an image or scene that has very little difference between the light values and the dark values. An image or scene with low contrast.

focal length The distance from the optical center of the lens when it is focused at infinity to its focal plane (sensor), described in millimeters (mm).

focal plane The area in the camera where the light passing through the lens is focused. In the A200, this is the digital sensor.

focus The adjustment of the lens to create a distinct and clear image.

front lighting A method of lighting where the main light is placed directly in front of the subject.

gigabyte A unit of measurement equaling 1 billion bytes. Used in describing the capacity of the memory cards used in digital photography.

high contrast A description of an image or scene where the highlights and shadows are at the extreme differences in density.

high key A description of a photograph with a light tone overall.

histogram A basic bar graph that shows the amount of pixels that fall into each of the 256 shades from pure black to pure white. The histogram view on the A200 also shows the values of the red, green, and blue color channels.

hot shoe The camera mount on top of the viewfinder that accepts Sony flash accessories. The hot shoe on the A200 is a proprietary design and does not accept standard hot shoe accessories designed for other camera manufacturers.

image rotation The ability of the camera to recognize the orientation in which the photo was taken and to display the image in the correct orientation when viewing it on the LCD.

ISO International Organization for Standardization. An international body that sets standards for film speeds. The standard is also known as ISO 5800:1987 and is a mathematical representation for measuring film speeds.

ISO sensitivity The light sensitivity of image sensors in digital cameras is rated using the standards set for film. Each doubling of the ISO makes the sensor twice as sensitive to light, meaning that in practical purposes, an ISO rating of 200 needs twice as much light as an ISO of 400.

JPEG Joint Photographic Experts Group. The most commonly used and universally accepted method for image file compression. The JPEG is a lossy form of compression, meaning that information is lost during the compression. JPEG files have a .JPG file extension. See also *lossy*.

Kelvin Abbreviated with K, it is a unit to measure color temperature. The Kelvin scale used in photography is based on the color changes that occur when a theoretical black body is heated to different temperatures.

LCD (liquid crystal display) The type of display used on most digital cameras to review your photos and display menus and shooting data. The 2.7-inch screen on the back of the A200 has a resolution of 230,000 pixels and has an anti-reflective coating.

light meter A device used to measure the amount of light in a scene. The readings from the light meter can be used to determine what settings can be used to produce a proper exposure. The A200 has a built-in light meter to determine what shutter speed and aperture to use in Auto mode, what shutter speed to use when you choose the aperture, and what aperture to use when you pick the shutter speed.

lossless A form of computer file compression that allows the original data to be reconstructed without losing any of the information. This is useful when it is important that no changes are made to the information. See also *compression* and *TIFF*.

lossy A form of computer file compression that reduces the file size by removing data. The file will not be an exact match to the original file but close enough to be of use. This form of compression suffers from generation loss. Repeatedly compressing the same file results in progressive data loss.

and, in photography, image degradation. See also *compression* and *JPEG*.

low key A description used to describe a photograph with a darker tone overall.

macro lens A specialty lens that allows for extreme close-ups with a reproduction ratio of 1:1, creating life-size images.

Manual exposure mode In this mode, the photographer determines the exposure by setting both the shutter speed and the aperture.

megapixel A description referring to the amount of pixels that a digital camera sensor has. 1 megapixel is equal to 1 million pixels.

memory card The removable storage device that image files are stored on. In the A200, the memory card is a CompactFlash card.

Metering modes The method the camera uses to determine what light to use in the metering process. See also *Multi-segment metering*, *Center-weighted metering*, and *Spot metering*.

Mode dial The large dial on the top left of the camera that is used to set the shooting mode for the camera.

Multi-segment metering The light meter built into the A200 divides the entire scene into 40 segments used to measure light. The light is measured in each of the 40 areas and combined to create an accurate measurement.

noise Extra unwanted pixels of random color in places where there should only be smooth color. Noise is created when the signal from the image sensor is amplified to match the ISO characteristics of film. The higher the ISO in a digital camera, the more noise is created.

noise reduction Software or hardware used to reduce unwanted noise in digital images. See also *noise*.

normal lens A lens that produces images in a perspective close to that of the human eye.

overexposure Allowing more than the recommended amount of light to reach the sensor, causing the image to appear too light and with less detail in the highlights.

panning A method that involves moving the camera in the same direction and speed that the subject is moving, resulting in an image where the subject is in acceptable focus while the background is blurred.

pixel A contraction of the words *picture elements* that describes the smallest unit that makes up a digital image.

prime lens A lens with a single focal length.

Program Auto mode In this mode, the camera sets the shutter speed, aperture, and ISO to achieve the correct exposure in the same way it does in the Auto adjustment mode. The photographer can adjust these settings for more control over the exposure, giving a higher level of user control over the exposure compared to the Auto adjustment mode.

RAW A file type that stores the image data without any in-camera processing. The A200 uses a proprietary file type that needs to be processed by software before it can be used. The RAW file type has the extension of ARW.

Rear-curtain sync The ability to fire the flash at the end of the exposure instead of at the beginning. This freezes the action at the end of the exposure.

red eye A condition that occurs when photographing people or animals with a flash that is positioned too close to the lens causing the light from the flash to be reflected off of the back of the eye and back toward the camera's lens. In animals this effect may not be red, but instead is often blue or green.

Red-Eye Reduction A flash mode that fires a short burst of light right before the photograph is taken in hopes of causing the subject's pupils to contract and lessen the amount of light that can be reflected back.

reflector Any surface that can be used to redirect light. Specialty reflectors for photography come in different sizes, shapes, and colors and are designed to reflect light onto the subject.

saturation In color, it is the intensity of a specific hue.

self-timer The ability of the camera to take an exposure after a predetermined amount of time when the Shutter button has been pressed. The A200 has two self-timer countdowns, one for 2 seconds and one for 10 seconds.

sharp A way to describe a well-focused image.

shutter A movable cover that controls the amount of light that is allowed to reach the sensor, by opening for a specific length of time designated by the shutter speed.

Shutter button The button that is used to move the shutter out of the way, so a photograph can be taken. Pressing the Shutter button halfway down locks the autofocus.

shutter speed The amount of time that the shutter is open and letting light reach the image sensor.

Shutter Priority mode In this mode the photographer sets the shutter speed and the camera sets the aperture.

side lighting A method of lighting where the main light source is to the side of the subject.

silhouette An image or scene where the subject is represented by a solid black object against a lighter background. See also *backlighting*.

slow A description referring to the maximum aperture of a lens. Lenses with a maximum aperture of f/8 are considered very slow. See also *fast*.

Spot metering The only area that the camera uses to meter the light is a small area in the center of the scene.

stop A term of measurement in photography that refers to any adjustment in the exposure. When stop is used to describe shutter speed, a 1-stop increase doubles the shutter speed, and a 1-stop decrease halves the shutter speed. When stop is used to describe aperture, a 1-stop increase doubles the amount of light reaching the sensor, and a 1-stop decrease halves the light reaching the sensor. When used to describe ISO, a 1-stop increase doubles the ISO while a 1-stop decrease halves it.

Super SteadyShot Vibration reduction technology that is built into the A200. The camera can shift the sensor to match the movement of the camera body, resulting in sharper photos when using longer shutter speeds.

telephoto effect A photographic optical illusion that occurs when using a long focal length lens where objects can appear closer together than they really are.

telephoto lens A lens with a focal length longer than normal.

TIFF Tagged Image File Format. A lossless file format for images that is universally acceptable by image-editing software. See also *lossless*.

tonal range The shades of gray that exist between solid black and solid white.

top lighting A method of lighting where the main light is placed above the subject.

underexposure Allowing less than the recommended amount of light to reach the sensor, causing the image to appear too dark with a loss of detail in the shadows.

vibration reduction See *Super SteadyShot*.

warm A descriptive term for an image or scene that has an orange or red cast.

white balance An adjustment to the colors that the camera records to match the lighting of the scene.

wide-angle lens A lens description that refers to lenses with shorter-than-normal focal lengths.

zoom lens A lens that has a range of focal lengths.

Index

Continued